MANGA 100
The Cute Collection

Draw Your Favorite Character Types from Popular Genres

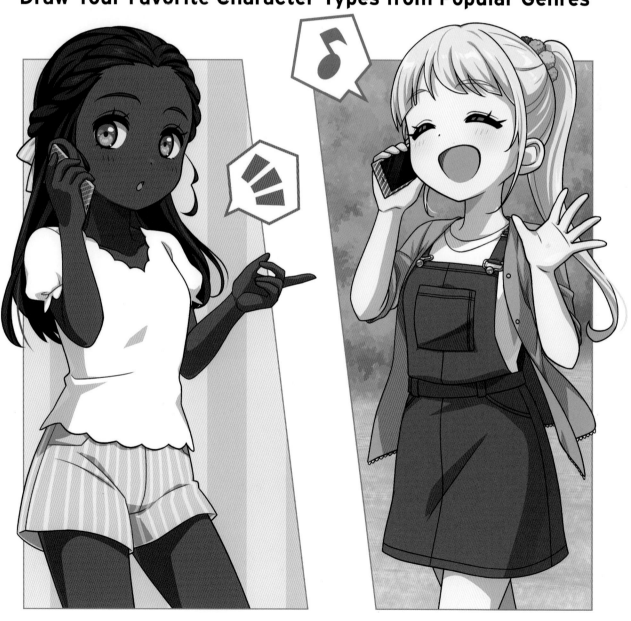

 Get Creative 6

DRAWING WITH Christopher Hart

An imprint of **Get Creative 6**
19 West 21st Street, Suite 601 New York, NY 10010
Sixthandspringbooks.com

Editor
LAURA COOKE

Creative Director
IRENE LEDWITH

Designer
JENNIFER MARKSON

Contributing Artists
@EZURINX
AKANE
AYASAL
HAIYUN
KOU KUBOTA
OUSUKE YOSHITATSU
PH MARCONDES
SHOUU KUN
TABBY CHAN
CHRISTOPHER HART

Chief Executive
CAROLINE KILMER

President
ART JOINNIDES

Chairman
JAY STEIN

Dedicated to my dog, Spencer, who would be the best manga artist ever, if he only had opposable thumbs

Library of Congress Cataloging-in-Publication Data
Names: Hart, Christopher, 1957- author.
Title: The cute collection : draw your favorite character types from popular genres / Christopher Hart.
Description: New York, NY : Drawing with Christopher Hart, [2023] | Series: Manga 100 | Includes index. | Audience: Ages 12+
Identifiers: LCCN 2023012815 | ISBN 9781684620678 (paperback)
Subjects: LCSH: Cartooning--Technique. | Comic strip characters--Japan. | Manga (Comic books) | BISAC: ART / Techniques / Cartooning | ART / Techniques / Drawing
Classification: LCC NC1764.5.J3 H369193 2023 | DDC 741.5/1--dc23/eng/20230412
LC record available at https://lccn.loc.gov/2023012815

Manufactured in China

1 3 5 7 9 10 8 6 4 2

christopherhartbooks.com
facebook.com/CARTOONS.MANGA
youtube.com/user/chrishartbooks

Contents

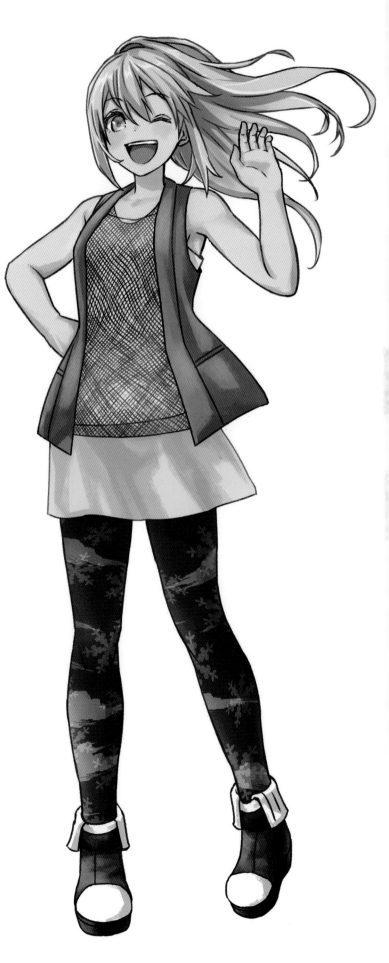

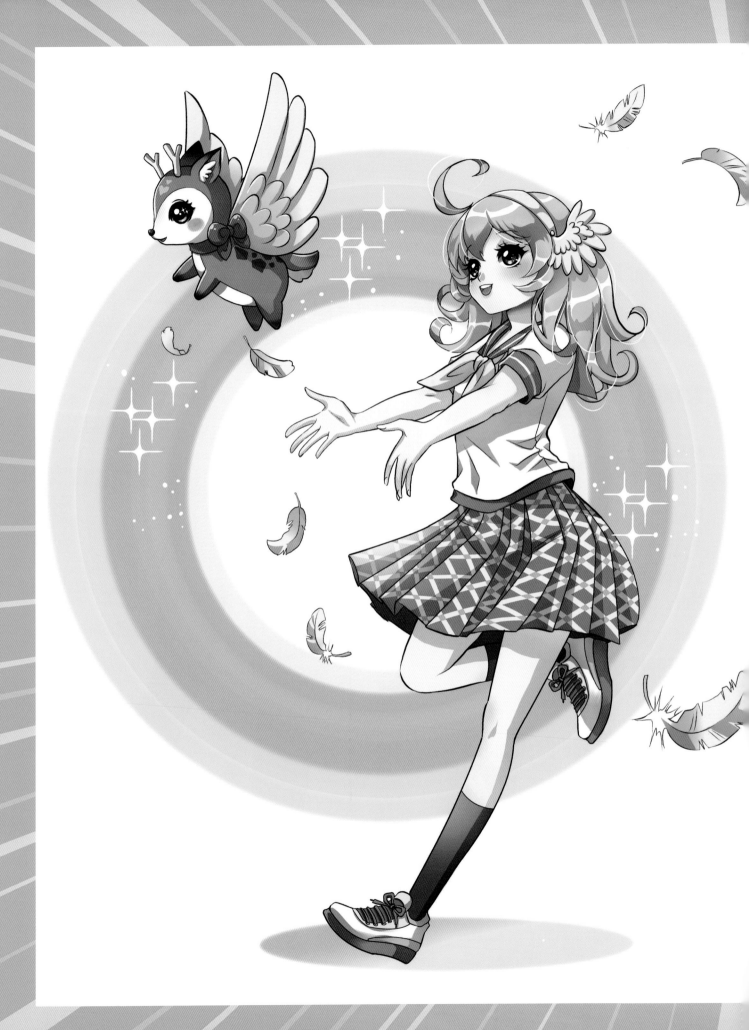

Introduction

This book is chock-full of easy-to-follow tutorials for drawing the cutest character types in manga. In this book, we'll cover every aspect of cuteness, including teenagers, funny characters, magical beings, brave types, and even pets of the future—a novel character type from Japan. You'll also learn techniques for drawing cute and trendy outfits, which can make your characters eye-catching. By using the simple drawing techniques in this book, you'll be able to put together an impressive array of characters and learn how to draw your own original creations, too. Whether you're just starting out or you have some experience in art, this book offers practical advice for drawing manga. So let's get cute, and let's get started!

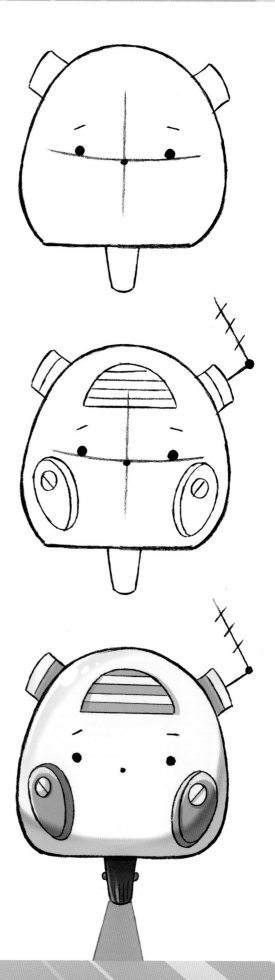

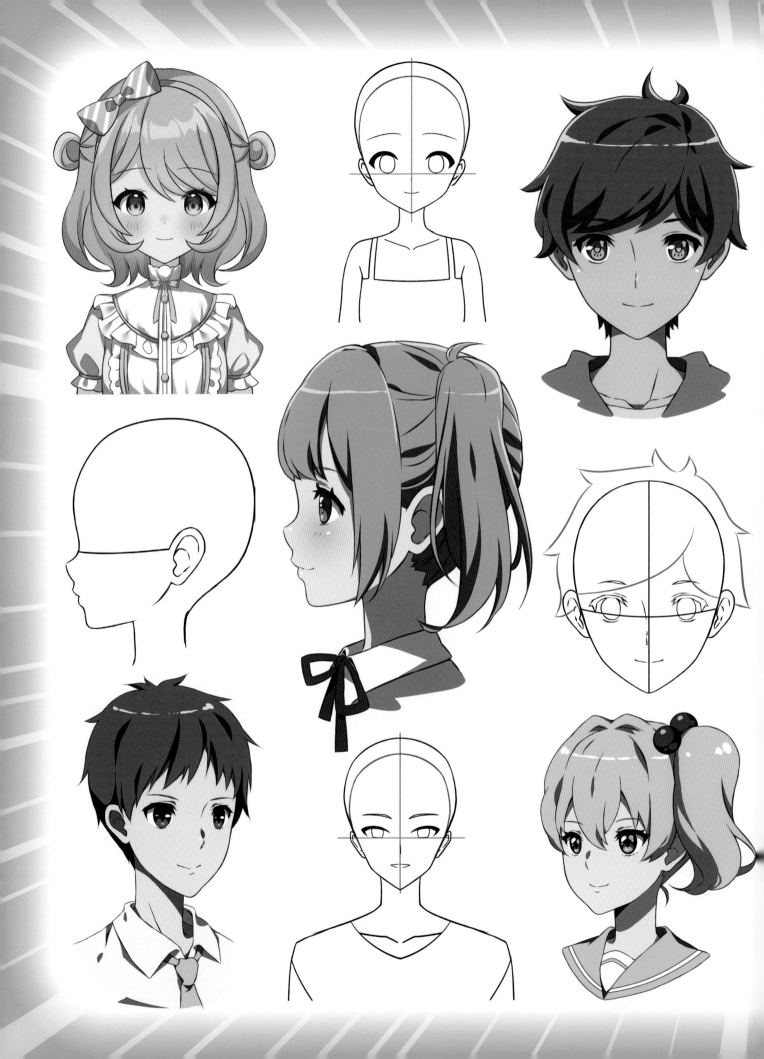

Basics of Drawing the Head

Many beginning artists learn to draw the head by using basic shapes and guidelines. But there's more to drawing manga characters than that. In this opening chapter, you'll get tips that are easy to use, and that can also propel your drawings to the next level. I'm talking about essential proportions and contours. And these can be customized to your character type. Best of all, by using these techniques, you can avoid making common mistakes. Let's try them out.

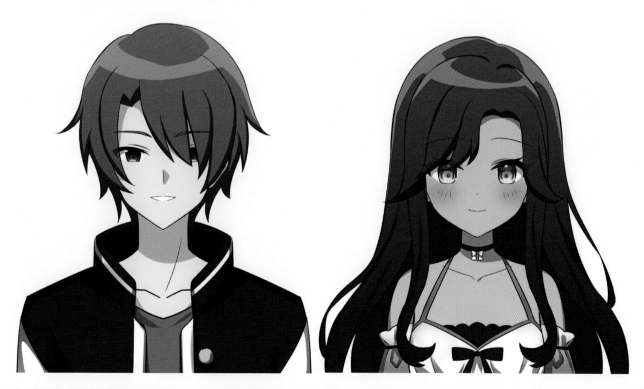

Female: Front View

The first step is an egg shape, but the bottom (jaw area) is more angular, so it appears to taper.

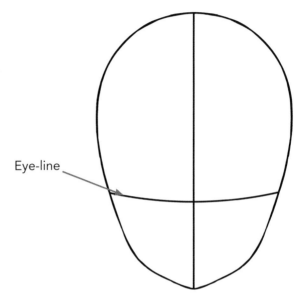

Eye-line

The centerline runs from the top of the head to the tip of the chin, while the horizontal eye-line is curved.

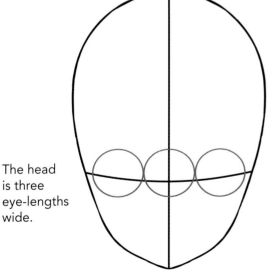

The head is three eye-lengths wide.

Proportions: There is one eye-length between the two eyes. You can draw these circles lightly to help with eye placement, then erase them later.

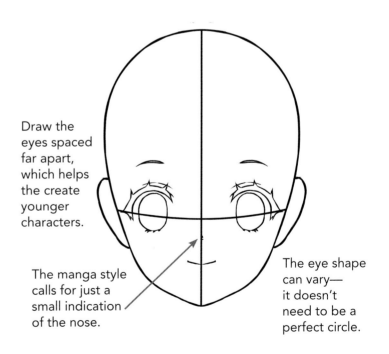

Draw the eyes spaced far apart, which helps the create younger characters.

The manga style calls for just a small indication of the nose.

The eye shape can vary— it doesn't need to be a perfect circle.

Draw a relaxed outline of the hair.

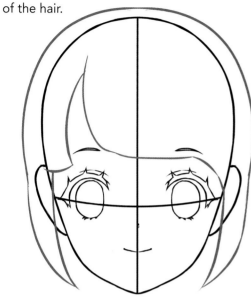

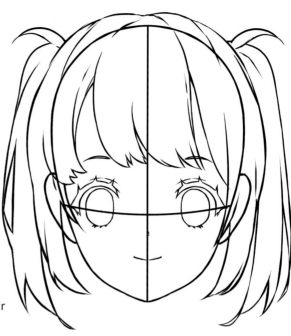

Keep the hair floppy for a relaxed look.

GOOD TO KNOW!
Hair is very important to the look. In fact, if you change a hairstyle, you'll change a character!

Color brings out the impact of the eyes. The eye color is rarely consistent throughout: Some of the eye is lighter, some is darker, and some is shiny.

Male: Front View

The overall shape of the head head is similar among many character types. It's the features, expression, and hairstyle that create the differences.

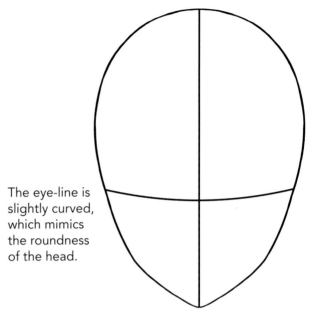

The eye-line is slightly curved, which mimics the roundness of the head.

The upper head is oversized on manga characters, but covered with hair so you don't always notice it.

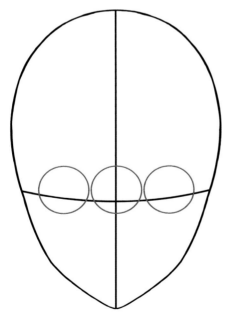

This eye proportion—with a space of one eye-length between the two eyes—works when drawing real people as well!

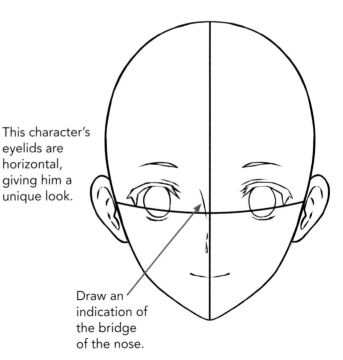

This character's eyelids are horizontal, giving him a unique look.

Draw an indication of the bridge of the nose.

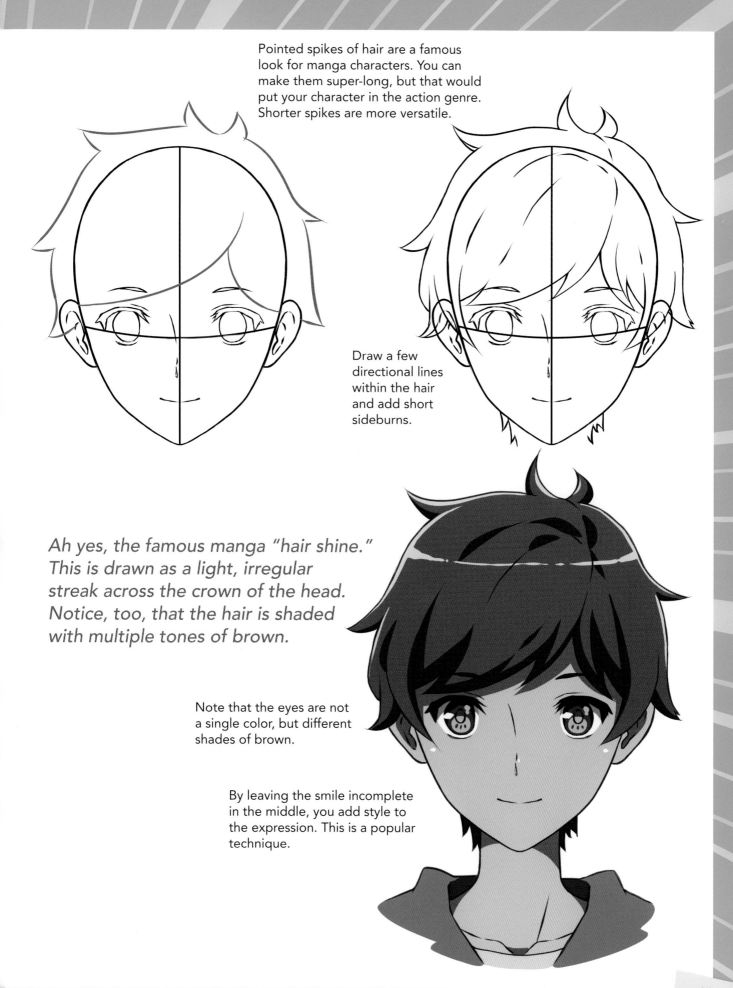

Pointed spikes of hair are a famous look for manga characters. You can make them super-long, but that would put your character in the action genre. Shorter spikes are more versatile.

Draw a few directional lines within the hair and add short sideburns.

Ah yes, the famous manga "hair shine." This is drawn as a light, irregular streak across the crown of the head. Notice, too, that the hair is shaded with multiple tones of brown.

Note that the eyes are not a single color, but different shades of brown.

By leaving the smile incomplete in the middle, you add style to the expression. This is a popular technique.

Drawing the Head in Profile

Female: Side View

The back of the head is big and serves as a counterbalance to the front of the face.

The guideline for the eyes starts at the bridge of the nose.

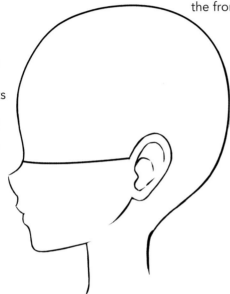

The upper red line shows the classic inward curve of the front of the face.

The diagonal red line shows the slope from the tip of the nose to the bottom of the chin.

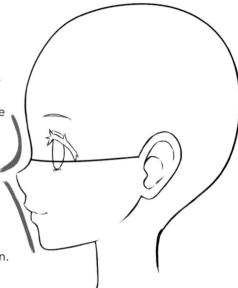

The large, round back of the head gives the character a cute look.

The eyelid slopes toward the ear.

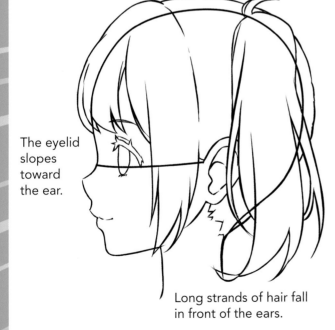

Long strands of hair fall in front of the ears.

Charming characters have large, round foreheads.

A slight overbite is a popular look for manga characters.

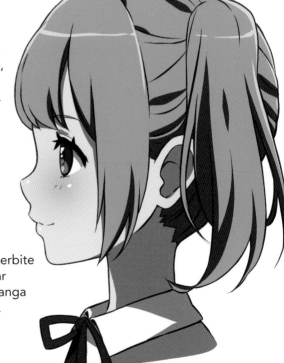

Male: Side View

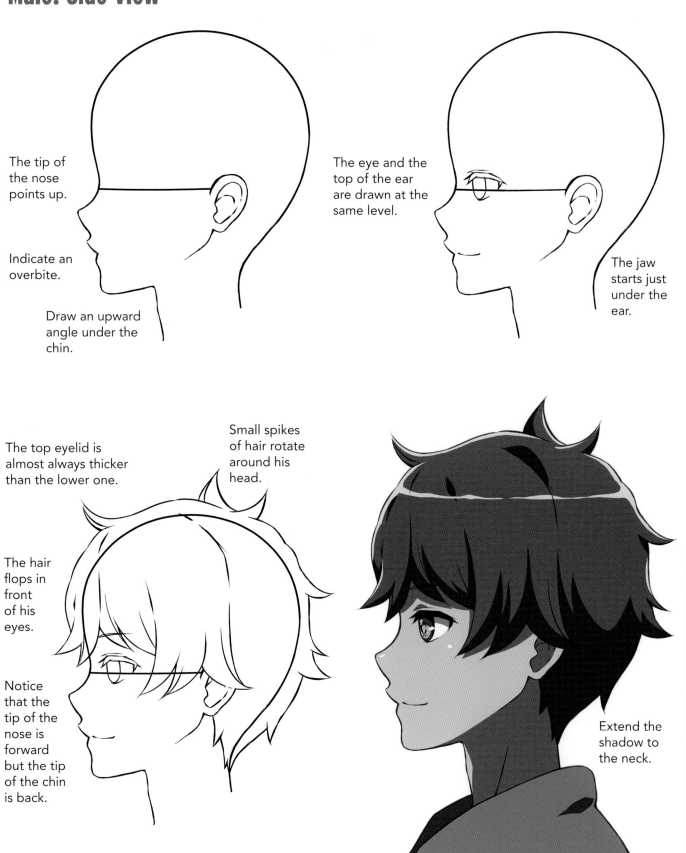

The tip of the nose points up.

Indicate an overbite.

Draw an upward angle under the chin.

The eye and the top of the ear are drawn at the same level.

The jaw starts just under the ear.

The top eyelid is almost always thicker than the lower one.

Small spikes of hair rotate around his head.

The hair flops in front of his eyes.

Notice that the tip of the nose is forward but the tip of the chin is back.

Extend the shadow to the neck.

#3 Head Rotations

If you have difficulty drawing your character at views other than front or profile, this section will be helpful. It provides the basics for turning the male and female heads in a complete rotation in eight easy steps. Drawing the same character at different angles can propel your skills to the next level.

Female: Rotation

FRONT VIEW

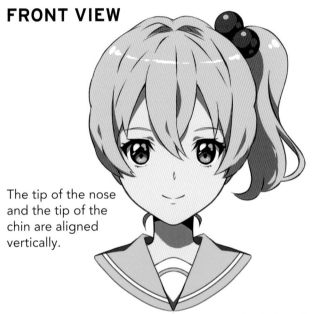

The tip of the nose and the tip of the chin are aligned vertically.

This popular angle is symmetrical: The left and right sides of the face are the same. It can fall out of symmetry when an uneven expression is introduced or when the head is turned slightly.

3/4 LEFT–FRONT

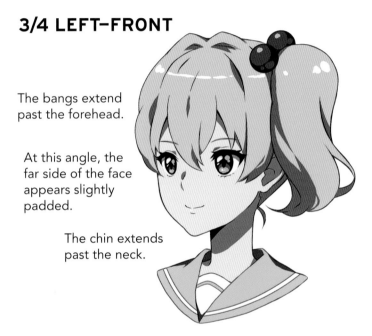

The bangs extend past the forehead.

At this angle, the far side of the face appears slightly padded.

The chin extends past the neck.

LEFT PROFILE

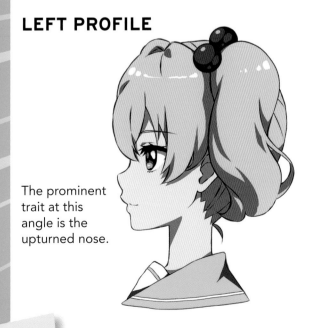

The prominent trait at this angle is the upturned nose.

3/4 LEFT–BACK

The ponytail is fully visibly at this angle.

BACK VIEW

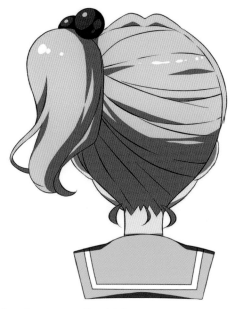

Except for the ponytail, which is off to the side, the back of the head is symmetrical (balanced on both sides).

3/4 RIGHT–BACK

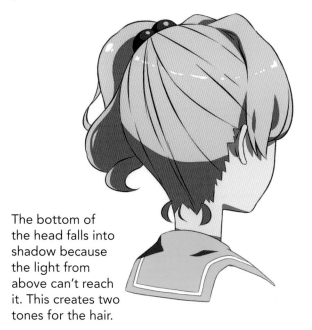

The bottom of the head falls into shadow because the light from above can't reach it. This creates two tones for the hair.

RIGHT PROFILE

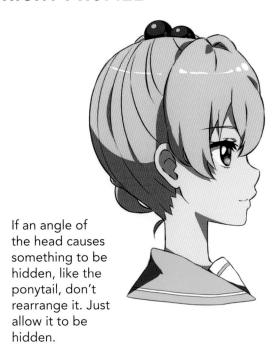

If an angle of the head causes something to be hidden, like the ponytail, don't rearrange it. Just allow it to be hidden.

3/4 RIGHT–FRONT

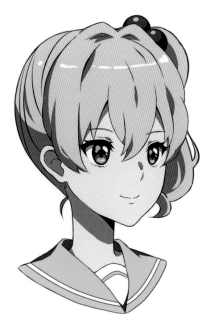

In a ¾ view, the far eye will appear to be smaller than the near eye, and it will be close to the edge of the face.

#4 Male Rotation

FRONT VIEW

3/4 LEFT-FRONT

The top of the head, in back, is the highest point.

GOOD TO KNOW!
Proportion tip: Both eyes are the same distance.from the bridge of the nose.

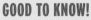

The tip of the nose and the tip of the chin are centered over the neck.

The jawline tapers evenly on both sides, keeping the head shape symmetrical.

The far eye is drawn as an oval.

At this angle, the hair falls just behind the ear and attaches to the back of the neck.

LEFT PROFILE

3/4 LEFT-BACK

Flop a little hair over the ears.

The underside of the chin angles upward before attaching to the neck.

Indicate a slight angle of the jaw, just below the ear.

Note the subtle contours of the side of the face.

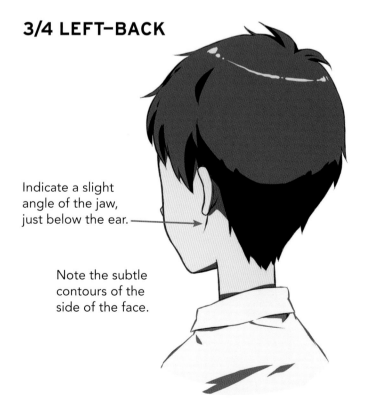

BACK VIEW

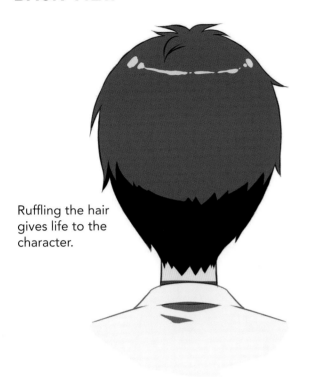

Ruffling the hair gives life to the character.

3/4 RIGHT–BACK

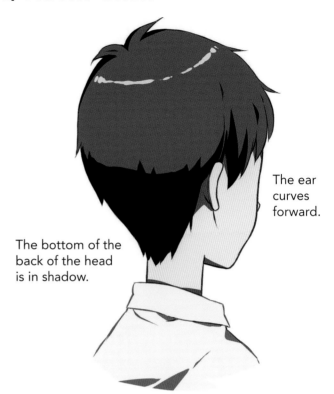

The ear curves forward.

The bottom of the back of the head is in shadow.

RIGHT PROFILE

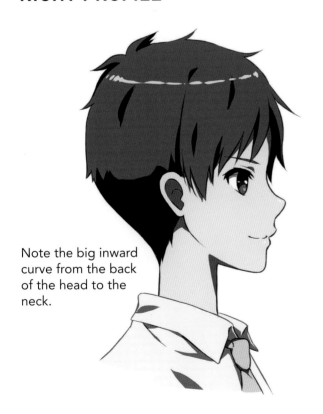

Note the big inward curve from the back of the head to the neck.

3/4 RIGHT–FRONT

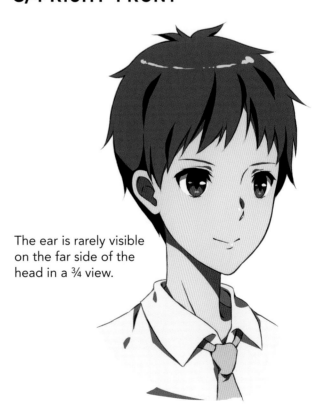

The ear is rarely visible on the far side of the head in a ¾ view.

#5 The Top 5 Hairstyles in Manga

Eyes and hair are the signature characteristics of manga characters. Together, they indicate the age, role in the story, and personality type. Let's look at the five most popular hairstyles, which you can build on to customize your own drawings.

Ponytail

Number five on our countdown of cute manga hairstyles is the ponytail. The ponytail is versatile because it goes with any age, from preteens to young adults.

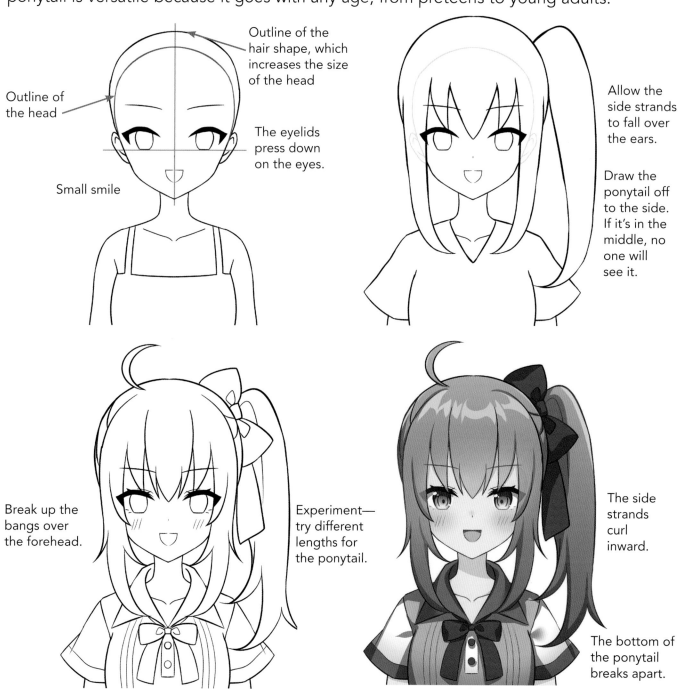

Outline of the hair shape, which increases the size of the head

Outline of the head

The eyelids press down on the eyes.

Small smile

Allow the side strands to fall over the ears.

Draw the ponytail off to the side. If it's in the middle, no one will see it.

Break up the bangs over the forehead.

Experiment— try different lengths for the ponytail.

The side strands curl inward.

The bottom of the ponytail breaks apart.

Short and Cute

The fourth haircut on our list is the adorable short flip. This cute haircut lends itself to accessories. It's used to create a character type that is a best friend and a positive thinker. The hairstyle surrounds the head, which keeps the viewer's eye on her expression.

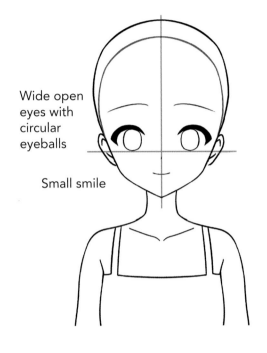

Wide open eyes with circular eyeballs

Small smile

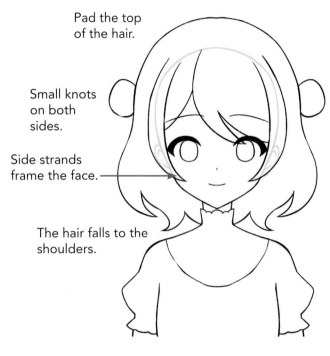

Pad the top of the hair.

Small knots on both sides.

Side strands frame the face.

The hair falls to the shoulders.

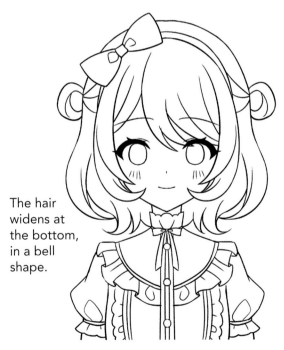

The hair widens at the bottom, in a bell shape.

This style has three layers:
- *Bangs*
- *Hair over the forehead*
- *Hair on the sides of the face.*

19

#7 Simple Braids

Number three on the list of cute manga hairstyles is braids. Drawing braids doesn't have to be complicated.Here's how to do it: Taper the braids so they appear widest at the shoulders and narrowest where they fall to the arms.

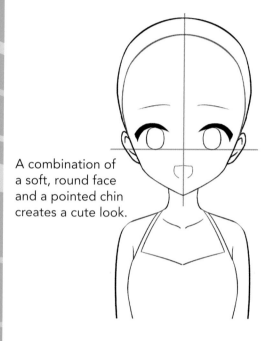

A combination of a soft, round face and a pointed chin creates a cute look.

Draw tips of hair on both sides of the head.

The braids begin at shoulder level. This means you have shorter braids to draw, while still achieving the same effect of longer braids.

The braids curve away from the shoulders so they don't crowd the image.

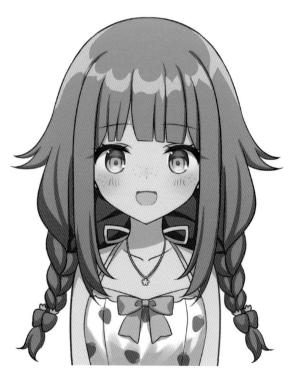

That famous manga hair shine can also be drawn as an uneven line across the top of the forehead.

Shoulder-Length

Number two on the all-time list of must-know haircuts is the ever-versatile shoulder-length haircut. All it takes is a simple cut with a ruffle along the bottom. You can give it a part on either side or straight down the middle.

This is a slightly introverted haircut. Let's show that by giving our character a modest expression.

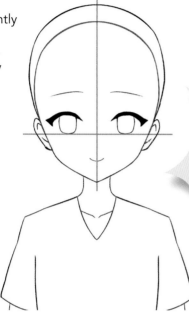

This style is neat and tidy.

TIP
When you begin with the outline of the head, instead of starting with the hair, all styles are possible.

The side strands are short, ending just above the mouth.

The hair ends in a blunt line behind the neck.

Choppy pieces run across the bangs and are repeated across the shoulders.

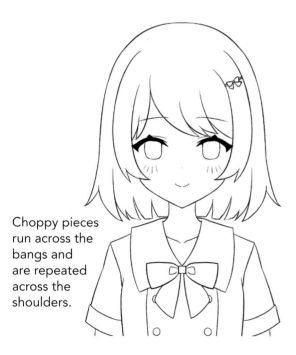

That famous manga hair shine can also be drawn as a ring around the top of the head.

The shine indicates a light source overhead, like a ceiling light.

21

#9 Long and Dramatic

And the most popular hairstyle in manga is (drumroll, please) . . . long and dramatic hair! This hairstyle looks cool on a character and is fun to draw as well. Most of the hair falls softly on her shoulders, but importantly, some will flow off for an elegant look.

TIP
The thing to remember about drawing long and dramatic hair is that it starts out with a controlled look around the head. But around shoulder level, it goes off on its own.

Let's give this character extra thick eyelids, which will stand out against a backdrop of dramatic hair.

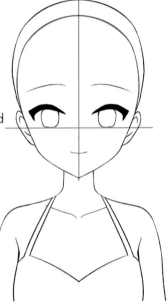

The hair falls gently over one eye. This establishes a dramatic look.

The hair widens out at the shoulders.

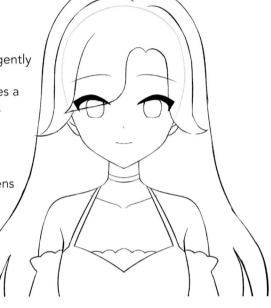

Draw each strand of hair in the same direction as the ones next to it. That will make the hair look like it's flowing, which is pleasing to the eye.

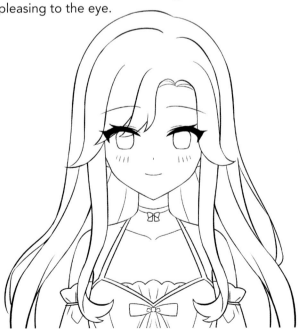

Show space between some of the strands, for variety.

Long, flowing strands fall in front of the shoulders.

Boys' Hair

Yes, boys' haircuts made it onto the list (but only as runners-up). If you have trouble drawing male characters, these hints may be useful. You'll find that hairstyles go a long way toward developing boy characters.

Floppy

The astute manga fan will notice that the chunks of hair are spaced fairly evenly apart, and they lean in the same direction, creating a pleasing rhythm. The rest of the hair falls in an even outline around his head.

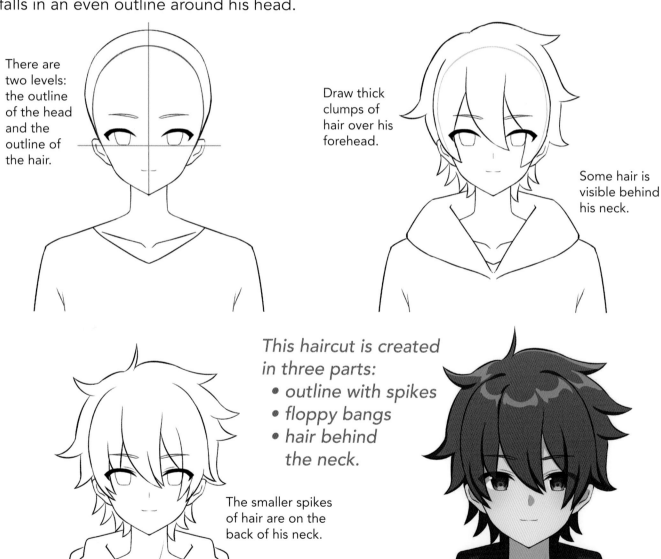

There are two levels: the outline of the head and the outline of the hair.

Draw thick clumps of hair over his forehead.

Some hair is visible behind his neck.

This haircut is created in three parts:
- *outline with spikes*
- *floppy bangs*
- *hair behind the neck.*

The smaller spikes of hair are on the back of his neck.

23

#11 Boy Bangs

Bangs look good when they're slightly separated. If they're drawn together in one clump, they look like a slab of hair, which is, like, huh? But, wait! Can he see the chalkboard with hair in front of his eyes? He doesn't need to. He's copying off the person next to him.

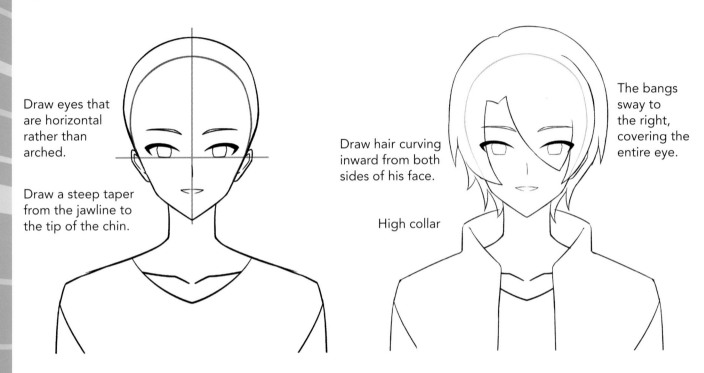

Draw eyes that are horizontal rather than arched.

Draw a steep taper from the jawline to the tip of the chin.

Draw hair curving inward from both sides of his face.

High collar

The bangs sway to the right, covering the entire eye.

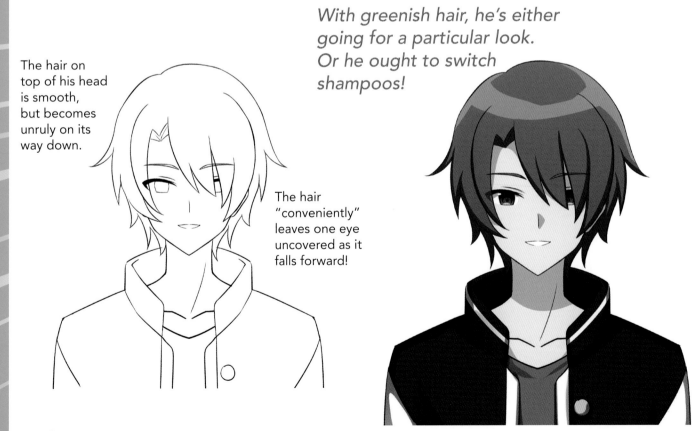

The hair on top of his head is smooth, but becomes unruly on its way down.

The hair "conveniently" leaves one eye uncovered as it falls forward!

With greenish hair, he's either going for a particular look. Or he ought to switch shampoos!

Center Part

From a character design point of view, the center part is an excellent option. It causes the hair to move away from the face and eyes, giving the viewer a clear look at your character's face. And an open face creates a cute, friendly type.

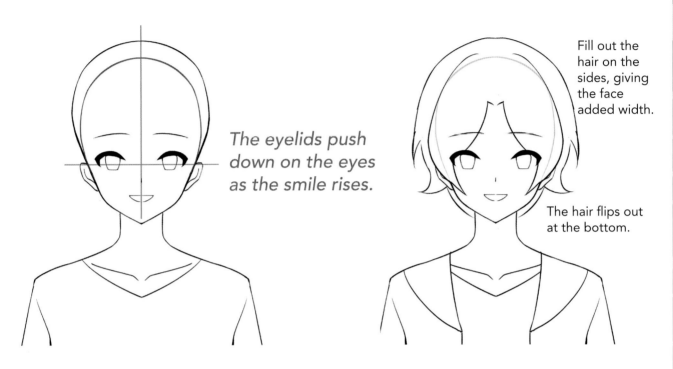

The eyelids push down on the eyes as the smile rises.

Fill out the hair on the sides, giving the face added width.

The hair flips out at the bottom.

Mess up the hair a bit to give your character a typical teenage look.

The tip of the forehead always shows a little "V" in a middle part.

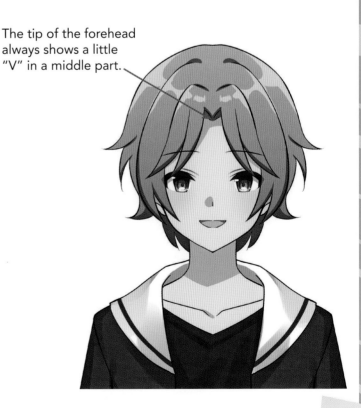

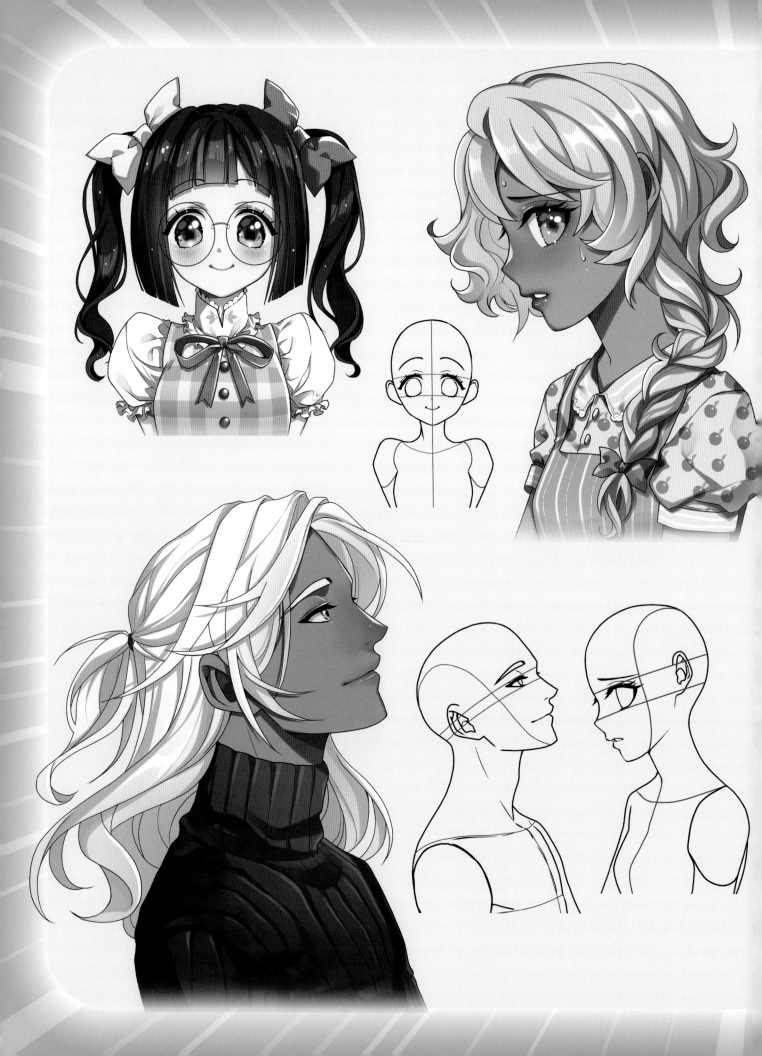

Essential Character Types

These ten cute-character types are fan favorites. With these tutorials, you won't have to draw plain faces anymore. Now, you can learn how to infuse your drawings with personality. It only takes three ingredients: the head shape, the eyes, and the hairstyle. Adding cute-character appeal is a skill, and important for any manga artist. You can apply these techniques to your own original characters.

#13 Upbeat Types

Upbeat characters are a great type for starting a story. Their enthusiasm is infectious, and so off they go with their friends following them on a great adventure! Too bad no one asked if she knew where they were going!

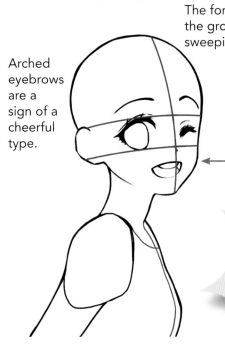

Arched eyebrows are a sign of a cheerful type.

The forehead lays the groundwork for sweeping bangs.

The lower part of the face pushes outward to create the cheek area.

The brim of the hat is short and flips up.

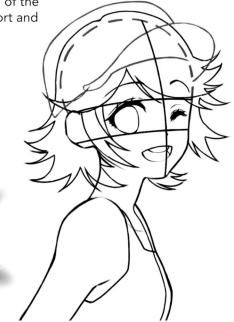

GOOD TO KNOW!
Even though the body leans forward, the guideline on the head is straight up-and-down.

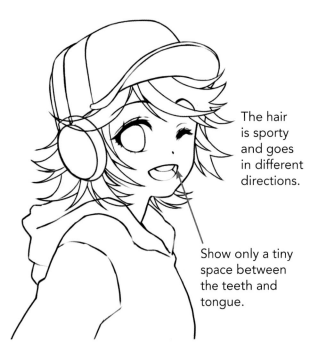

The hair is sporty and goes in different directions.

Show only a tiny space between the teeth and tongue.

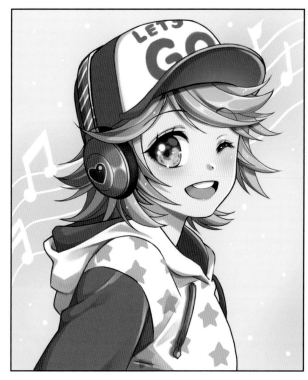

Upbeat colors and that fun pattern go with her smile.

Sincere Types

Sincere characters are popular and are usually drawn with large eyes. Their faces are wide open; you can read their emotions like a book. The key to drawing this type is keeping the features simple and straightforward.

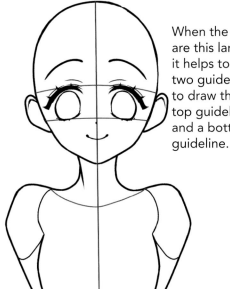

When the eyes are this large, it helps to use two guidelines to draw them—a top guideline and a bottom guideline.

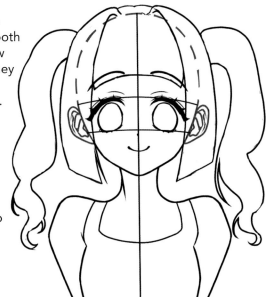

Flop some hair over both ears—draw them so they match on both sides.

Draw the pigtails so they get wiggly at the tips.

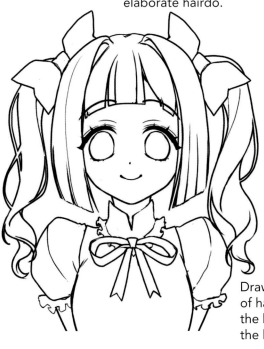

Bows and other accessories go particularly well with an elaborate hairdo.

Draw strands of hair within the body of the hairdo.

Notice that the oversized eyeglasses go down to the level of the mouth.

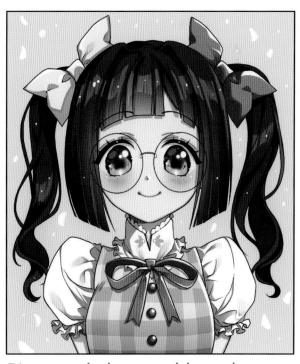

Big, round glasses add another dimension to the character by giving her an eager look.

#15 Quick-to-Anger Type

Have you ever heard the phrase, "Here comes trouble?" Well, here she is! This tightly wound character is a scene-stealer. Viewers can't take their eyes off characters who are always on the verge of a meltdown. Go ahead, tell her to have a great day. See how that goes over.

Let's start by getting the angle of the head right. The chin dips as the shoulder rises.

Notice the eyelashes coming off the top of the eyelids. This gives her a stealthy stare.

Draw a small mouth expression—the quiet before the storm!

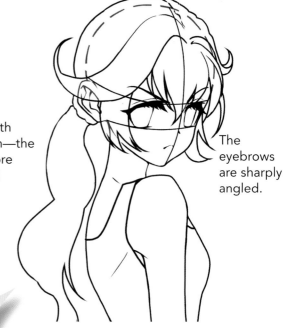

The eyebrows are sharply angled.

GOOD TO KNOW!
It's a popular technique to add a reddish color to the face, to indicate her blood pressure is rising.

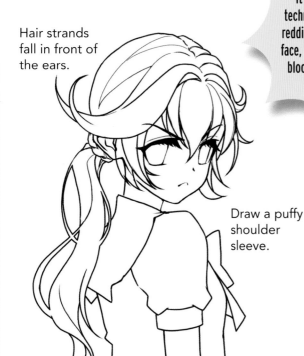

Hair strands fall in front of the ears.

Draw a puffy shoulder sleeve.

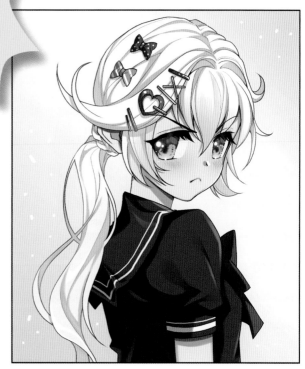

When a character is angry, it's all about the eyes.

Brave Type

She's a part time martial arts expert and full-time high school student. She's not afraid of anything except the social studies midterm exam. Young heroes don't want to fight, but sometimes they have to in order to rescue others.

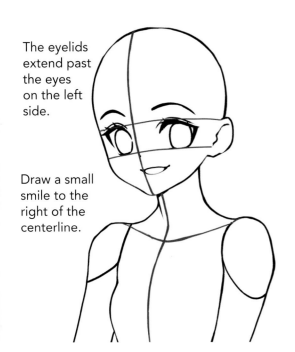

The eyelids extend past the eyes on the left side.

Draw a small smile to the right of the centerline.

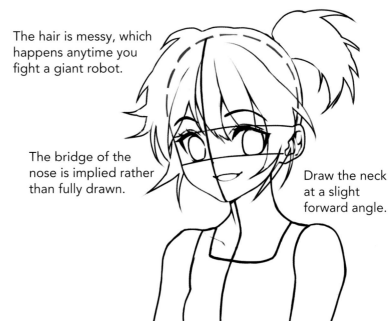

The hair is messy, which happens anytime you fight a giant robot.

The bridge of the nose is implied rather than fully drawn.

Draw the neck at a slight forward angle.

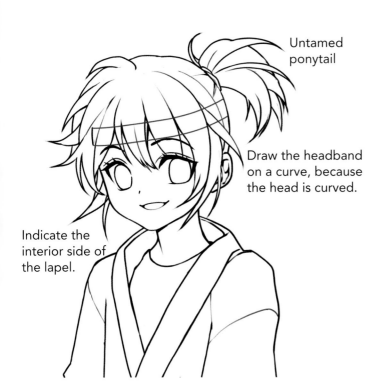

Untamed ponytail

Draw the headband on a curve, because the head is curved.

Indicate the interior side of the lapel.

Repeated streaks in the background are an excellent way to raise the energy level in a scene.

#17 Free Spirit Type

The free spirit can find the silver lining on a gloomy day. If her friends are feeling down, she can help to lift their spirits. This type also makes a great addition to the adventure genre. Can you imagine a situation where she and her buddies are about to face off against awesome enemies? Where do they get the courage? From her!

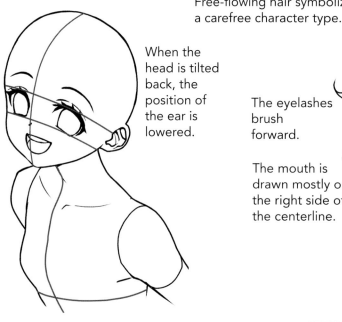

Draw the eyes within the guidelines, which are tilted up.

When the head is tilted back, the position of the ear is lowered.

Free-flowing hair symbolizes a carefree character type.

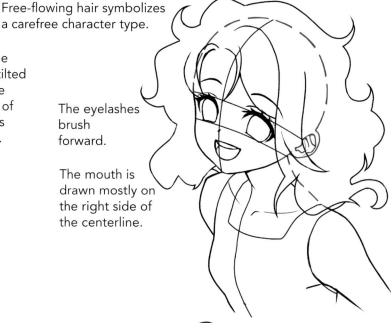

The eyelashes brush forward.

The mouth is drawn mostly on the right side of the centerline.

Draw a boatneck collar with a profusion of flounces. This doesn't have to be detailed or exact, it's the basic idea that you're going for.

The color of the flower matches the color on the outfit, in keeping with the theme.

Stressed-Out Type

Characters in turmoil are a feature of many manga stories. After all, they're teenagers, and inner turmoil is their business. But everyone, and not just teens, can relate to a character in a stressful situation. Therefore, this type can form a bond between the reader and the character.

Draw the eyebrow close to the eye, then angle it up.

This guideline defines the contour of the side of the face.

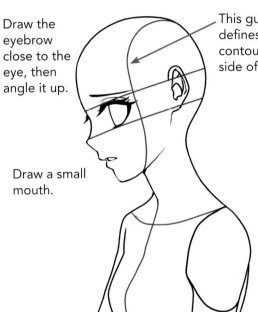

Draw a small mouth.

Her choppy hair reflects inner turmoil.

Bring the hair forward in order to frame the face.

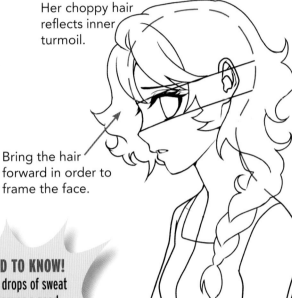

GOOD TO KNOW!
A few drops of sweat are never a good sign! They're an easy way to signal a cute character in distress.

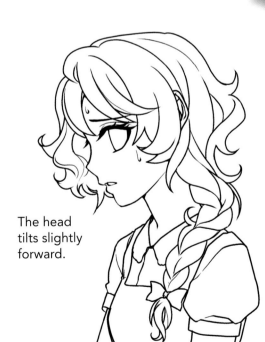

The head tilts slightly forward.

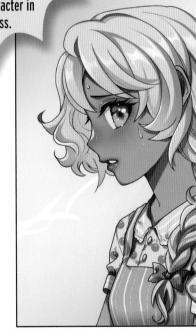

By drawing an eye glancing back, you show her distress. Making small choices like this are what drawing is all about.

#19 Sheepish Type

This type usually has a crush on someone. But every time he starts to talk, his face turns crimson red! So, he says nothing and remains silent with an awkward expression. Way to go, big fella.

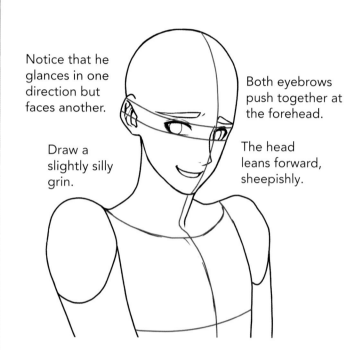

Notice that he glances in one direction but faces another.

Draw a slightly silly grin.

Both eyebrows push together at the forehead.

The head leans forward, sheepishly.

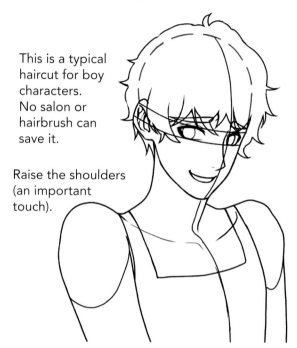

This is a typical haircut for boy characters. No salon or hairbrush can save it.

Raise the shoulders (an important touch).

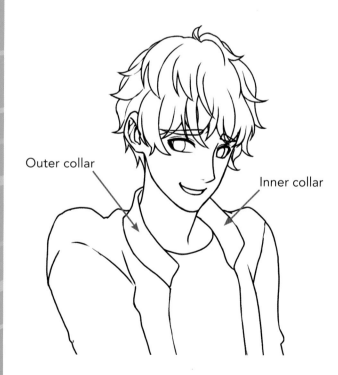

Outer collar

Inner collar

A blushing color and flying sweat drops may not be the most effective way to introduce yourself to a girl, but it's funny, so use it!

Laid-Back Type

This laid-back character can be soooo annoying. He sits at a café for hours savoring his avocado toast. Wait—he's almost done. Oh no! He just ordered a latte!

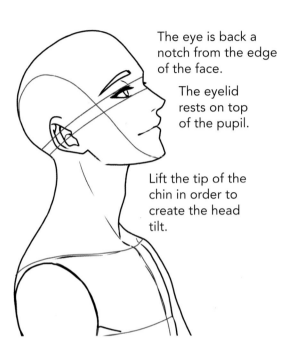

The eye is back a notch from the edge of the face.

The eyelid rests on top of the pupil.

Lift the tip of the chin in order to create the head tilt.

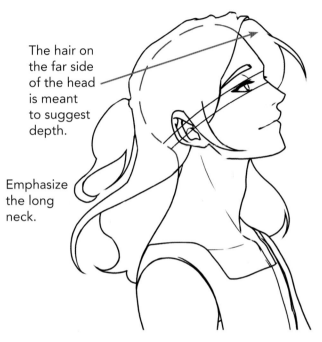

The hair on the far side of the head is meant to suggest depth.

Emphasize the long neck.

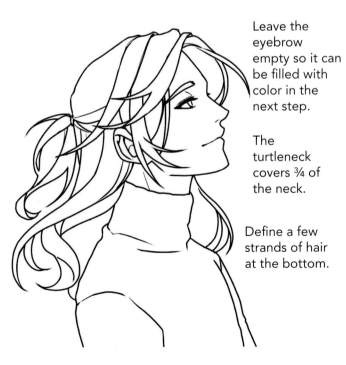

Leave the eyebrow empty so it can be filled with color in the next step.

The turtleneck covers ¾ of the neck.

Define a few strands of hair at the bottom.

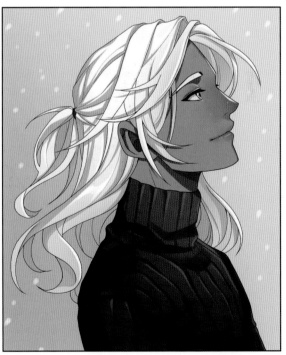

Are those petals or snowflakes in the background? In pop art, it doesn't really matter. The goal isn't to be literal, but to create a mood.

#21 Protective Type

The protective type keeps an eye out to make sure everything is okay. His instincts are honed and his reflexes are quick. He may be in the background, but he's always watching and can leap into action at any time.

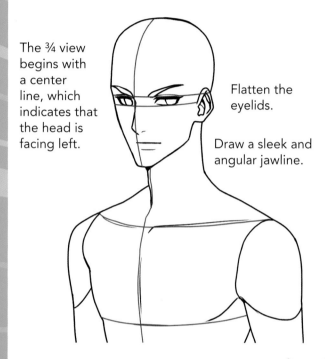

The ¾ view begins with a center line, which indicates that the head is facing left.

Flatten the eyelids.

Draw a sleek and angular jawline.

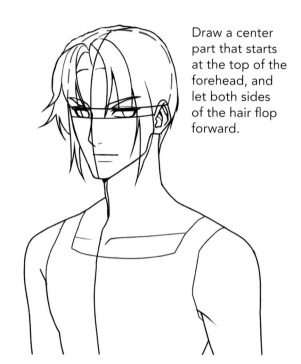

Draw a center part that starts at the top of the forehead, and let both sides of the hair flop forward.

GOOD TO KNOW!
When drawing a side-eye glance, don't move the head, just move the eyes.

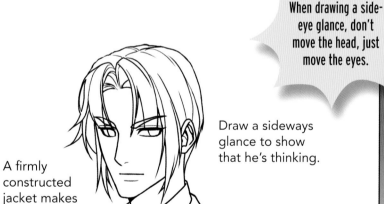

A firmly constructed jacket makes the shoulders look wide.

Draw a sideways glance to show that he's thinking.

Comedian Type

This guy has a million funny things to say. He keeps the story engaging with his kooky style of humor. With those uneven eyebrows, he's cute and funny to look at.

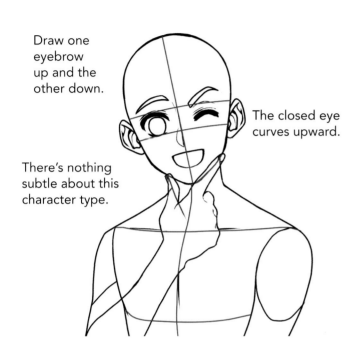

Draw one eyebrow up and the other down.

The closed eye curves upward.

There's nothing subtle about this character type.

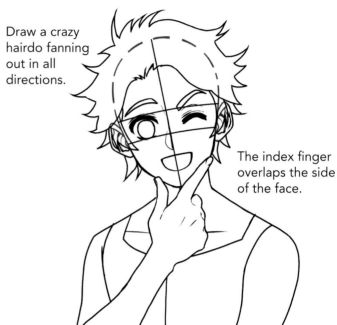

Draw a crazy hairdo fanning out in all directions.

The index finger overlaps the side of the face.

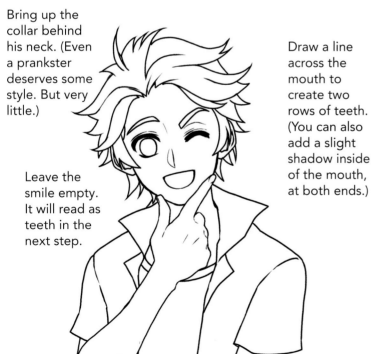

Bring up the collar behind his neck. (Even a prankster deserves some style. But very little.)

Leave the smile empty. It will read as teeth in the next step.

Draw a line across the mouth to create two rows of teeth. (You can also add a slight shadow inside of the mouth, at both ends.)

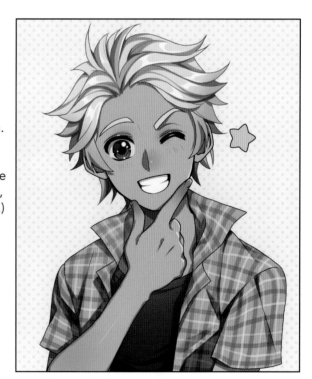

He'll probably end up being a neuroscientist or a stand-up comic. Hopefully not both at the same time.

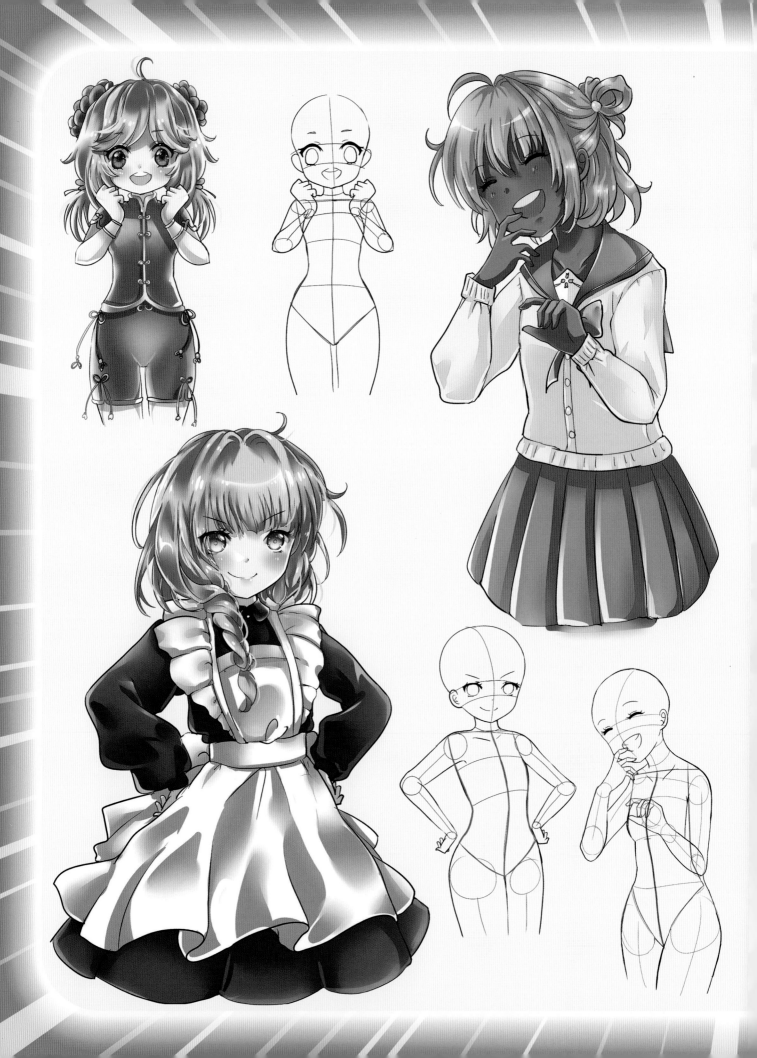

Moods and Attitudes

One of the creative challenges for a manga artist is to draw expressions that readers can relate to. Sometimes an emotion is obvious, like when someone is happy. But it can also be subtler, such as when a deceptive character says something sweet but is actually scheming. This section will give you ideas, steps, and examples for creating engaging characters with something on their minds. You'll also notice that the upper body in this chapter's tutorials is outlined in blue. This is a helpful reminder, demonstrating that the body, as well as the face, expresses attitudes.

#23 Snickering

Laughing is something you do with someone. Snickering is something you do at someone's expense. In a comedy scene, snickering may be a little mean, but let's face it, it can be pretty funny. (I feel guilty admitting that, but it's true!)

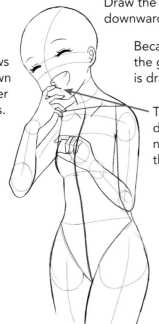

Draw the eyes with thick, downward-curving lines.

Because of the head tilt, the guideline for the eyes is drawn at an angle.

The eyebrows are drawn high over the eyes.

The mouth is drawn on the near side of the centerline.

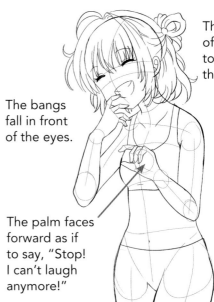

The hair is bit of a jumble due to the action of the laugh.

The bangs fall in front of the eyes.

The palm faces forward as if to say, "Stop! I can't laugh anymore!"

A laugh is different from a smile: When someone laughs, the body gets into the action, whereas the body can remain still in a smile.

Add a collar, cuffs, and a trim.

A popular variation of the school uniform is the sweater top, which appears loose and comfortable.

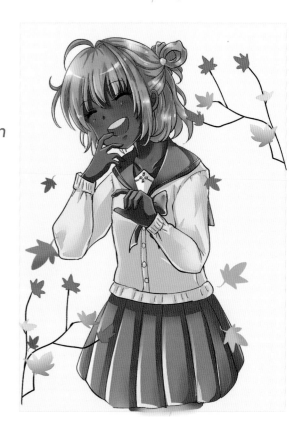

Big Idea!

When a character gets a big idea, as they often do, it doesn't necessarily mean it's a *good* idea, which is where the humor comes in. Her eyes widen as she gets a burst of inspiration. The pose is followed by a mad dash to jot it down.

The eyelids lift way up, above the eyeballs.

Squeeze the forearms against the upper arms.

The pose is tense but symmetrical.

Draw the hair in two lengths: chin level and shoulder level.

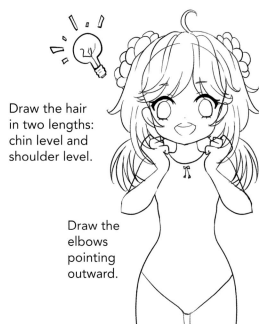

Raise the shoulders.

Draw the elbows pointing outward.

Be careful not to overlap the face with the hands—the face is the star of the expression.

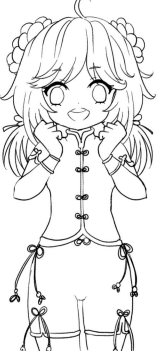

The outline of the outfit is also the outline of the figure.

The rose-colored hair accessories match the eyes and outfit.

The hair color matches the color of the bracelets.

#25 Helpful Angels

Angelic characters make frequent appearances in manga. Sometimes they arrive to grant a request or be your guide. Either way, when they arrive, good things happen. She has kind eyes, which are drawn with glittering eyeballs and multiple eyelashes.

The top of the head is wide and the lower half of the face is narrow.

Dark eyelids rest on top of the eyeballs.

Draw petite facial features.

The wrists are positioned over the heart.

The upper arms are vertical, but the forearms are diagonal.

Kind expressions are drawn with a small smile and slightly worried eyebrows. It really works!

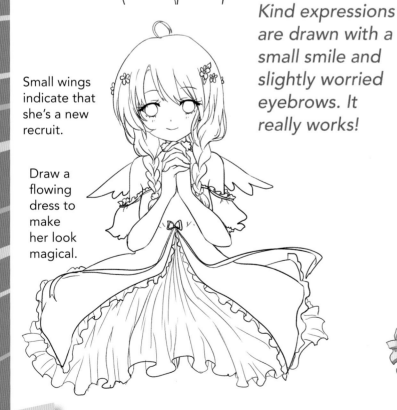

Small wings indicate that she's a new recruit.

Draw a flowing dress to make her look magical.

Getting Even

She's a pastry chef with a grudge. If you don't put money in the tip jar, you could walk away wearing a pineapple upside-down cake as a hat. No charge for the napkins.

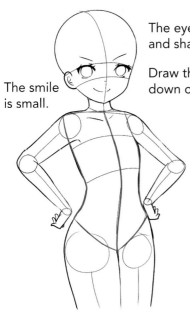

The eyebrows are short and sharply angled.

Draw the eyelids pressing down on the eyeballs.

The smile is small.

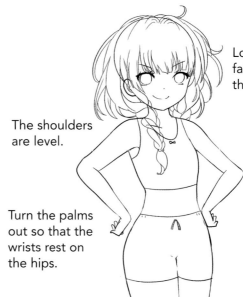

Loose bangs fall just above the eyes.

The shoulders are level.

Turn the palms out so that the wrists rest on the hips.

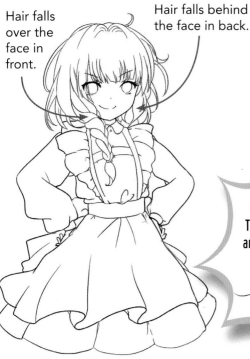

Hair falls over the face in front.

Hair falls behind the face in back.

Draw loose, flowing lines to create folds and flounces.

Is that a look of guilt and remorse on her face? That would be a "no."

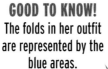

GOOD TO KNOW!
The folds in her outfit are represented by the blue areas.

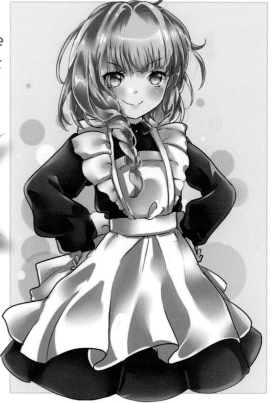

43

#27 Not Interested

Here, we see a character who has been informed by her best friend that a certain boy likes her. She spots him and, as you can see, she can hardly contain her enthusiasm.

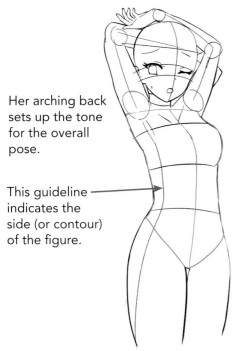

Her arching back sets up the tone for the overall pose.

This guideline indicates the side (or contour) of the figure.

One eye wants to stay awake and the other wants to sleep!

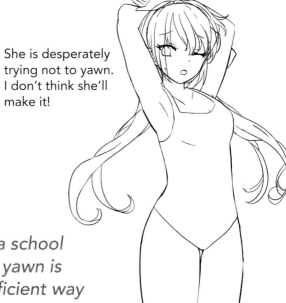

She is desperately trying not to yawn. I don't think she'll make it!

For a manga school character, a yawn is the most efficient way of turning down an invitation to the prom.

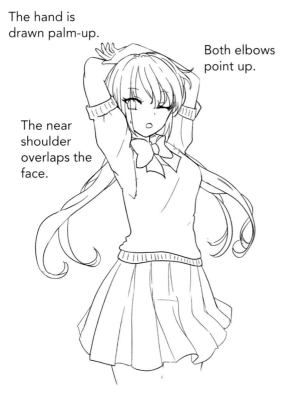

The hand is drawn palm-up.

The near shoulder overlaps the face.

Both elbows point up.

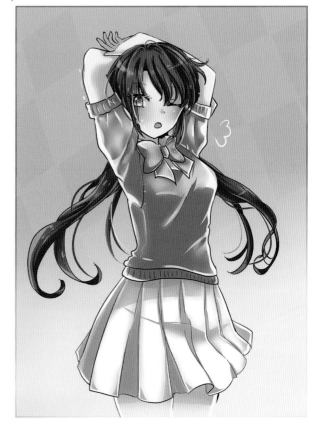

No Way!

Most manga characters are easy to get along with. Not this one. She refuses to give an inch, even if it would ensure world peace. Once you see the arms crossed in front of her body, it's time to give up. There's no chance to reach an understanding—unless you offer an unconditional apology.

This testy expression starts with angled eyebrows and folded arms.

Keep the eyes big to maximize the expression (and the cuteness!).

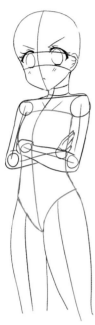

TIP
When drawing crossed arms, the elbows are always lower than the wrists.

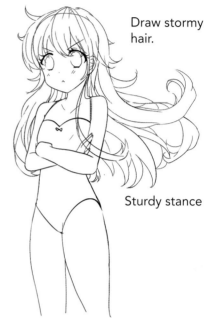

Draw stormy hair.

Sturdy stance

Add a few frustration stars orbiting around her.

Notice that her arms are pressed against her body—nothing is relaxed!

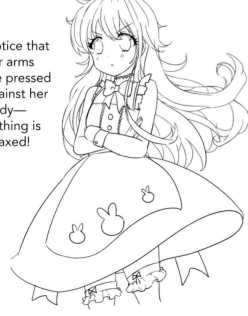

Add pink blush to her cheeks, just below the eyes.

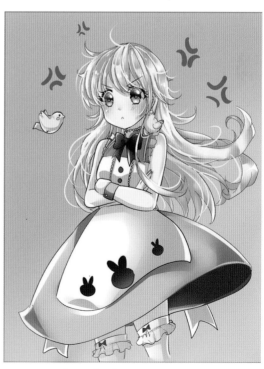

Manga school characters can appear volatile one moment and cheery the next. That's part of the fun.

45

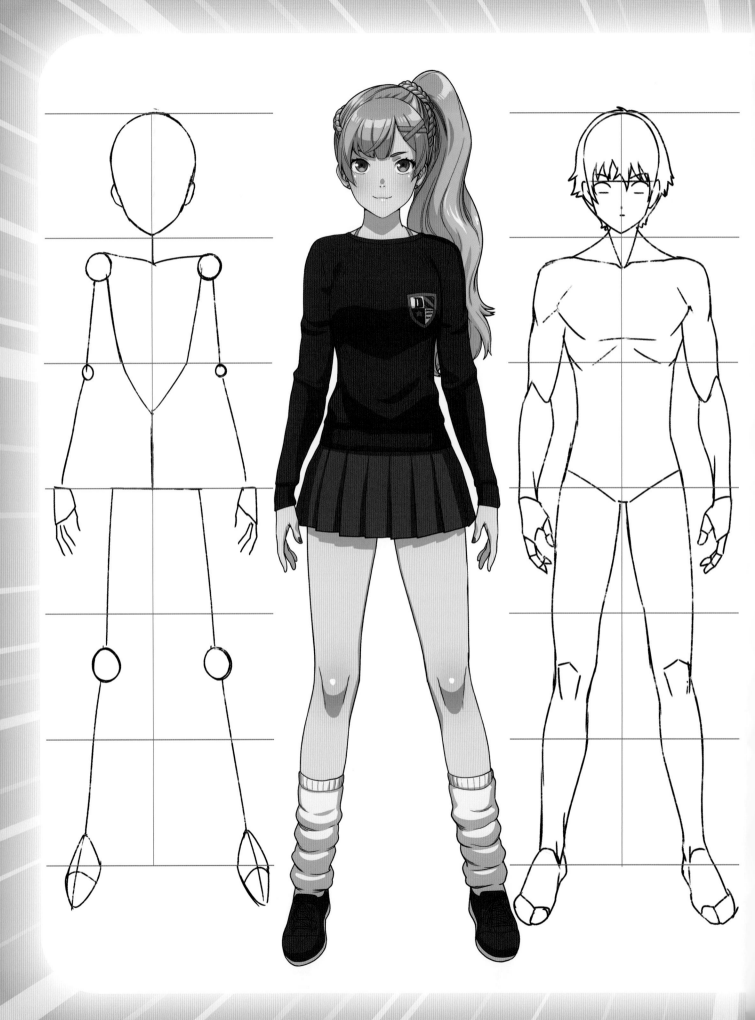

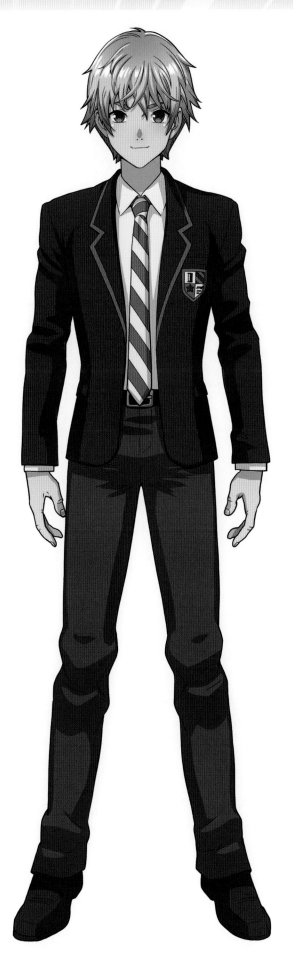

Drawing the Body– An Overview

Most people don't realize how tall the body is. Stand next to a car or a dog and you'll realize that we humans are quite long! Therefore, it's important to establish a few basic proportions to keep the figure looking correct. These proportions are simple guidelines that are easy to follow. They can help you to keep your characters consistent an any angle.

#29 Helpful Proportions

Popular manga types, such as high school teens, have proportions quite similar to real human proportions, which makes them easy to learn. Because manga is a highly stylized art form, manga artists will sometimes adjust the proportions to create a unique look. For example, a character may have slightly longer legs or a shorter upper body. But generally, you and manga characters have a lot in common. Let's check out how to draw them.

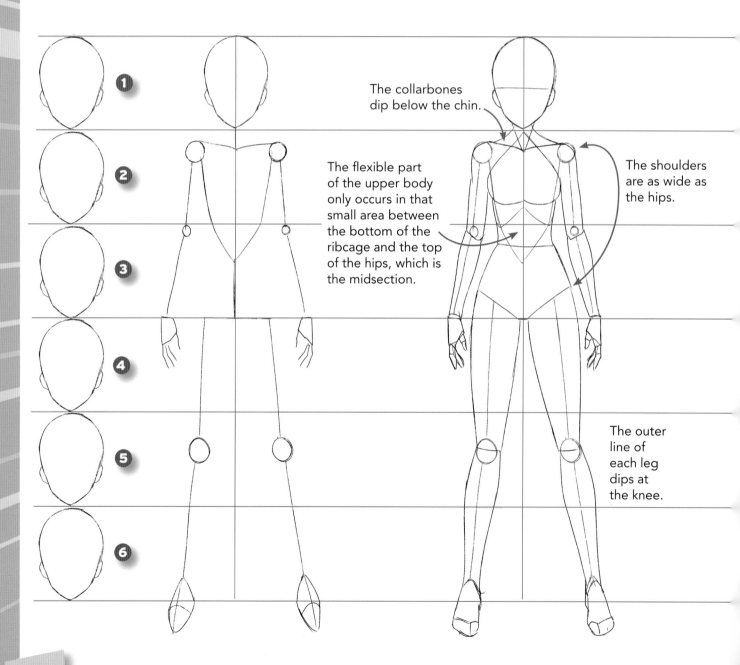

The collarbones dip below the chin.

The flexible part of the upper body only occurs in that small area between the bottom of the ribcage and the top of the hips, which is the midsection.

The shoulders are as wide as the hips.

The outer line of each leg dips at the knee.

Cute Girl-Front

The standard young adult is about seven heads tall. Manga characters are given a cute look by reducing the proportions to six heads tall, which is a slightly more compact look.

GOOD TO KNOW!
Sweaters, a popular part of school uniforms, typically show some bunching and creases (stresses). Skirts often show repeated folds.

The head is about half the length of the torso, as measured from the collarbones to the bottom of the ribs.

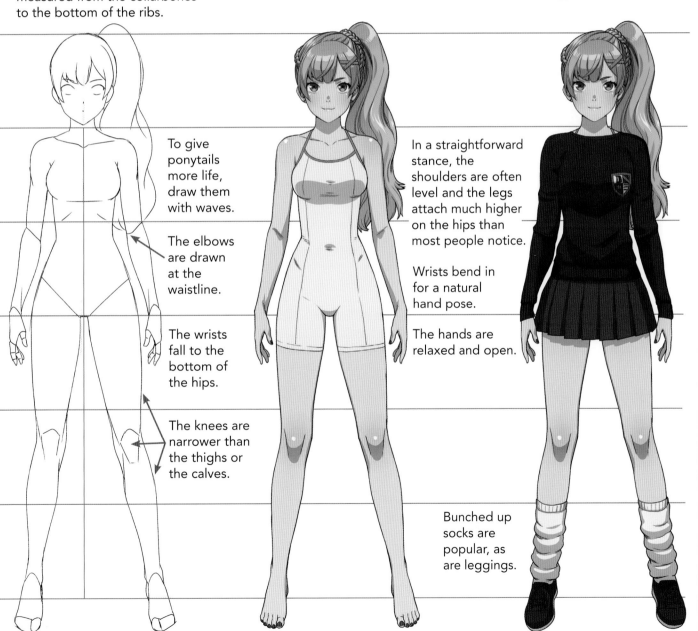

To give ponytails more life, draw them with waves.

The elbows are drawn at the waistline.

The wrists fall to the bottom of the hips.

The knees are narrower than the thighs or the calves.

In a straightforward stance, the shoulders are often level and the legs attach much higher on the hips than most people notice.

Wrists bend in for a natural hand pose.

The hands are relaxed and open.

Bunched up socks are popular, as are leggings.

#30 Cute Boy-Front

Once you're used to using proportions in simple standing poses, you can begin to incorporate them into more complex poses.

GOOD TO KNOW!
The teen years are a popular age for manga characters because that's when socializing becomes complicated, which creates interesting relationships

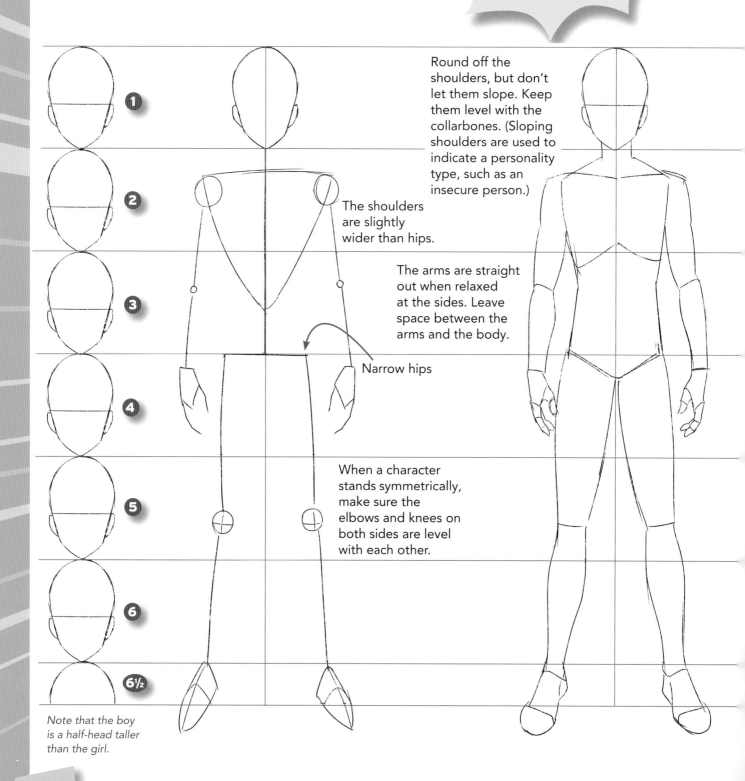

Round off the shoulders, but don't let them slope. Keep them level with the collarbones. (Sloping shoulders are used to indicate a personality type, such as an insecure person.)

The shoulders are slightly wider than hips.

The arms are straight out when relaxed at the sides. Leave space between the arms and the body.

Narrow hips

When a character stands symmetrically, make sure the elbows and knees on both sides are level with each other.

Note that the boy is a half-head taller than the girl.

50

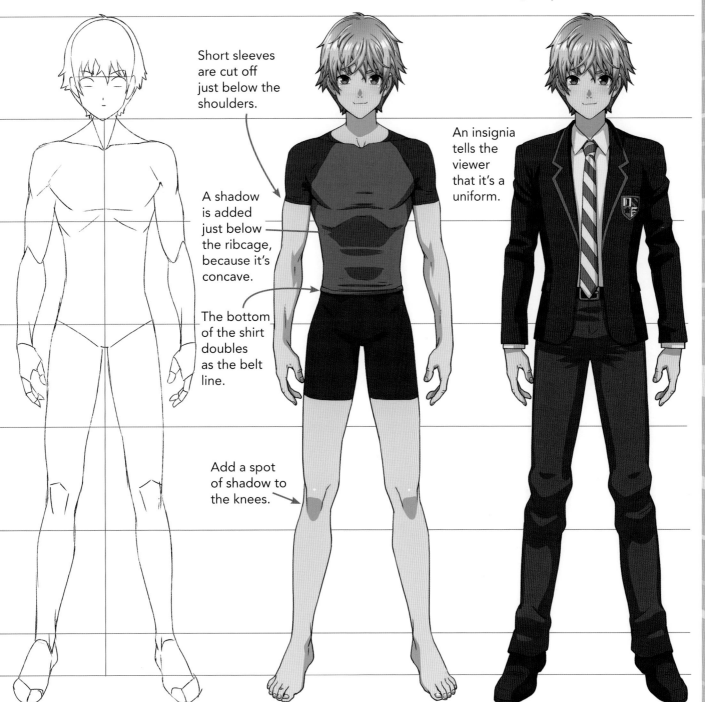

It took him twenty minutes figure out how to make that knot in his tie. Gold trim on the lapel of his school jacket gives it a touch of style. How did that get past the Dean?

Short sleeves are cut off just below the shoulders.

A shadow is added just below the ribcage, because it's concave.

The bottom of the shirt doubles as the belt line.

Add a spot of shadow to the knees.

An insignia tells the viewer that it's a uniform.

Cute Girl—Side View

Here are few tips for a character in a side view.
Remember that the side view tends to look
flat. Therefore, to compensate, emphasize
the curves in the outline of the figure.

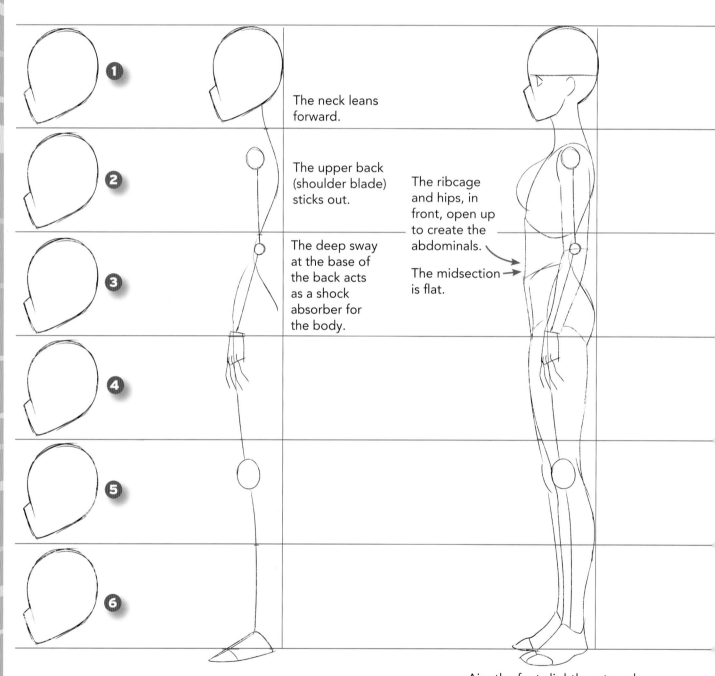

The neck leans
forward.

The upper back
(shoulder blade)
sticks out.

The ribcage
and hips, in
front, open up
to create the
abdominals.

The deep sway
at the base of
the back acts
as a shock
absorber for
the body.

The midsection
is flat.

Aim the feet slightly outward,
otherwise the far foot will
disappear behind the near foot.

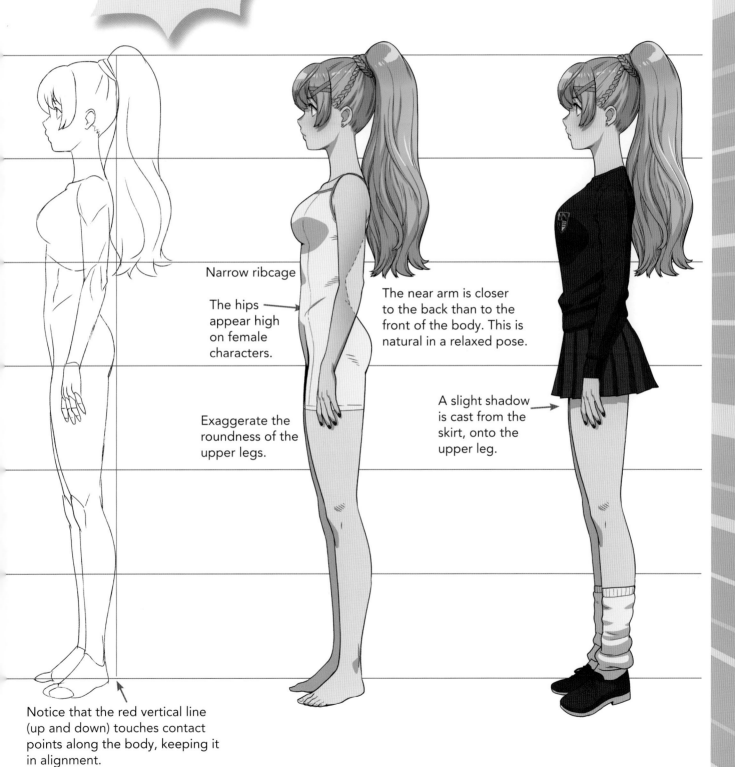

GOOD TO KNOW!
To check the alignment of your pose, run a vertical line from the back of the head to the back of the heels.

Narrow ribcage

The hips appear high on female characters.

Exaggerate the roundness of the upper legs.

The near arm is closer to the back than to the front of the body. This is natural in a relaxed pose.

A slight shadow is cast from the skirt, onto the upper leg.

Notice that the red vertical line (up and down) touches contact points along the body, keeping it in alignment.

Cute Boy–Side View

MYTH BUSTER! At this angle, you can see that there's no such thing as standing "straight"—the back is always curved. Those curves are what make a figure look lifelike.

GOOD TO KNOW!
Here's a common mistake, which you won't have to make! A short neck makes even a well-drawn character appear awkward. Check your character to be sure that you've left ample space between the chin and the collarbone.

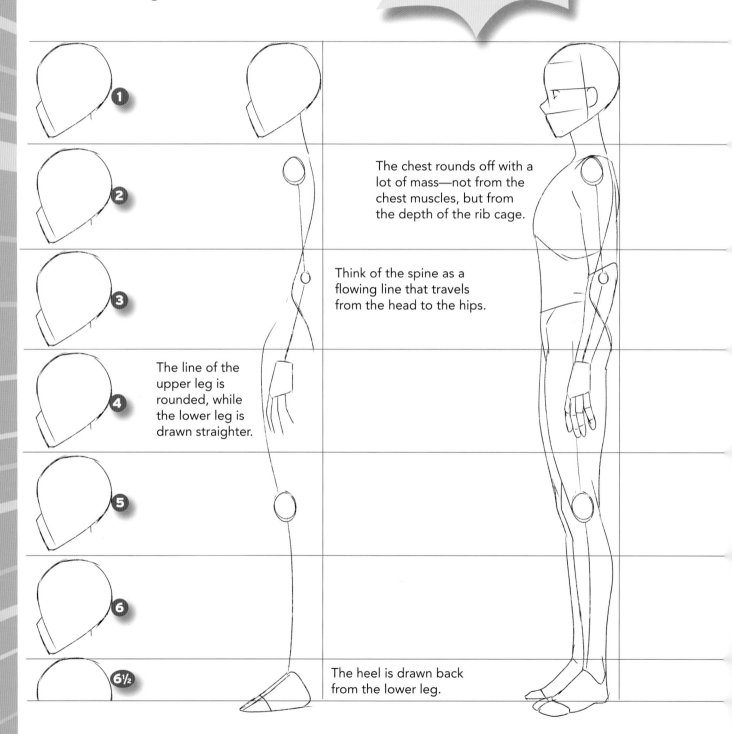

The chest rounds off with a lot of mass—not from the chest muscles, but from the depth of the rib cage.

Think of the spine as a flowing line that travels from the head to the hips.

The line of the upper leg is rounded, while the lower leg is drawn straighter.

The heel is drawn back from the lower leg.

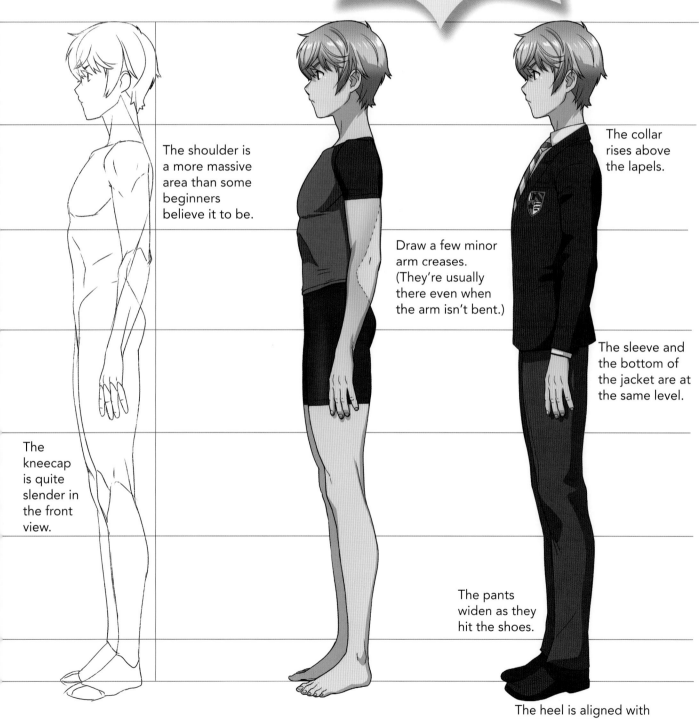

The shoulder is a more massive area than some beginners believe it to be.

Draw a few minor arm creases. (They're usually there even when the arm isn't bent.)

The collar rises above the lapels.

The sleeve and the bottom of the jacket are at the same level.

The kneecap is quite slender in the front view.

The pants widen as they hit the shoes.

The heel is aligned with the back of the head, not the center of the body.

#31 Trying It Out: Practice Poses

Now let's use the basics of figure drawing to create some fighter-type character poses. Fighters can be cute characters, too! We just make them younger and true blue.

Practice Pose: Fearless

Fearless characters strike a commanding pose that shows strength. You can create this pose by drawing wide shoulders and a wide stance.

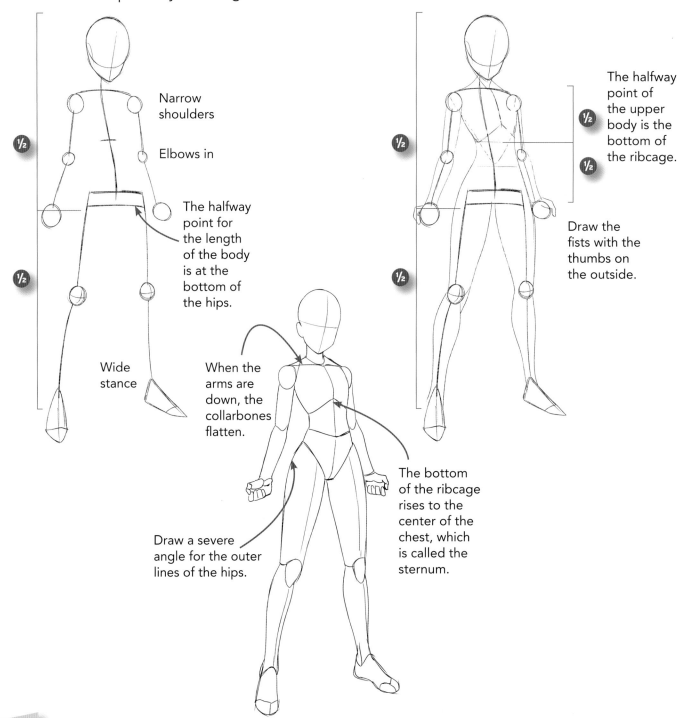

Narrow shoulders

Elbows in

The halfway point for the length of the body is at the bottom of the hips.

Wide stance

½ ½ ½

The halfway point of the upper body is the bottom of the ribcage.

½ ½ ½

Draw the fists with the thumbs on the outside.

When the arms are down, the collarbones flatten.

Draw a severe angle for the outer lines of the hips.

The bottom of the ribcage rises to the center of the chest, which is called the sternum.

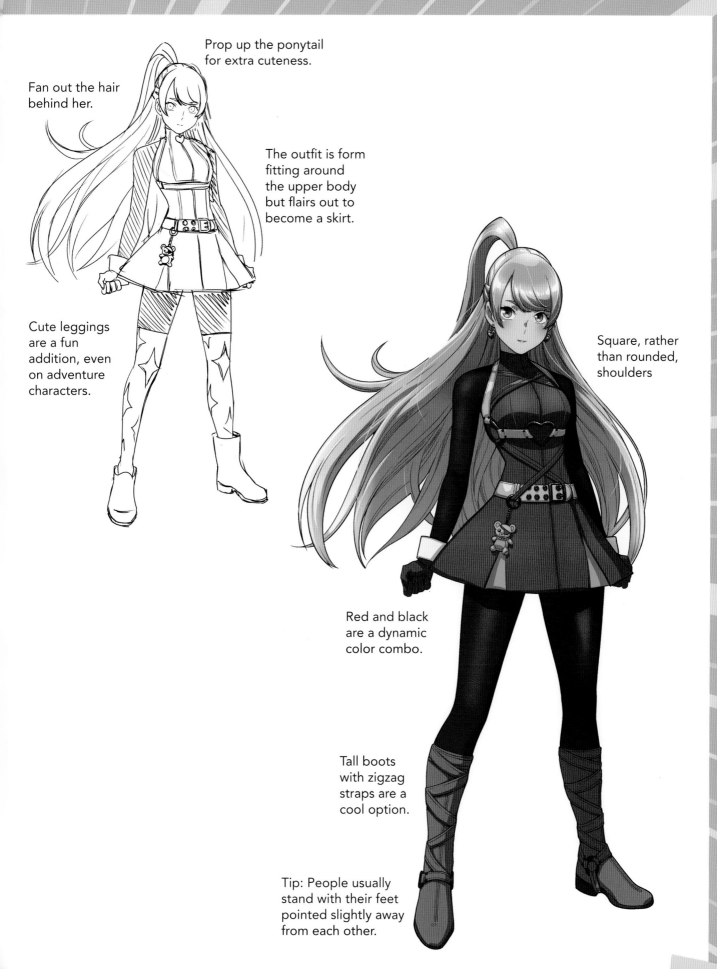

Fan out the hair behind her.

Prop up the ponytail for extra cuteness.

The outfit is form fitting around the upper body but flairs out to become a skirt.

Cute leggings are a fun addition, even on adventure characters.

Square, rather than rounded, shoulders

Red and black are a dynamic color combo.

Tall boots with zigzag straps are a cool option.

Tip: People usually stand with their feet pointed slightly away from each other.

#32-33 Teen Sword Fighter and Mascot

Where else but in a graphic novel can you find a friendly sword fighter? Maybe at a manga convention, but that's about it. His stance is relaxed but ready. His little friend is cute but annoying, like most mascots. The boy's hair flips—a typical hairdo for an action character. The costume is flashy but must not restrict his movements, so keep it loose.

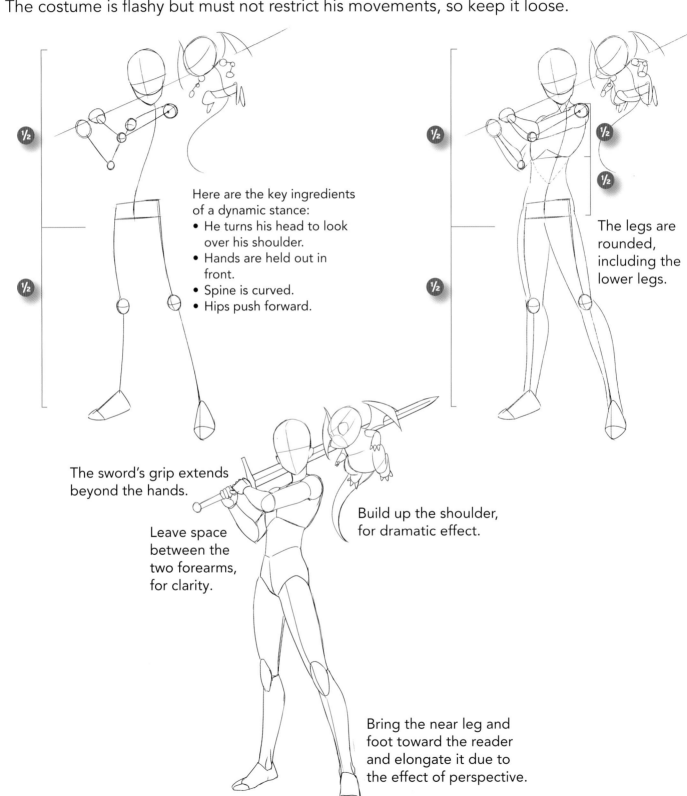

½ ½

Here are the key ingredients of a dynamic stance:
- He turns his head to look over his shoulder.
- Hands are held out in front.
- Spine is curved.
- Hips push forward.

½ ½

The legs are rounded, including the lower legs.

The sword's grip extends beyond the hands.

Leave space between the two forearms, for clarity.

Build up the shoulder, for dramatic effect.

Bring the near leg and foot toward the reader and elongate it due to the effect of perspective.

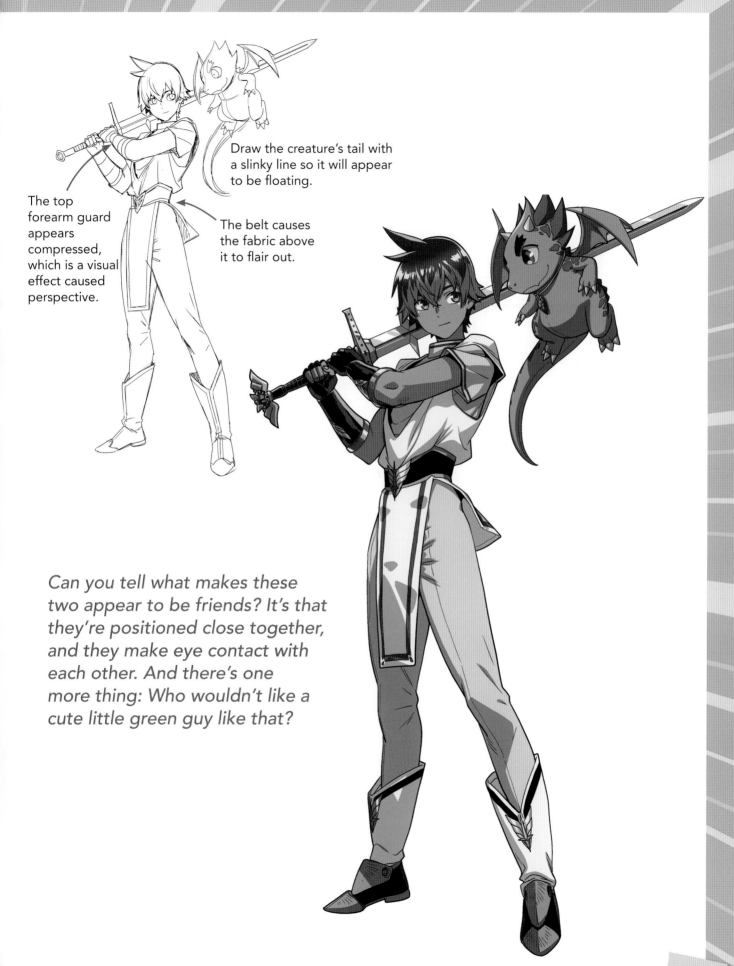

The top forearm guard appears compressed, which is a visual effect caused perspective.

Draw the creature's tail with a slinky line so it will appear to be floating.

The belt causes the fabric above it to flair out.

Can you tell what makes these two appear to be friends? It's that they're positioned close together, and they make eye contact with each other. And there's one more thing: Who wouldn't like a cute little green guy like that?

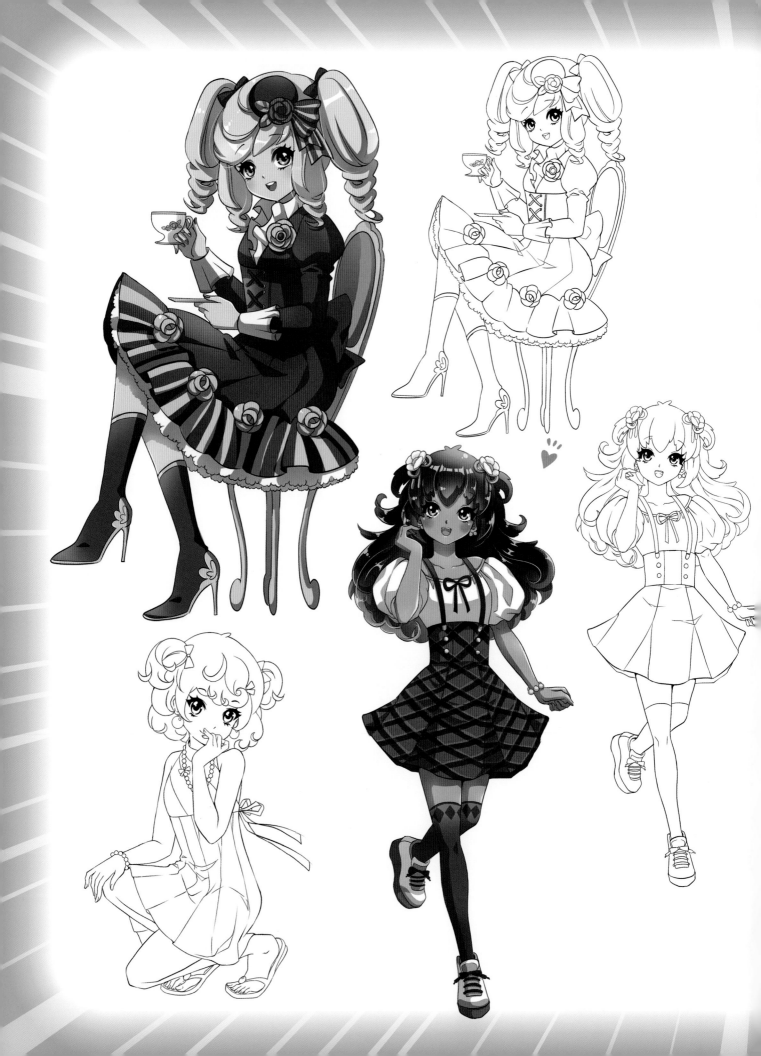

Tips for Drawing Cute Poses

Cute characters have that extra "something"—that extra personality and appeal. But it's not only their expressions that look cute, but their poses, too. Are there really techniques that can make a character's pose look cute? Absolutely! And here are a few basic hints to get you started!

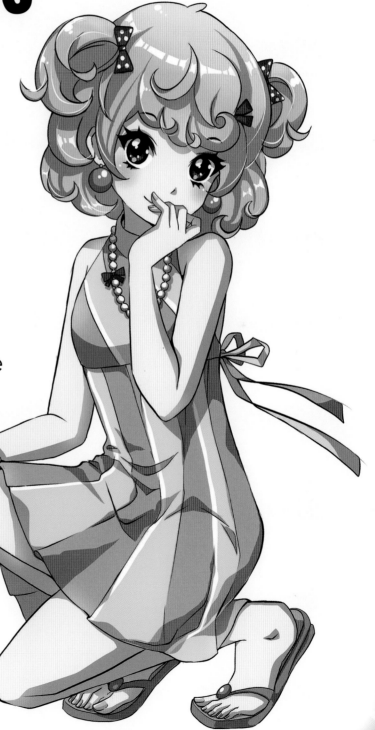

#34 A Quick Overview of Cute Poses

What makes a pose cute or appealing? In this section, we'll identify some of the hallmarks of cute poses before we get into the details of drawing them.

Charming Poses

Charming poses are often drawn with an arched back. This gives the character a friendly and innocent look. Another thing to keep in mind for charming poses is the raised shoulder. This technique creates a coy look.

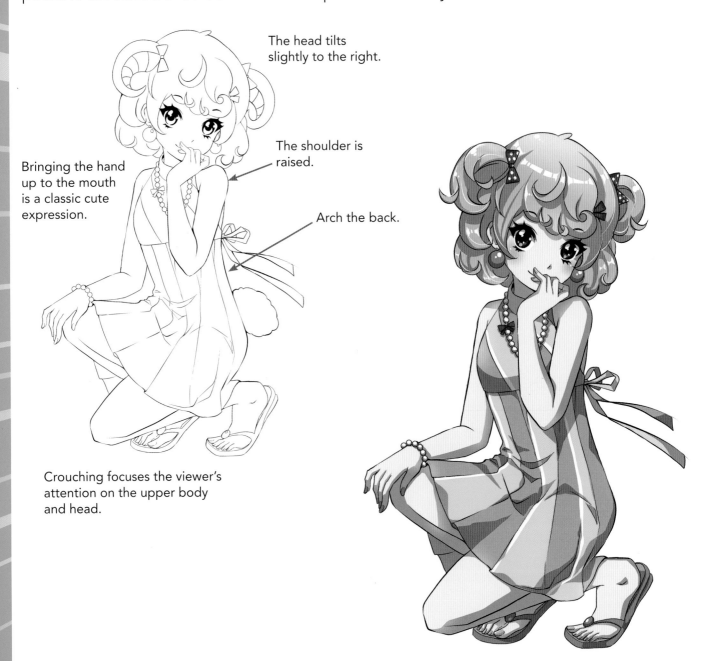

The head tilts slightly to the right.

The shoulder is raised.

Bringing the hand up to the mouth is a classic cute expression.

Arch the back.

Crouching focuses the viewer's attention on the upper body and head.

Trusting Type

Demure poses work for those characters who are so pure of heart that they trust everyone. That trust could be a problem in a manga story. Fortunately for this enchanted character, she has special powers, which she isn't even aware of, that will come out should she ever need them.

The posture is vertical, but the pose remains relaxed.

The head and neck are held straight up, creating an impression of honesty.

Big eyes are the driver of cute expressions.

The hair flows gently.

An introverted pose is often drawn with hands together and arms close to the body.

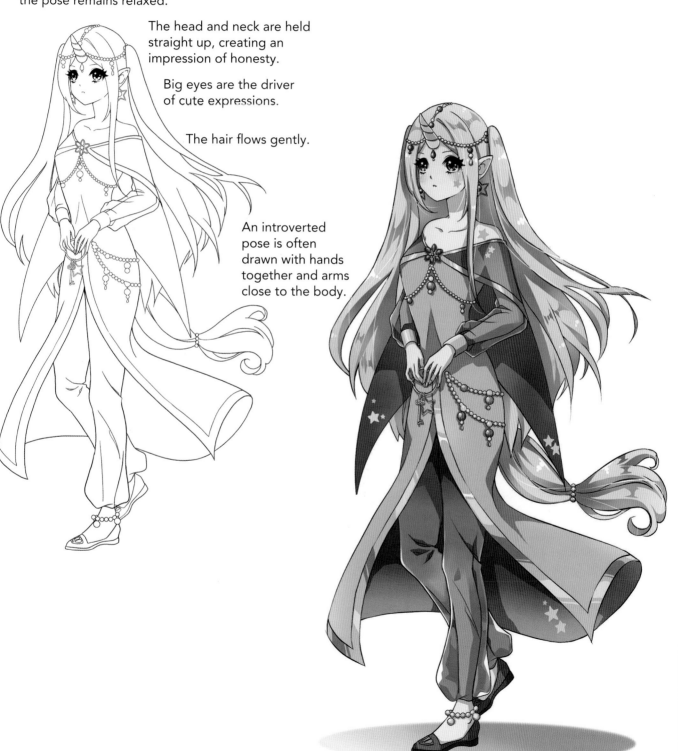

#36 Precious Type

The precious type is a dressed-up character who is extra adorable. She looks like she's been plucked from a dollhouse. There are many permutations of this look, which features turn-of-the-century elegance. Notice that the caricatured "proper" sitting pose underscores the theme.

Her gestures are controlled and restrained.

Draw the details: She has a dainty touch as she holds her cup and saucer.

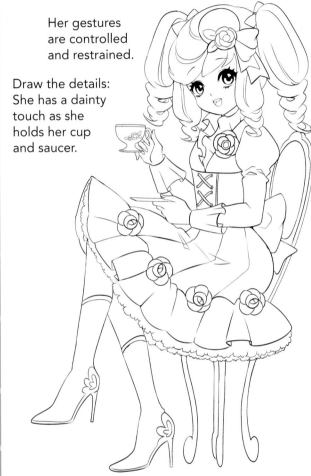

The higher the heels, the more you angle the toes down.

Her back doesn't even touch the hair.

Turn the torso just a touch toward the viewer, which is a friendlier pose than a strict side view.

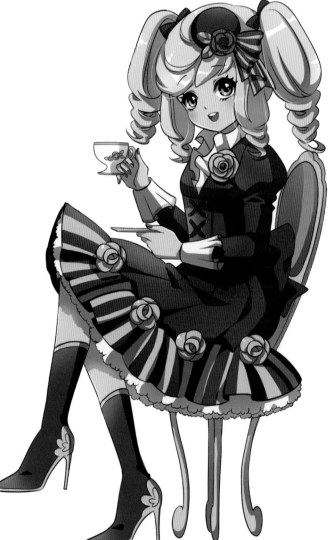

Poser Type

Cute characters create cute poses. When sketching a running pose, the legs are positioned like any other character, but the arms are freed to strike an adorable gesture.

Place the hand near the face in a classic "Who me?" gesture.

The hair is bouncy, reflecting the action of the pose.

The straight arm bends at the wrist.

The legs cross at the knees.

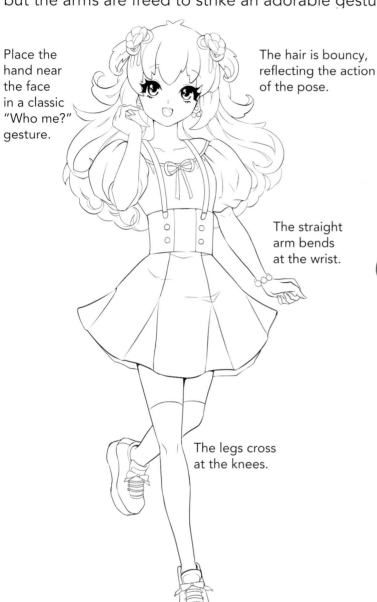

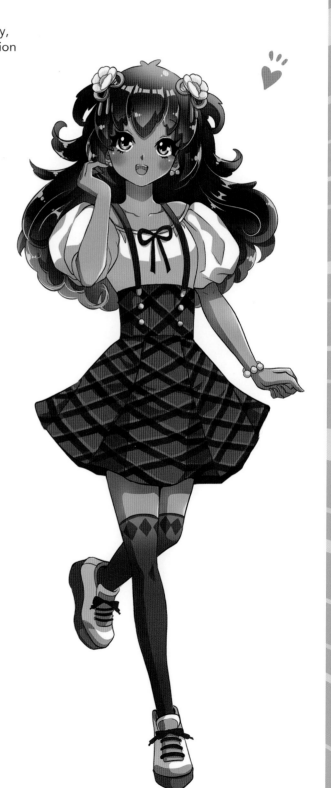

#38 Posing Prompts for Beginners

Now let's apply the techniques we just covered in the overview of cute poses. These prompts will help you learn to draw your own dynamic poses, step-by-step.

Foundation Pose

Drawing the figure in a front view will give you a head start when you establish your own original character. It will serve as blueprint from which to draw the other angles.

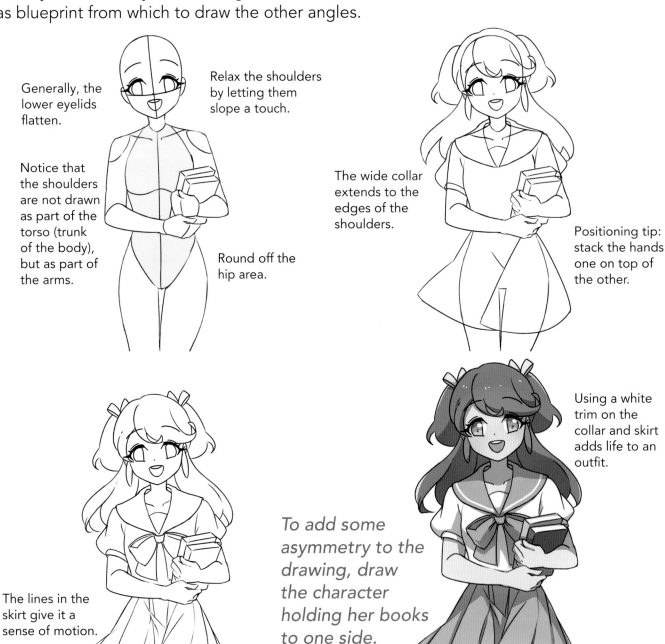

Generally, the lower eyelids flatten.

Relax the shoulders by letting them slope a touch.

Notice that the shoulders are not drawn as part of the torso (trunk of the body), but as part of the arms.

Round off the hip area.

The wide collar extends to the edges of the shoulders.

Positioning tip: stack the hands one on top of the other.

The lines in the skirt give it a sense of motion.

To add some asymmetry to the drawing, draw the character holding her books to one side.

Using a white trim on the collar and skirt adds life to an outfit.

Solitary Pose

In order to balance out the positive characters in manga, we need to create a few skeptics! This character may have a sense of optimism somewhere, but she probably wouldn't recognize it if she saw it. Cynical characters contribute funny and sarcastic comments to a story.

Note that she faces sideways toward the reader.

Position the hand and fingers to hold the brim of the cap.

The back retains a flowing line.

A solitary character will hide her face with her cap. If your character doesn't have a cap, then bangs can also be used to cover some of her face.

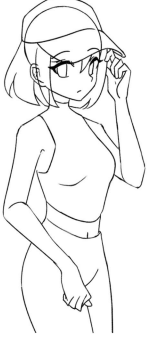

Her glance, over the shoulder, says "Stay away."

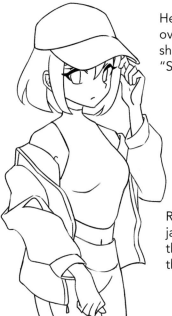

Rumple the jacket to relax the look of the pose.

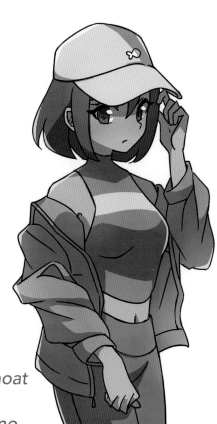

If she could build a little moat around herself, she would. Then she'd complain that no one in this town is friendly!

#40 Spontaneous Pose

You can get some great poses with a character who looks off guard. Therefore, draw the arms and legs so they appear randomly placed. Her torso also leans slightly back, which makes her look slightly off balance.

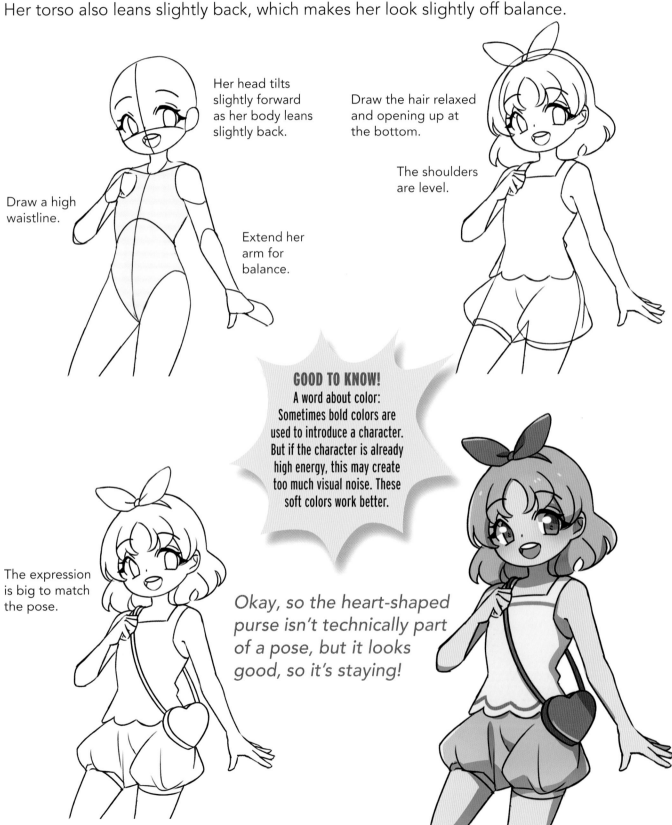

Her head tilts slightly forward as her body leans slightly back.

Draw a high waistline.

Extend her arm for balance.

Draw the hair relaxed and opening up at the bottom.

The shoulders are level.

GOOD TO KNOW!
A word about color: Sometimes bold colors are used to introduce a character. But if the character is already high energy, this may create too much visual noise. These soft colors work better.

The expression is big to match the pose.

Okay, so the heart-shaped purse isn't technically part of a pose, but it looks good, so it's staying!

Natural Standing Pose

This essential pose places most of the character's weight on one leg, allowing the other leg to relax. This transforms an ordinary pose into dynamic pose. Let's see how it's done.

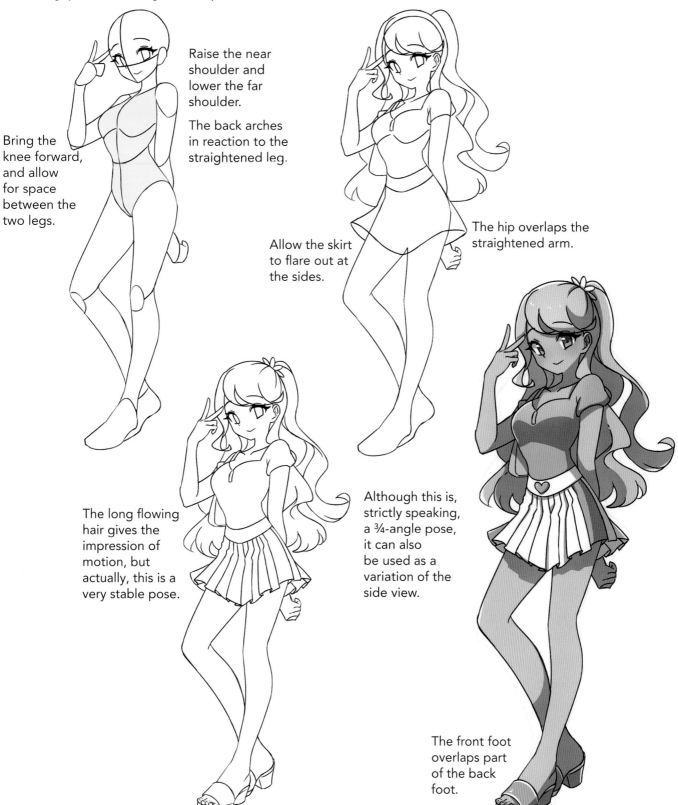

Raise the near shoulder and lower the far shoulder.

The back arches in reaction to the straightened leg.

Bring the knee forward, and allow for space between the two legs.

Allow the skirt to flare out at the sides.

The hip overlaps the straightened arm.

The long flowing hair gives the impression of motion, but actually, this is a very stable pose.

Although this is, strictly speaking, a ¾-angle pose, it can also be used as a variation of the side view.

The front foot overlaps part of the back foot.

#42 Frozen Poses

There's a saying that goes, "Don't try to do too much." The frozen pose is a good example. When someone is frightened, they stiffen. Drawing an elaborate pose to express a simple idea could work against you. Let's see how effective simplicity can be for your manga characters.

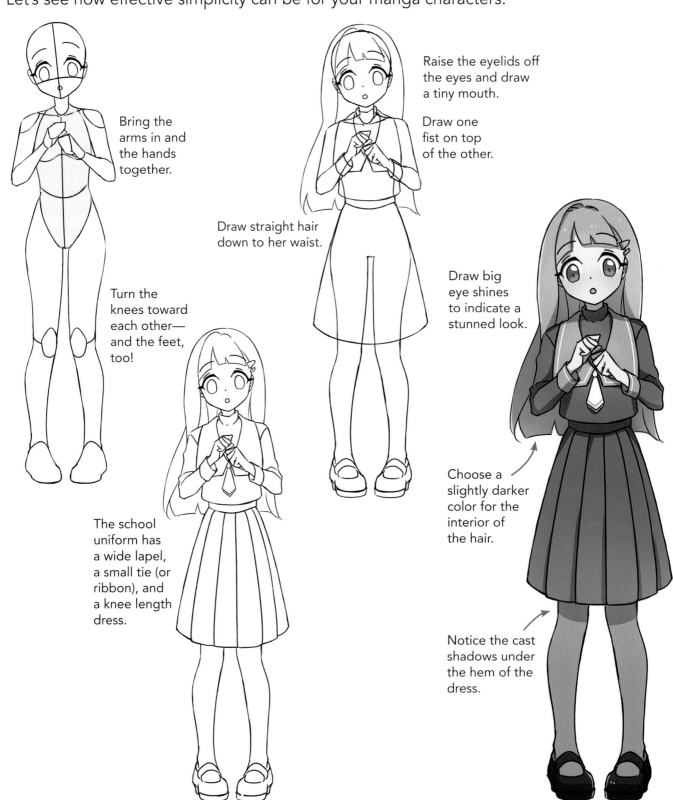

Bring the arms in and the hands together.

Turn the knees toward each other—and the feet, too!

Raise the eyelids off the eyes and draw a tiny mouth.

Draw one fist on top of the other.

Draw straight hair down to her waist.

Draw big eye shines to indicate a stunned look.

The school uniform has a wide lapel, a small tie (or ribbon), and a knee length dress.

Choose a slightly darker color for the interior of the hair.

Notice the cast shadows under the hem of the dress.

Dynamic Posing

Action poses show a lot of movement and twisting. This pose may not look too stable, but that's actually the point. Action poses are drawn to look slightly off balance. And when you play pickleball, you're slightly off balance. Let's see how it works.

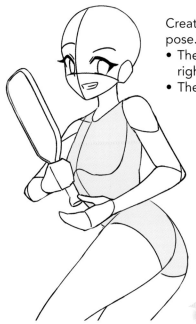

Create tension in the pose. Here's how:
- The torso twists right.
- The hips twist left.

The pickleball paddle is on a diagonal.

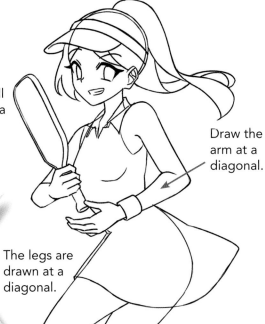

Draw the arm at a diagonal.

The legs are drawn at a diagonal.

GOOD TO KNOW!
Shadows, or shading, must be consistent so that they make sense. In this final picture, you can see how light affects different areas, and that it flows from one direction.

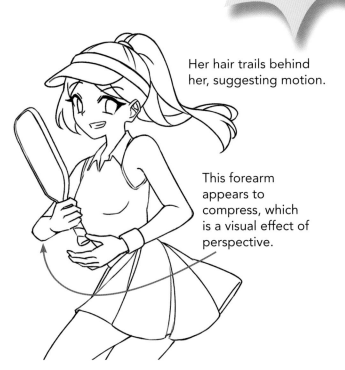

Her hair trails behind her, suggesting motion.

This forearm appears to compress, which is a visual effect of perspective.

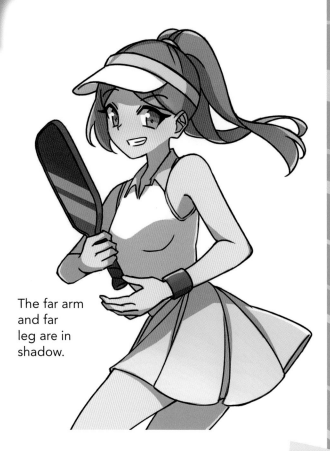

The far arm and far leg are in shadow.

#44 Gesture Poses

Gestures tell a story. All you need to do is position the arms and hands so that they communicate an idea or emotion. This gesture shows that the caller is talking too much, and that the listener is not loving it a lot.

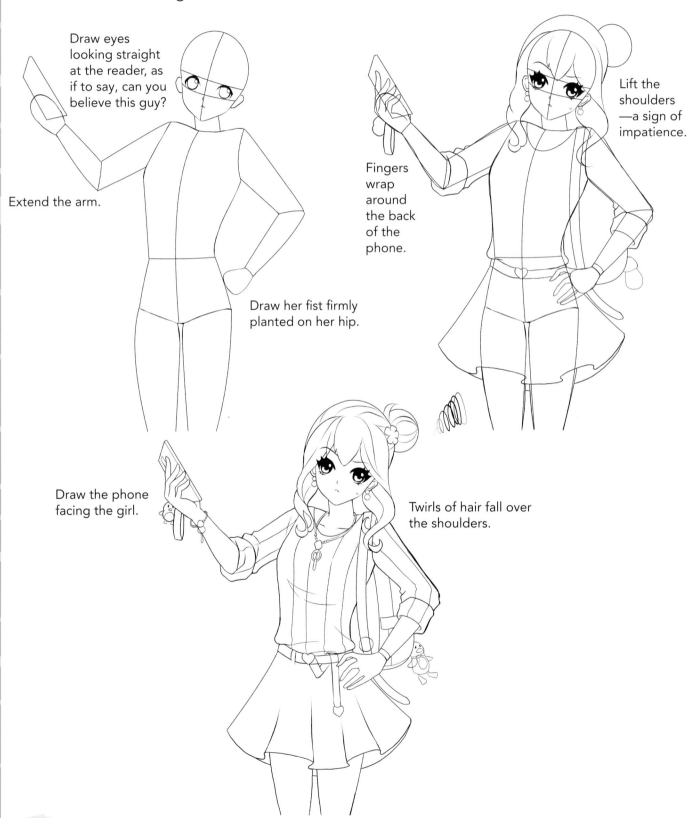

Draw eyes looking straight at the reader, as if to say, can you believe this guy?

Extend the arm.

Draw her fist firmly planted on her hip.

Fingers wrap around the back of the phone.

Lift the shoulders —a sign of impatience.

Draw the phone facing the girl.

Twirls of hair fall over the shoulders.

A zigzag effect is used to represent electricity in comic art.

Wake me up when he's finished talking.

Because cell phones are a part of everyday life, it's important to know how to draw them. They may be slender but they're still 3-dimensional, so draw a line down the side to indicate thickness.

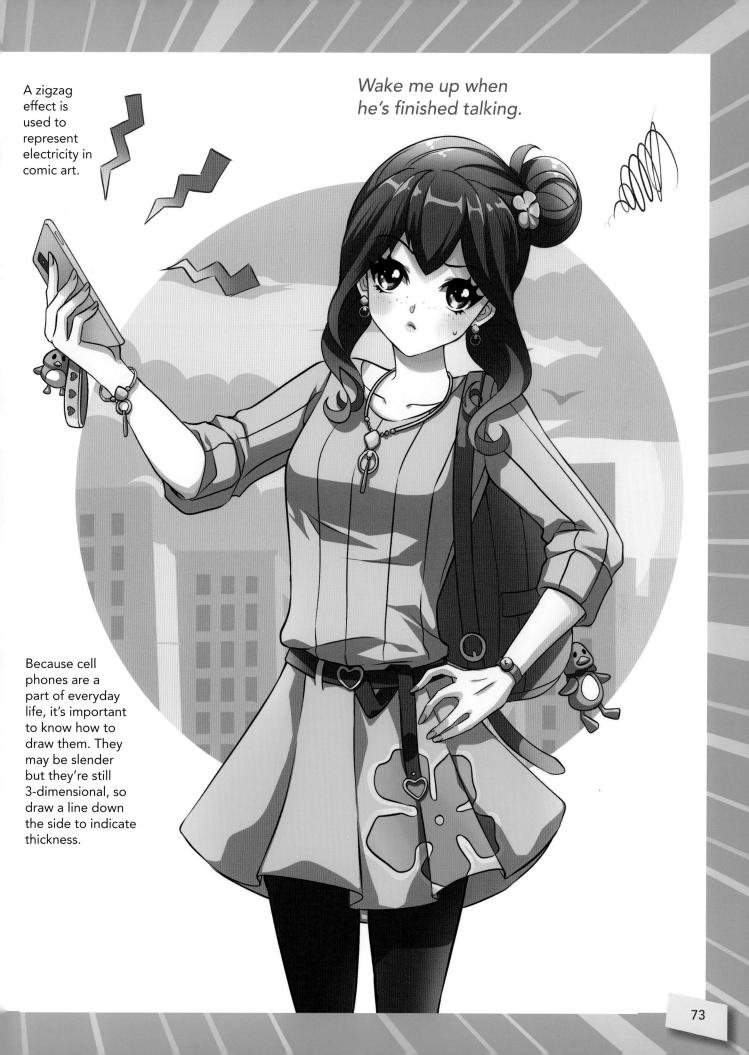

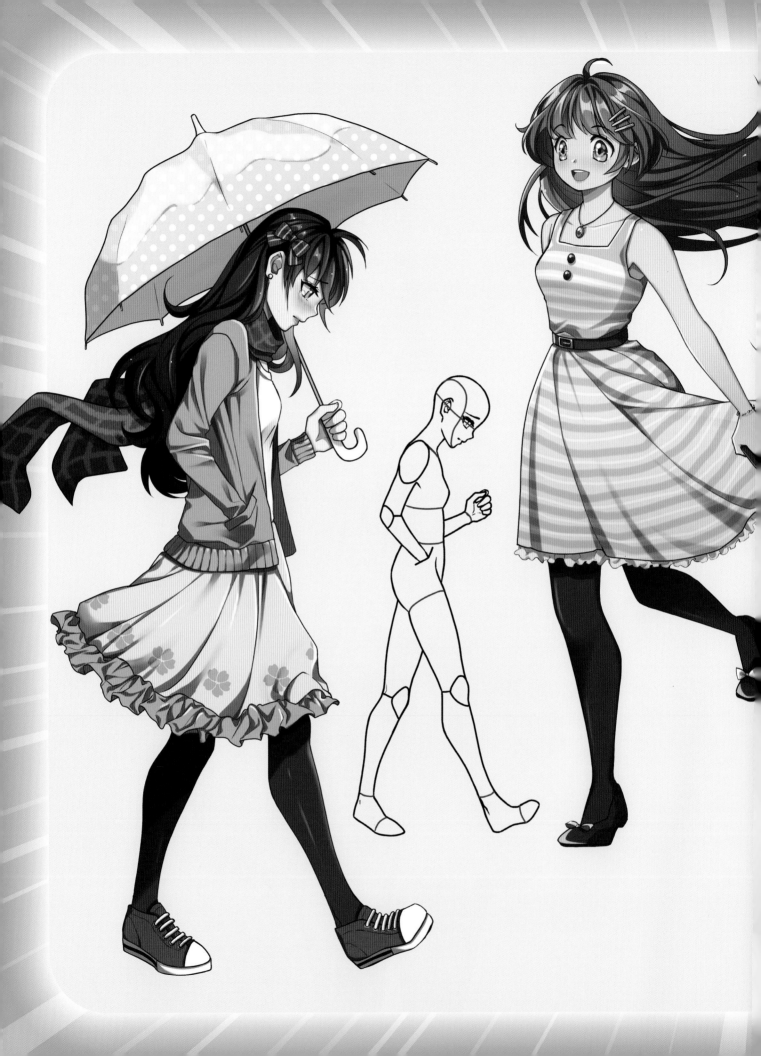

Deconstructing the Walk and Run

In art, the term *deconstructing* means looking at an image and figuring out how it's done. You'd be surprised how many people overlook this simple step. Not everybody walks or runs the same way, but they do have certain things in common. And that's what we want to pick up on. These common traits signal to the viewer what the character is doing. The way a character walks or runs can indicate a personality type.

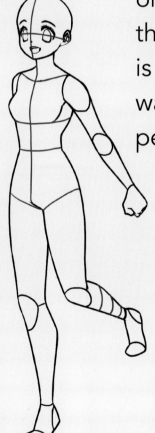

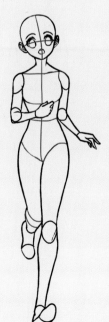

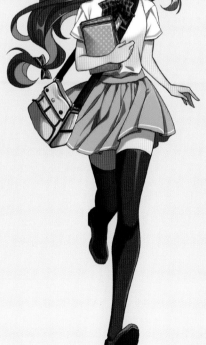

#45-46 Walking with Attitude

There's a trick for drawing someone walking and talking on the phone at the same time. First, draw the upper body, focusing on an emotion. Next, draw the lower in a walking pose.

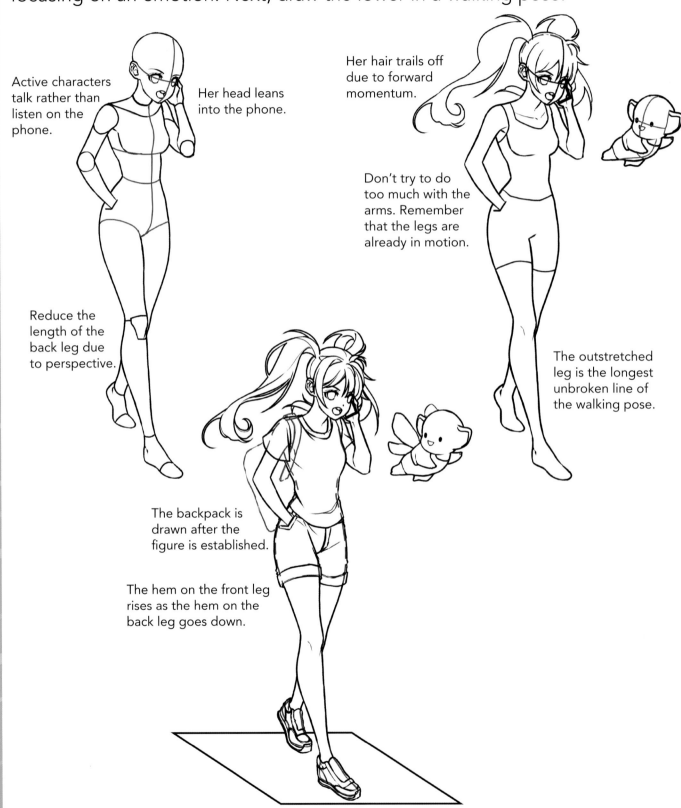

Active characters talk rather than listen on the phone.

Her head leans into the phone.

Her hair trails off due to forward momentum.

Don't try to do too much with the arms. Remember that the legs are already in motion.

Reduce the length of the back leg due to perspective.

The outstretched leg is the longest unbroken line of the walking pose.

The backpack is drawn after the figure is established.

The hem on the front leg rises as the hem on the back leg goes down.

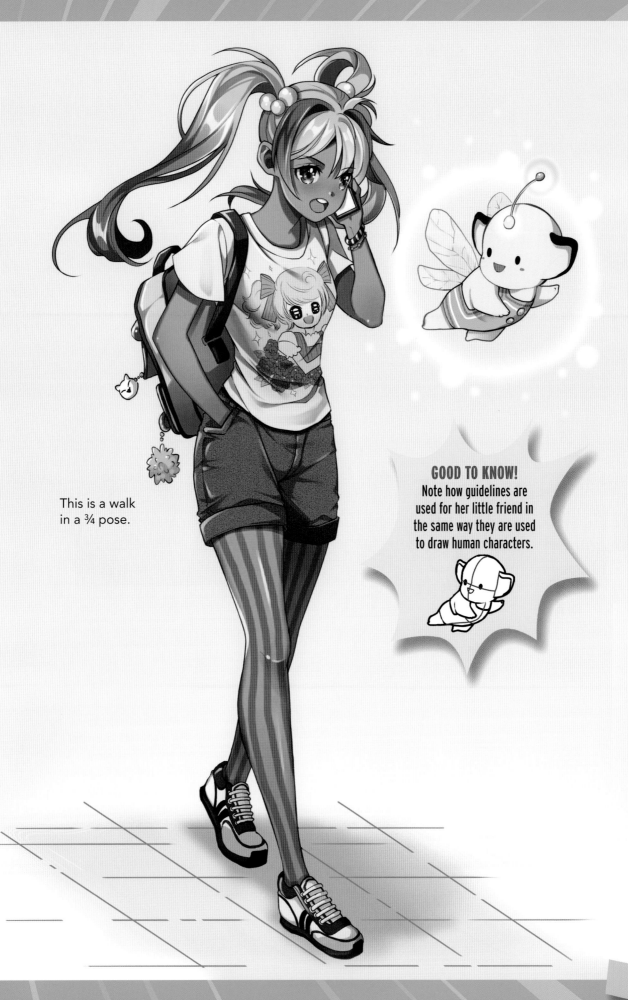

This is a walk in a ¾ pose.

GOOD TO KNOW!
Note how guidelines are used for her little friend in the same way they are used to draw human characters.

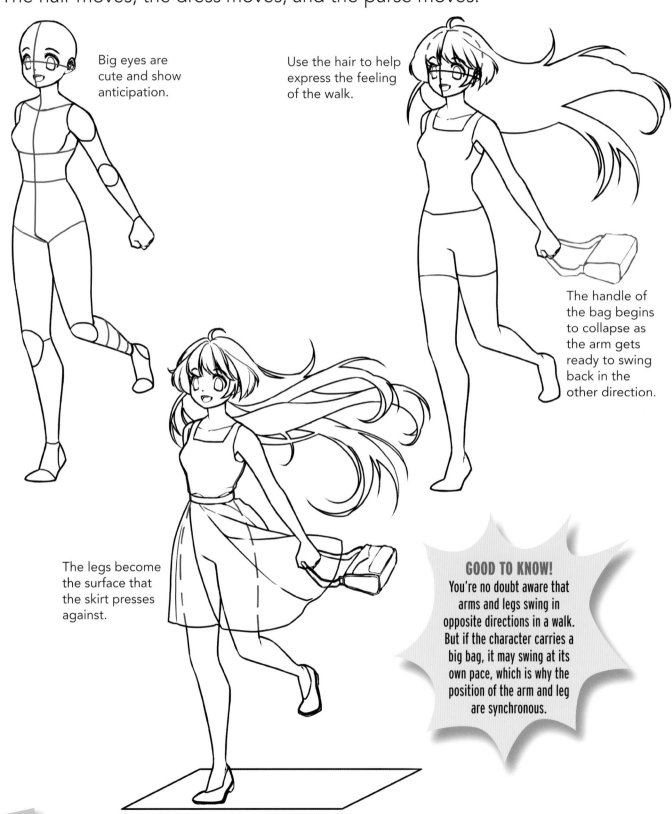

#47 Breezy Walk

A breezy walk shows the arms and legs relaxed and moving freely. This casual gait sets up a chain of events: The hair moves, the dress moves, and the purse moves.

Big eyes are cute and show anticipation.

Use the hair to help express the feeling of the walk.

The handle of the bag begins to collapse as the arm gets ready to swing back in the other direction.

The legs become the surface that the skirt presses against.

GOOD TO KNOW!
You're no doubt aware that arms and legs swing in opposite directions in a walk. But if the character carries a big bag, it may swing at its own pace, which is why the position of the arm and leg are synchronous.

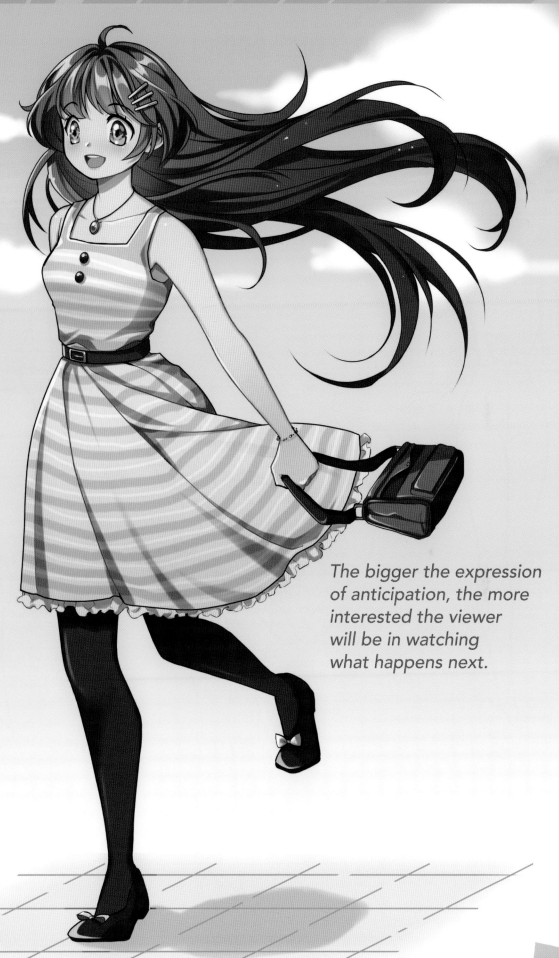

The bigger the expression of anticipation, the more interested the viewer will be in watching what happens next.

#48 Running (Front Angle)

The front angle run looks challenging but it's actually one of the easiest angles to draw. That's because the arms and legs are drawn close to the body, and therefore, you don't have to guess where to position them.

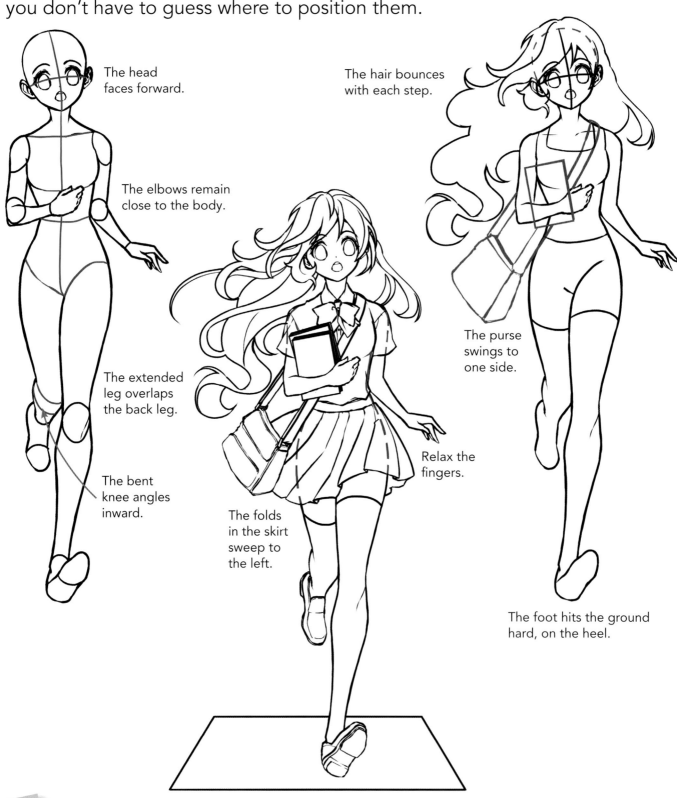

The head faces forward.

The hair bounces with each step.

The elbows remain close to the body.

The extended leg overlaps the back leg.

The bent knee angles inward.

The purse swings to one side.

The folds in the skirt sweep to the left.

Relax the fingers.

The foot hits the ground hard, on the heel.

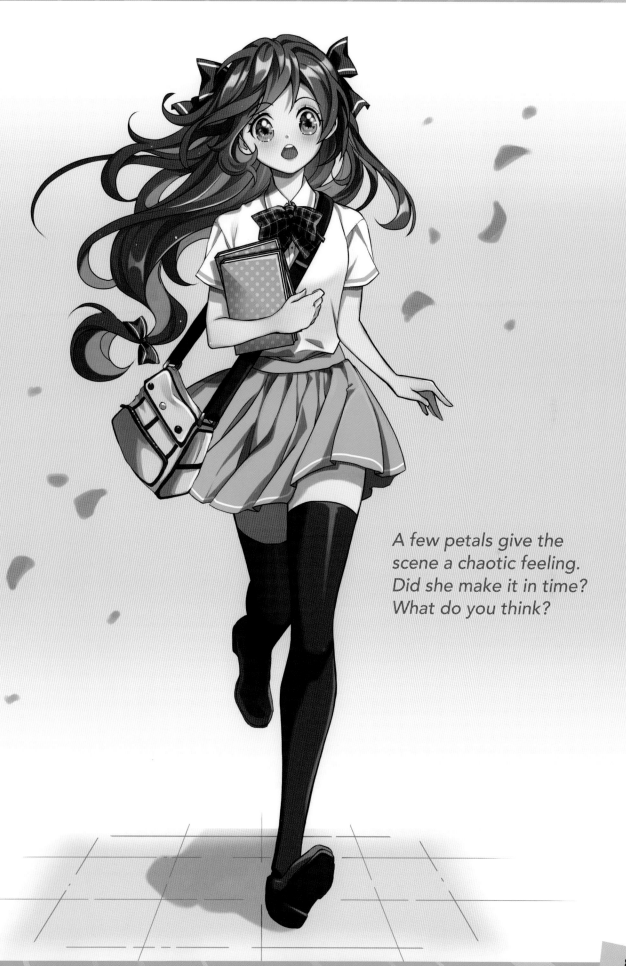

A few petals give the
scene a chaotic feeling.
Did she make it in time?
What do you think?

#49 Walking in the Rain

If you want to raise the "boo-hoo" quality of a moment, nothing works better than a character walking in the rain. The pose is fairly simple: Tilt the head down and take short strides. Done!

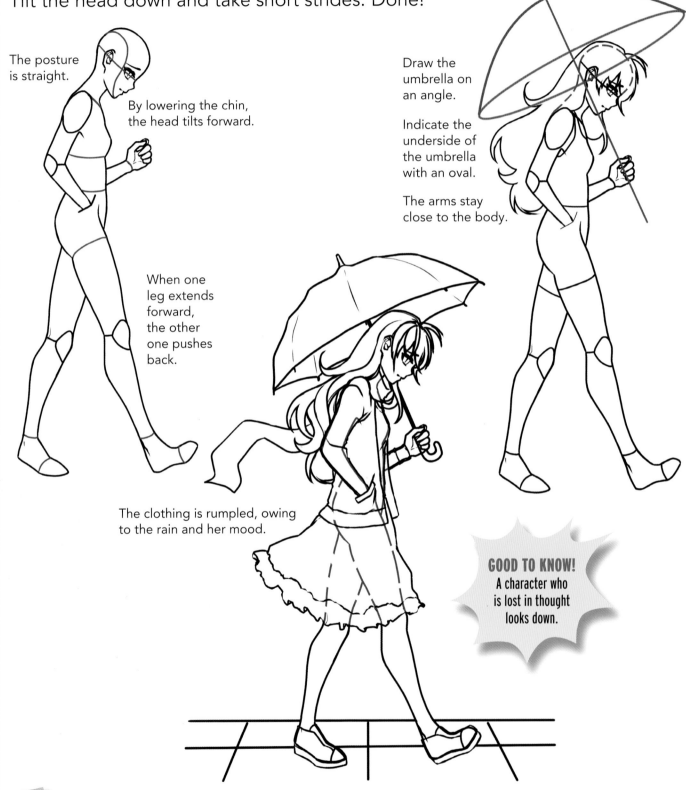

The posture is straight.

By lowering the chin, the head tilts forward.

When one leg extends forward, the other one pushes back.

Draw the umbrella on an angle.

Indicate the underside of the umbrella with an oval.

The arms stay close to the body.

The clothing is rumpled, owing to the rain and her mood.

GOOD TO KNOW!
A character who is lost in thought looks down.

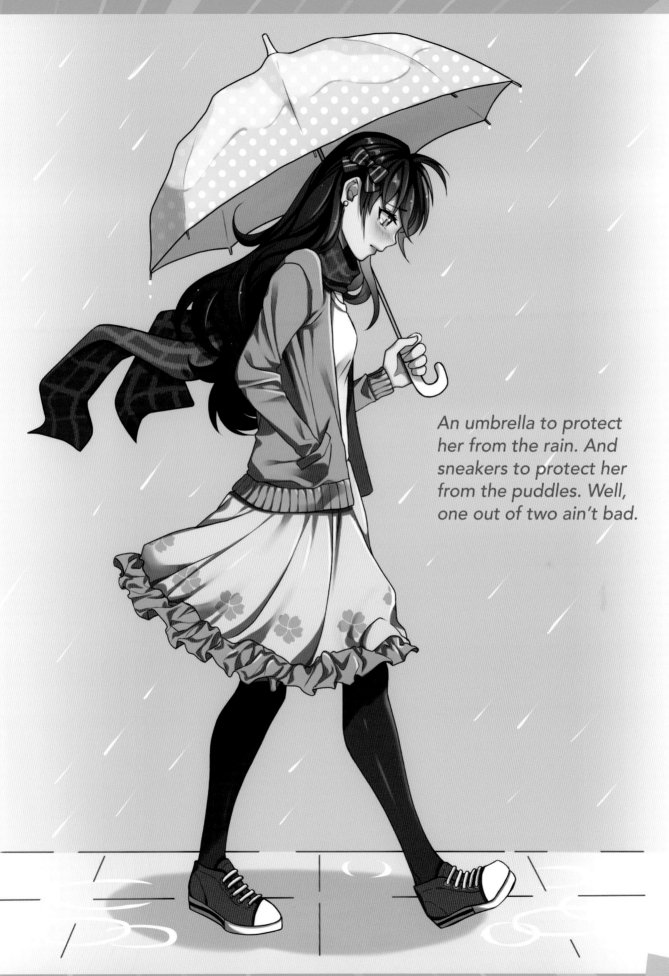

An umbrella to protect her from the rain. And sneakers to protect her from the puddles. Well, one out of two ain't bad.

#50 A Walk on the Beach

Now let's take what we've learned about how characters walk and apply it to a stroll along the beach. Add a gentle breeze to cause the clothes to move and bumpy clouds to decorate the sky, and you've got a complete scene.

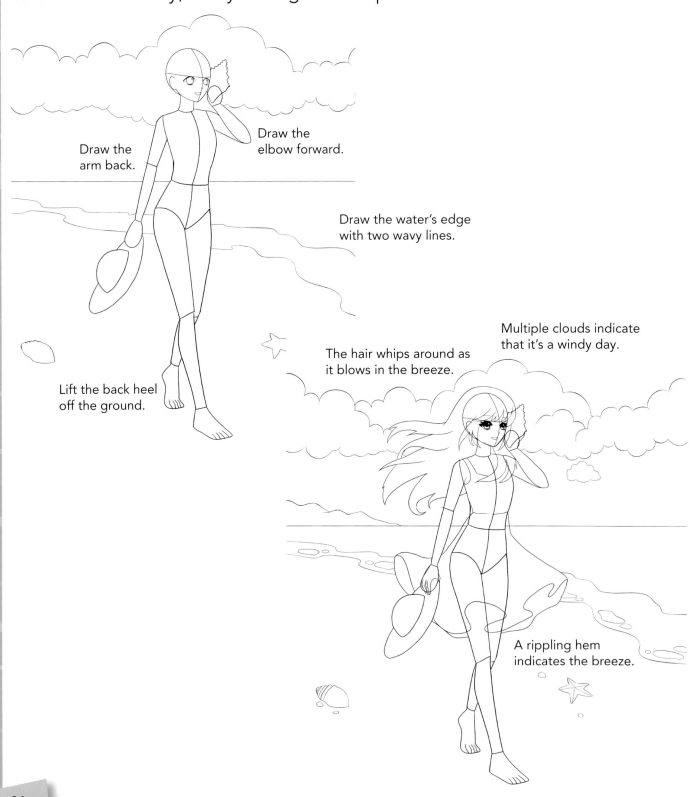

Draw the arm back.

Draw the elbow forward.

Draw the water's edge with two wavy lines.

Lift the back heel off the ground.

The hair whips around as it blows in the breeze.

Multiple clouds indicate that it's a windy day.

A rippling hem indicates the breeze.

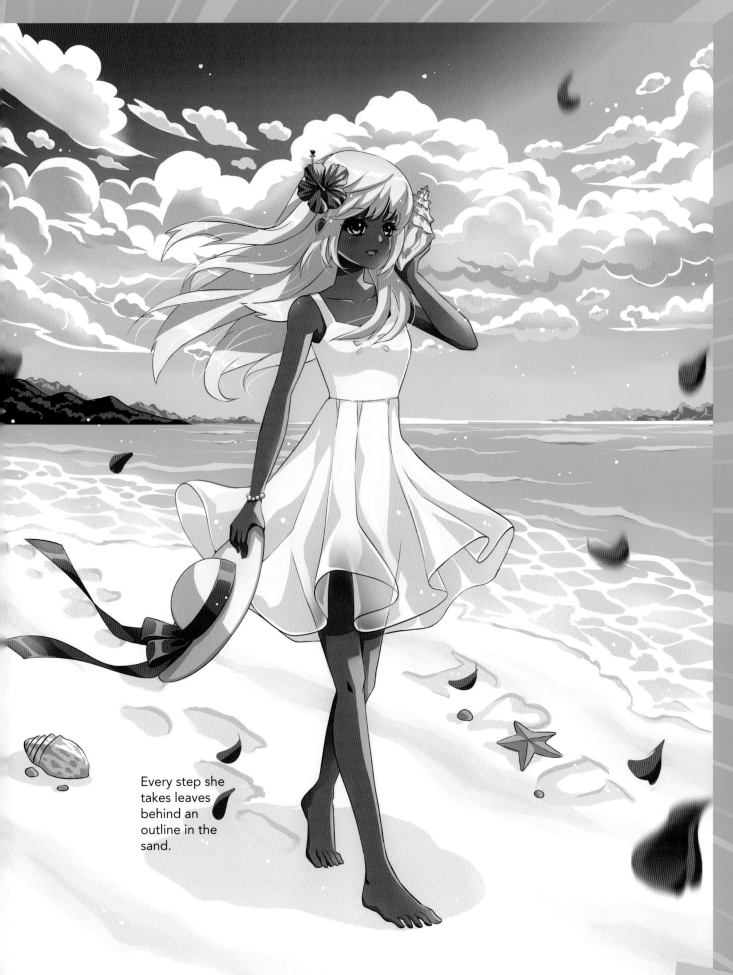

Every step she
takes leaves
behind an
outline in the
sand.

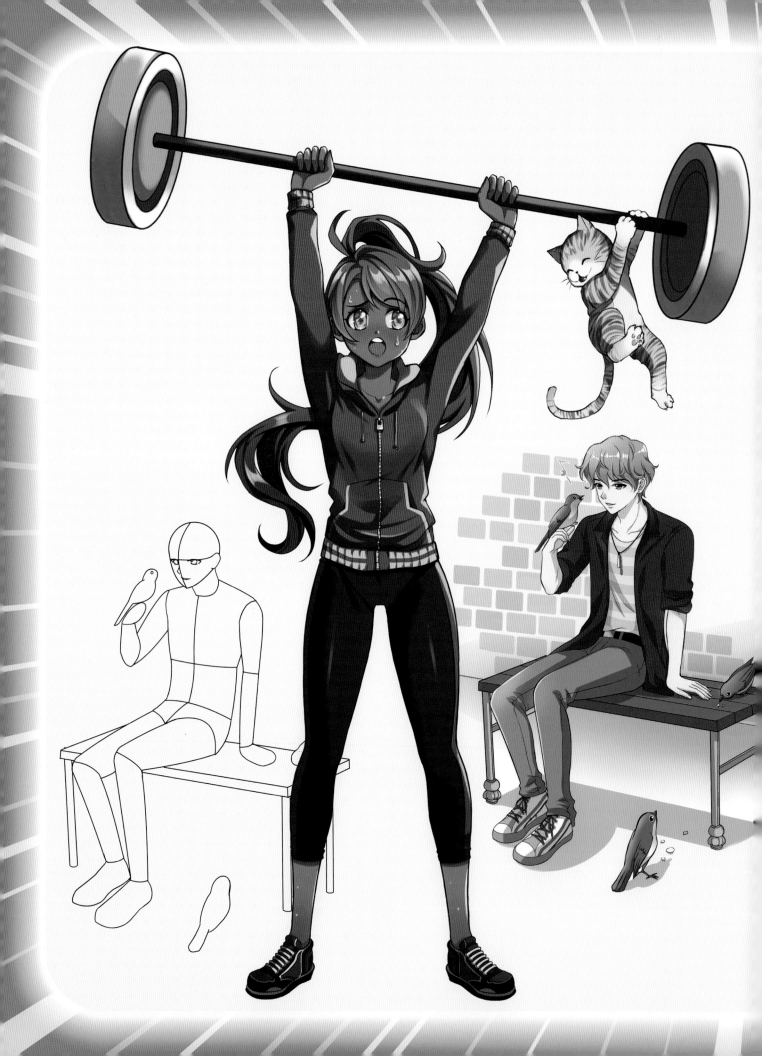

More Poses: Raising It a Notch

Now we'll move past basic poses to those that show manga characters reacting to things in their world. These are called *situational poses*. You see them when you read graphic novels or when you watch anime. Each pose is *about* something. A story or an emotion is implied. Anyone who has wanted to convey an idea with a picture will get valuable tips from this chapter.

#51-52 The Workout Companion

Ever hear of the term e*vil cat*? It's actually the same thing as *cat*. This demonstrates how to take a basic pose and toss a wrench into it. A humorous element doesn't need to be big, it just has to be unexpected.

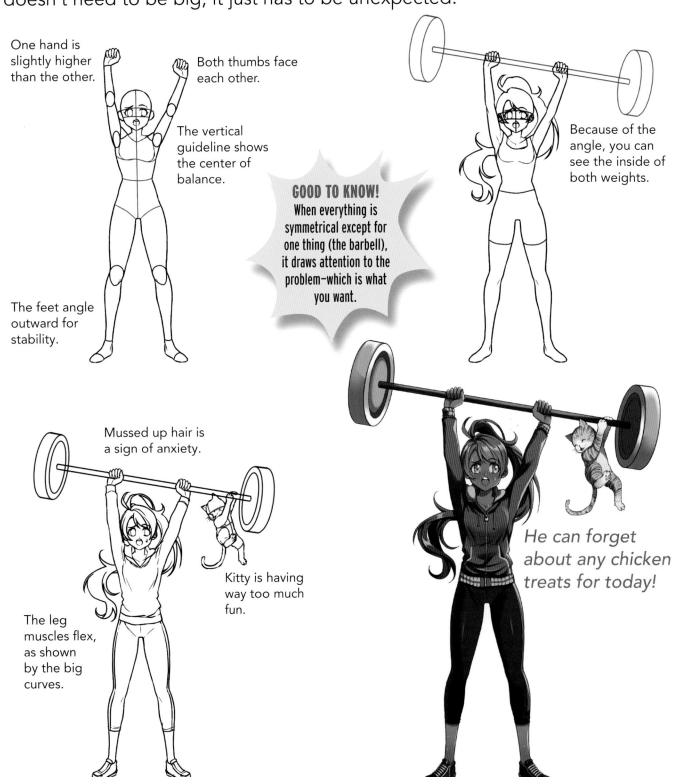

One hand is slightly higher than the other.

Both thumbs face each other.

The vertical guideline shows the center of balance.

The feet angle outward for stability.

GOOD TO KNOW! When everything is symmetrical except for one thing (the barbell), it draws attention to the problem—which is what you want.

Because of the angle, you can see the inside of both weights.

Mussed up hair is a sign of anxiety.

The leg muscles flex, as shown by the big curves.

Kitty is having way too much fun.

He can forget about any chicken treats for today!

The Music Lesson

I'm not totally on board with the idea that she's going to be a concert pianist. This cute and humorous character is created with a simple twist of the torso. She faces right but turns her head left, while maintaining her hand position and the threat that she will continue playing.

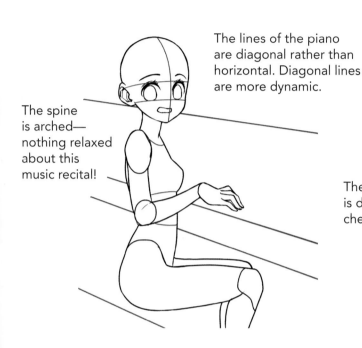

The lines of the piano are diagonal rather than horizontal. Diagonal lines are more dynamic.

The spine is arched—nothing relaxed about this music recital!

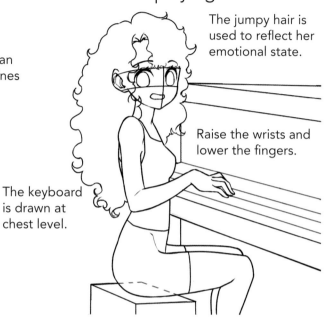

The jumpy hair is used to reflect her emotional state.

Raise the wrists and lower the fingers.

The keyboard is drawn at chest level.

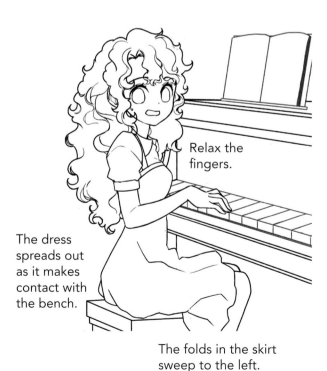

Relax the fingers.

The dress spreads out as it makes contact with the bench.

The folds in the skirt sweep to the left.

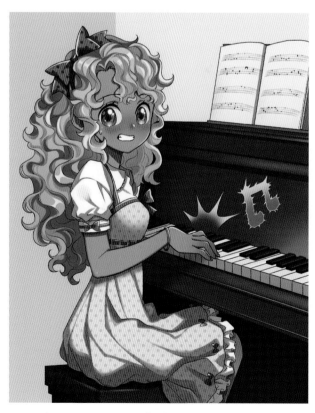

Ouch! It's a good thing that Mozart isn't alive to hear that.

#54 Straightening Out a Mess

This is a basic pushing pose, and it has many uses. This freshman struggles to prevent her stuff from bursting out into the hallway. Like most pushing poses, her posture is drawn on a diagonal, with the supporting leg back.

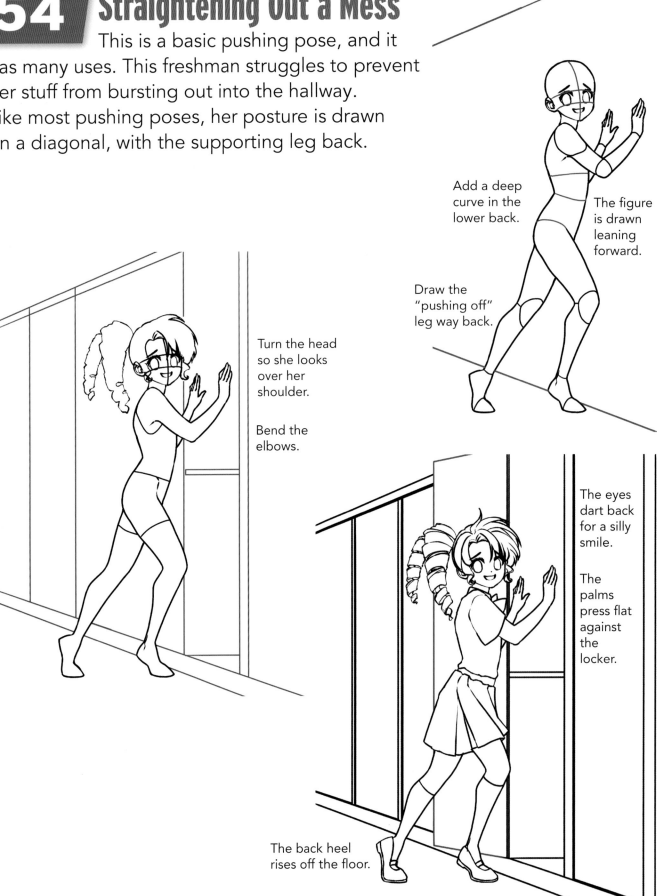

Add a deep curve in the lower back.

The figure is drawn leaning forward.

Draw the "pushing off" leg way back.

Turn the head so she looks over her shoulder.

Bend the elbows.

The eyes dart back for a silly smile.

The palms press flat against the locker.

The back heel rises off the floor.

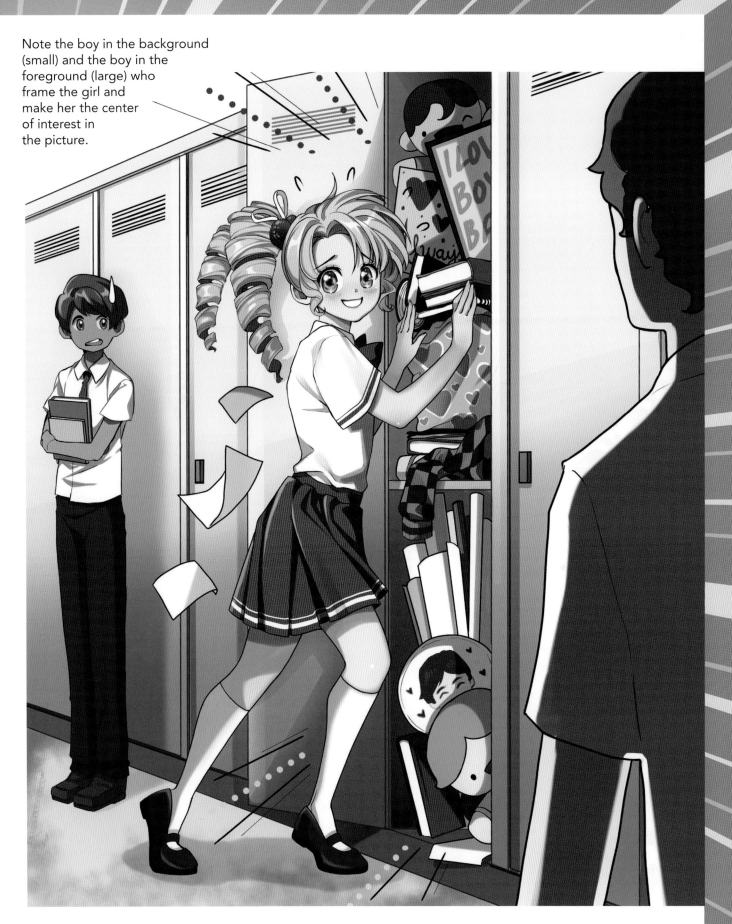

Note the boy in the background (small) and the boy in the foreground (large) who frame the girl and make her the center of interest in the picture.

Her locker is all a jumble. And this is after she organized it!

#55 Sitting Pose #1—Basic

In the front-angle seated pose, the effect of foreshortening causes the legs to appear compressed. This angle is easier to draw. Simply slouch the posture enough so that the character appears relaxed. The chest should curve inward. And place one hand on the bench to prop him up.

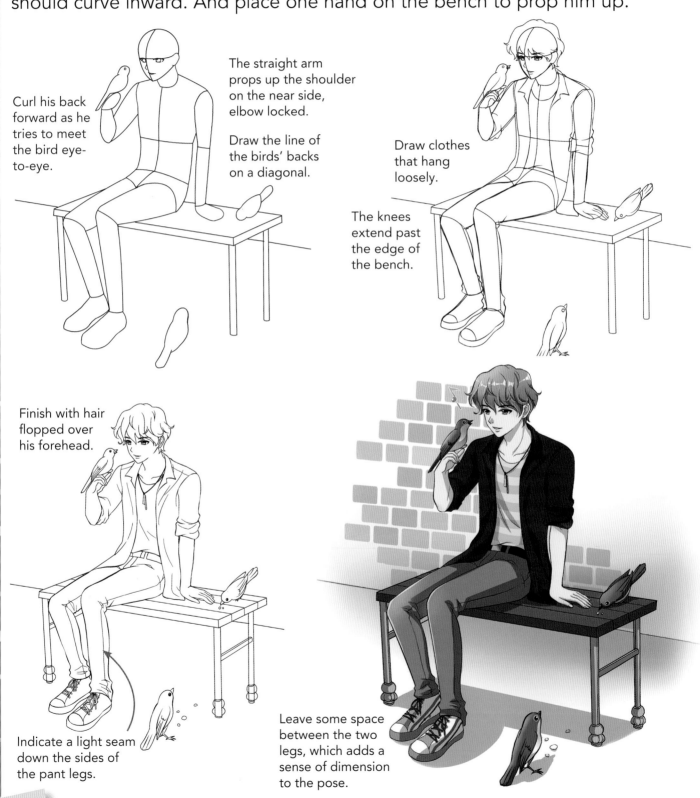

Curl his back forward as he tries to meet the bird eye-to-eye.

The straight arm props up the shoulder on the near side, elbow locked.

Draw the line of the birds' backs on a diagonal.

The straight arm props up the shoulder on the near side, elbow locked.

Draw clothes that hang loosely.

The knees extend past the edge of the bench.

Finish with hair flopped over his forehead.

Indicate a light seam down the sides of the pant legs.

Leave some space between the two legs, which adds a sense of dimension to the pose.

Sitting Pose #2—Intermediate

A sitting pose is an excellent choice for showing a character's mood and mindset. This guy has a moment to think things over. Soon, he will make a decision, stand up, and take a new direction with confidence.

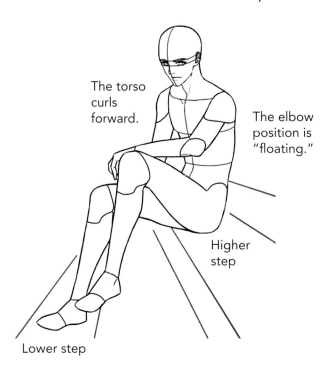

The torso curls forward.

The elbow position is "floating."

Higher step

Lower step

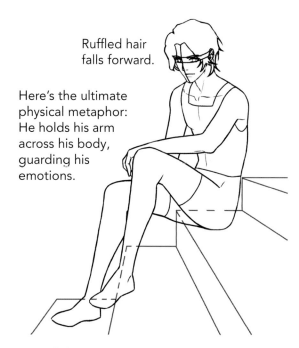

Ruffled hair falls forward.

Here's the ultimate physical metaphor: He holds his arm across his body, guarding his emotions.

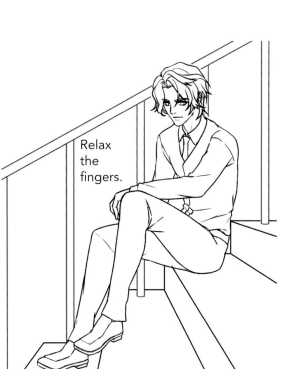

Relax the fingers.

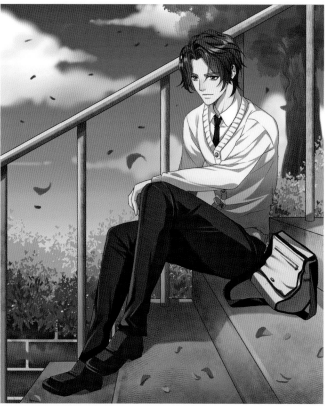

Intense thinking is an important part of many sitting poses.

#57 Wishing on a Star

Dramatic poses take dramatic backgrounds, and balconies are scene stealers. Bright city lights convey a hopefulness about this character. In many stories, there's a moment when a character makes an important decision. Such decisions might be about romance, career, or moving across country to start a new life.

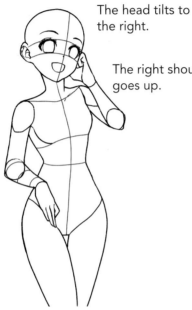

The head tilts to the right.

The right shoulder goes up.

The left shoulder dips, to compensate. (Compensating is an important principle in art.)

The elbow rests on the railing.

The higher the floor, the windier the balcony, which is reflected by the flowing hair and skirt.

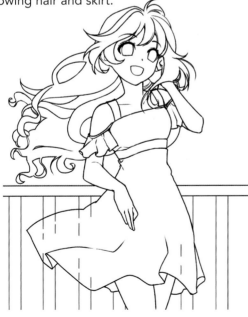

With the hair and outfit flapping in the wind, the pose doesn't have to work as hard.

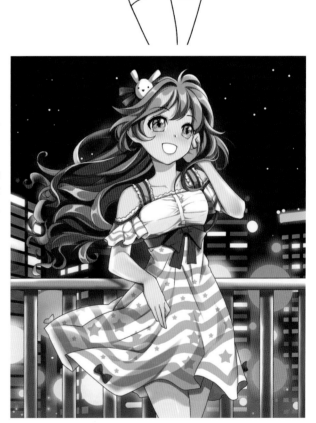

Leave the background somewhat abstract. The rectangles read as individual apartments and the spheres of light read as downtown.

Novel Poses

The key to drawing a pose you've never tried before is to simplify it. Only show enough information to convey the basic idea. For example, feeding fish in an aquarium could be drawn a million different ways, but the simplest way is usually the best. Let one arm carry the action.

Draw big, tall eyes for a happy expression.

The head tilts forward.

The back of her hand faces her.

Turn the body to the left so it's in a ¾ pose.

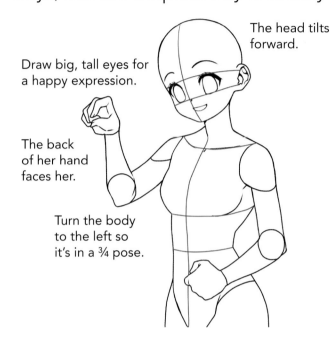

Lower the near arm, which allows the higher hand (with the food in it) to define the action.

The elbows are drawn at different heights.

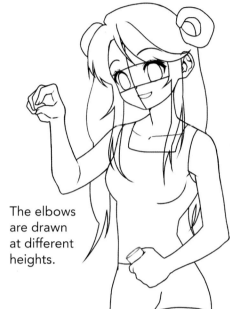

With the figure in place, draw the tank, and allow the arm to show through the water.

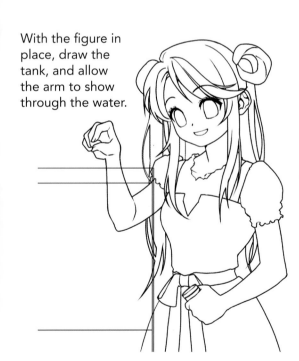

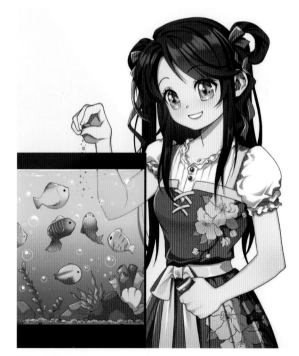

The body is set back from the fish tank, so that it doesn't crowd the action. Placement is an important part of laying out a scene.

95

#59 Doing Homework on the Go!

It's helpful to practice poses in real-world environments—especially when it entails characters who do a million things at the same time. They can do homework, listen to music, chew bubble gum, and read texts at the same time. Oh, and you can't see it, but she's also tapping her feet.

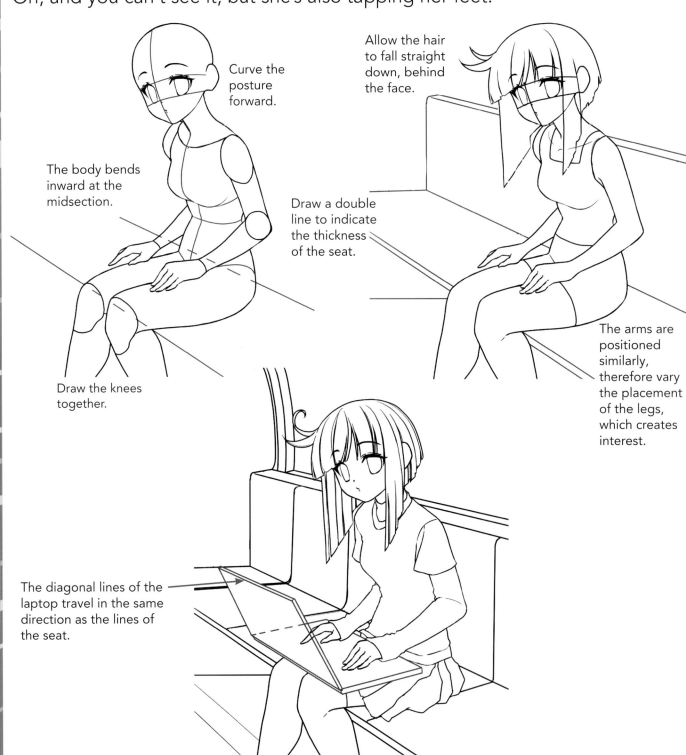

Curve the posture forward.

Allow the hair to fall straight down, behind the face.

The body bends inward at the midsection.

Draw a double line to indicate the thickness of the seat.

Draw the knees together.

The arms are positioned similarly, therefore vary the placement of the legs, which creates interest.

The diagonal lines of the laptop travel in the same direction as the lines of the seat.

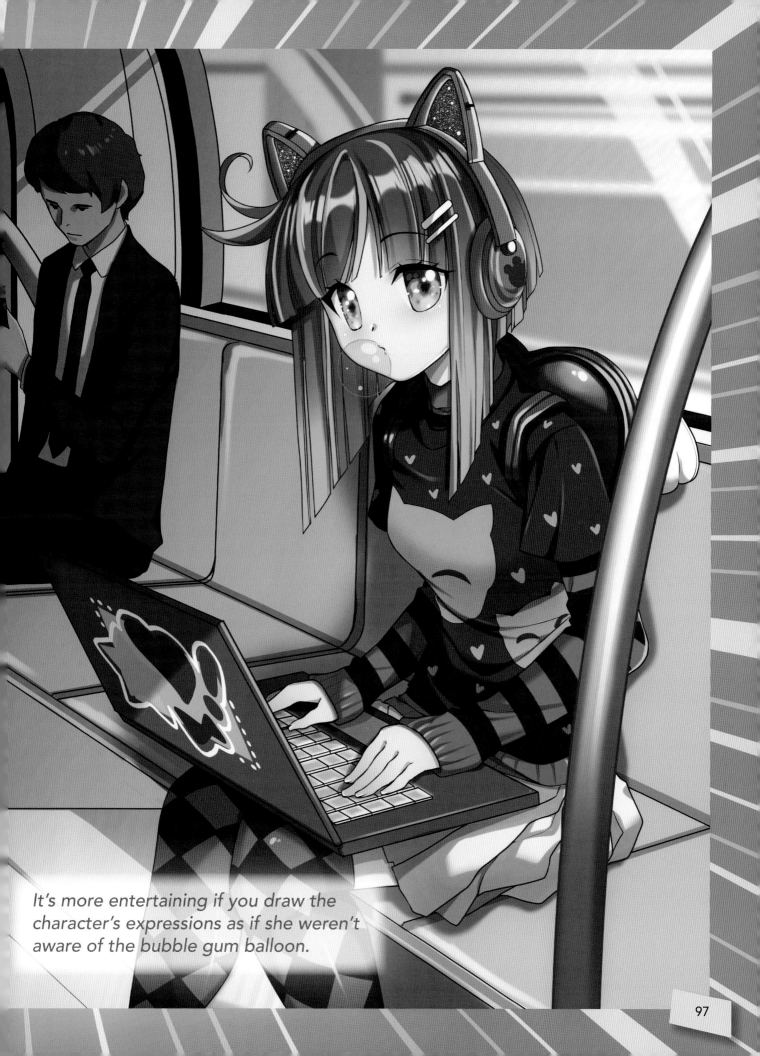

It's more entertaining if you draw the character's expressions as if she weren't aware of the bubble gum balloon.

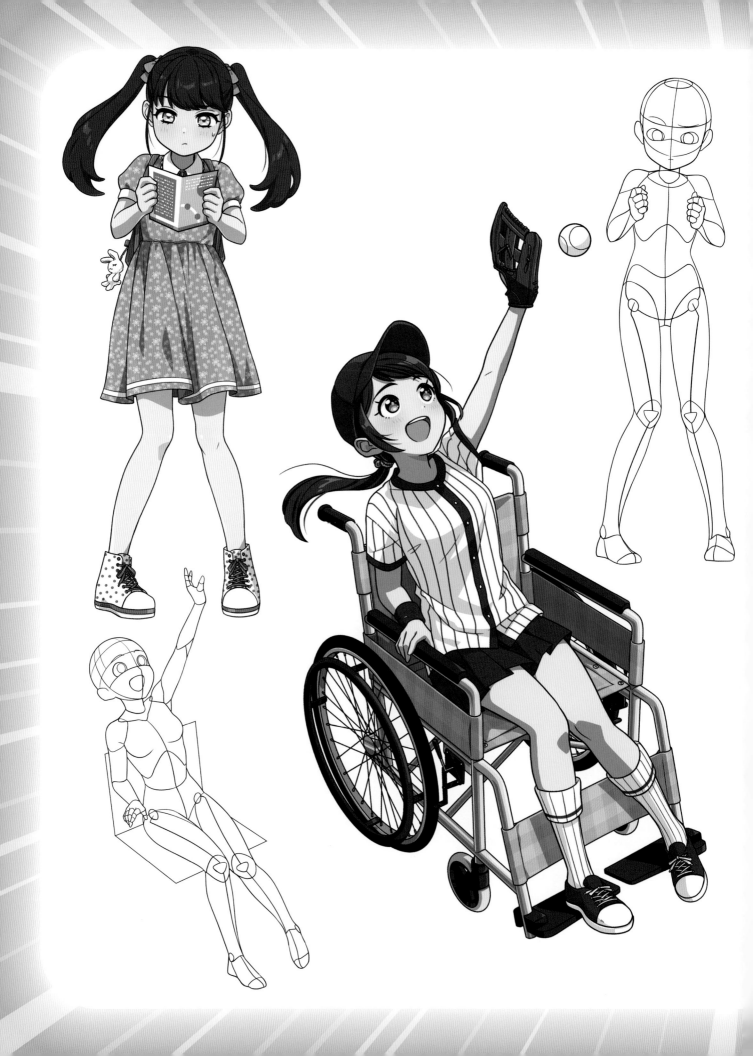

Adorable Middle School Characters

Young teens are very popular character types in manga. They're smart, determined, silly, and sometimes completely clueless! Because they're so expressive, young characters are funny and endearing in everyday situations. The first step in the tutorials shows the basic construction—how it's done. The rest are just a matter of refining it. Let's create a few humorous situations, and watch the characters react!

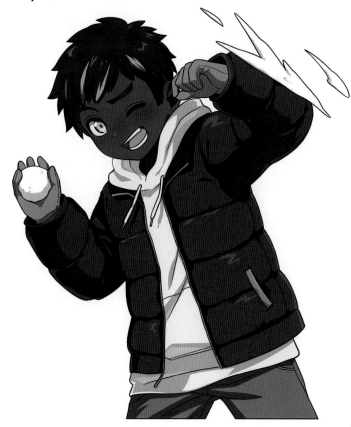

#60 Lost in the Big City

When a character is overwhelmed in a scene, it's a good choice to draw her from a low-angle, so that the viewer is looking up at her. That causes the skyscrapers behind her to look tall and overwhelming, and she looks small as a result. She checks her map, but she can't find the store that sells kawaii plush toys and keychains. This is a catastrophe!

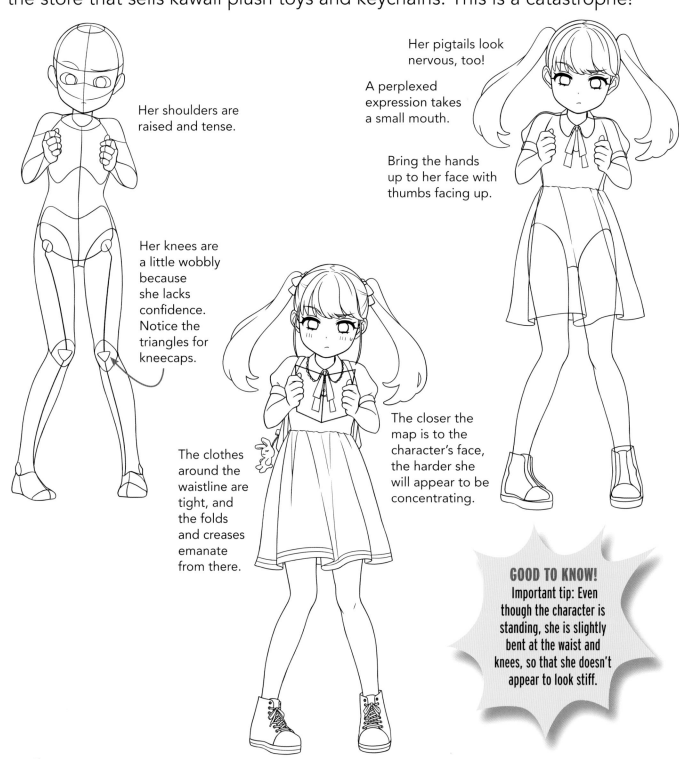

Her shoulders are raised and tense.

Her knees are a little wobbly because she lacks confidence. Notice the triangles for kneecaps.

Her pigtails look nervous, too!

A perplexed expression takes a small mouth.

Bring the hands up to her face with thumbs facing up.

The clothes around the waistline are tight, and the folds and creases emanate from there.

The closer the map is to the character's face, the harder she will appear to be concentrating.

GOOD TO KNOW!
Important tip: Even though the character is standing, she is slightly bent at the waist and knees, so that she doesn't appear to look stiff.

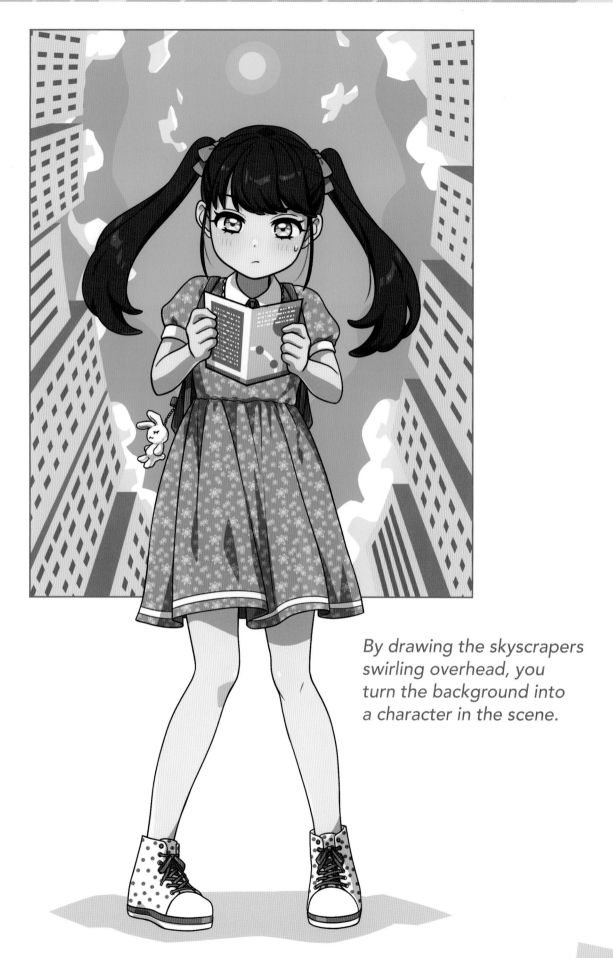

By drawing the skyscrapers swirling overhead, you turn the background into a character in the scene.

#61-62 Turbo Charged Chatting

Isn't it curious that some friends never run out of things to talk about? When drawing two people chatting, draw one talking and one reacting. This makes it easier for the reader to understand. Making one character look more active than the other creates contrast, which is an appealing approach.

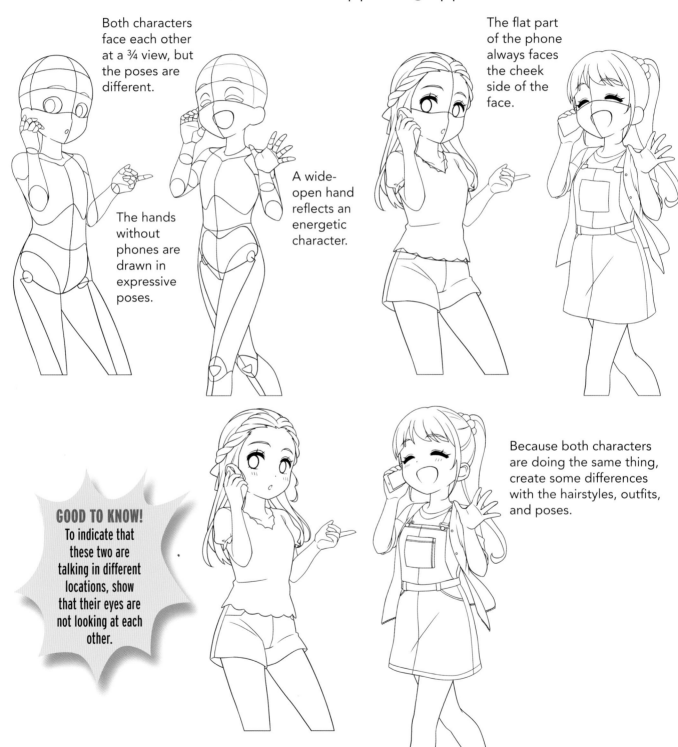

Both characters face each other at a ¾ view, but the poses are different.

The hands without phones are drawn in expressive poses.

A wide-open hand reflects an energetic character.

The flat part of the phone always faces the cheek side of the face.

Because both characters are doing the same thing, create some differences with the hairstyles, outfits, and poses.

GOOD TO KNOW!
To indicate that these two are talking in different locations, show that their eyes are not looking at each other.

The box around each girl drives home the idea that they are separated by distance.

Notice that the sound effect bubbles break out of the borders of the boxes. This is a graphic way to add energy to a scene.

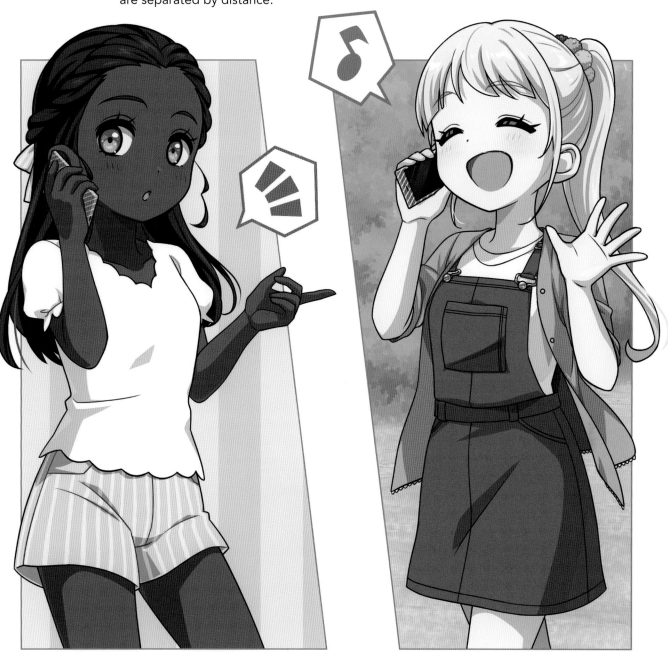

They can keep this up all day and into next week.

#63 Snowball Fight

This is a classic reaction shot: A character stops in mid-action (throwing) as he gets tagged first (story of my childhood). He winces by closing one eye and opening his mouth to form a grimace. Finally, he raises his shoulders as he ducks out of the way.

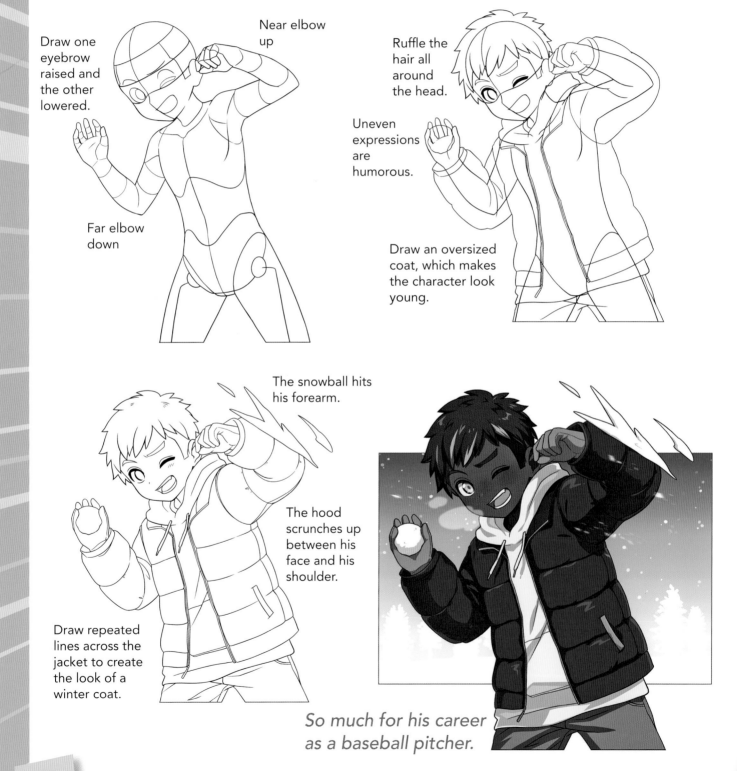

Draw one eyebrow raised and the other lowered.

Near elbow up

Far elbow down

Ruffle the hair all around the head.

Uneven expressions are humorous.

Draw an oversized coat, which makes the character look young.

The snowball hits his forearm.

The hood scrunches up between his face and his shoulder.

Draw repeated lines across the jacket to create the look of a winter coat.

So much for his career as a baseball pitcher.

Paying Attention in Class

She better stop daydreaming before that gum bubble pops. Draw big, wide eyes looking away, totally distracted. Relax her shoulders. This will cause a funny and tense reaction when the teacher suddenly calls on her. I don't know what she's thinking about but I can guarantee you it's not photosynthesis.

A round head is an important aspect of a cute character.

Wide eyes, off to the side, show the character lost in thought.

Lean the weight of her upper body onto one arm.

The bottom arm stabilizes the top arm.

Draw big, round eyes with rising eyelids and eyebrows.

Indicate a seam on the side of the torso. (This makes the upper body look three-dimensional.)

The folds fall in an uneven line over the legs.

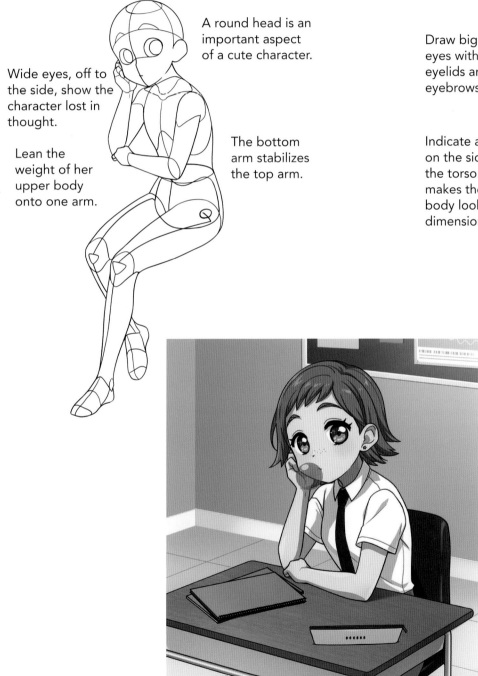

The teacher has been very patient during the class lecture. But when that bubble bursts, all bets are off.

#65 The Winning Play!

The determination to give one's all takes something extra from those facing special challenges. To capture the spirit of this picture, show the concentration in her eyes as she locks onto the ball. Her back arches as she stretches as far as she possibly can— and then, even a bit farther. Got it!!

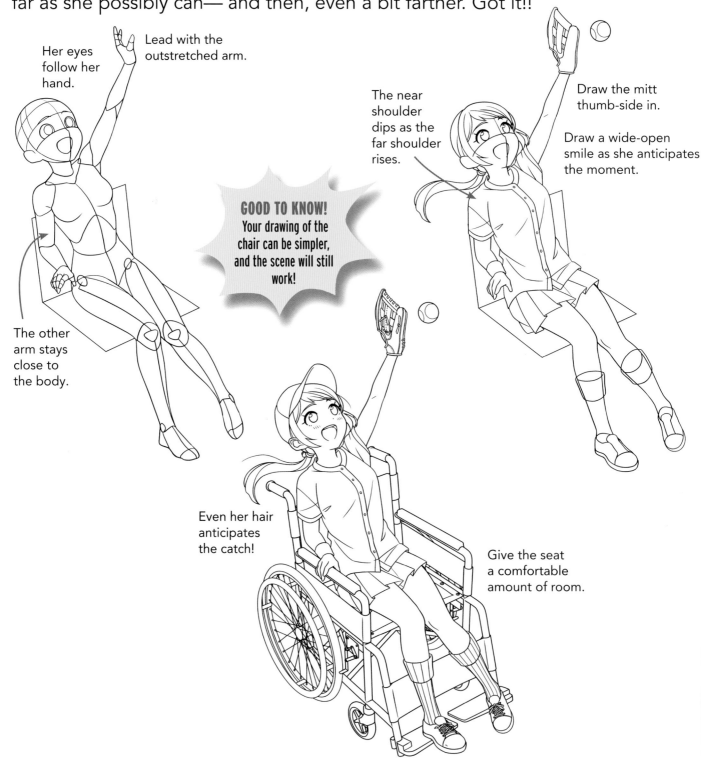

Her eyes follow her hand.

Lead with the outstretched arm.

The near shoulder dips as the far shoulder rises.

Draw the mitt thumb-side in.

Draw a wide-open smile as she anticipates the moment.

GOOD TO KNOW!
Your drawing of the chair can be simpler, and the scene will still work!

The other arm stays close to the body.

Even her hair anticipates the catch!

Give the seat a comfortable amount of room.

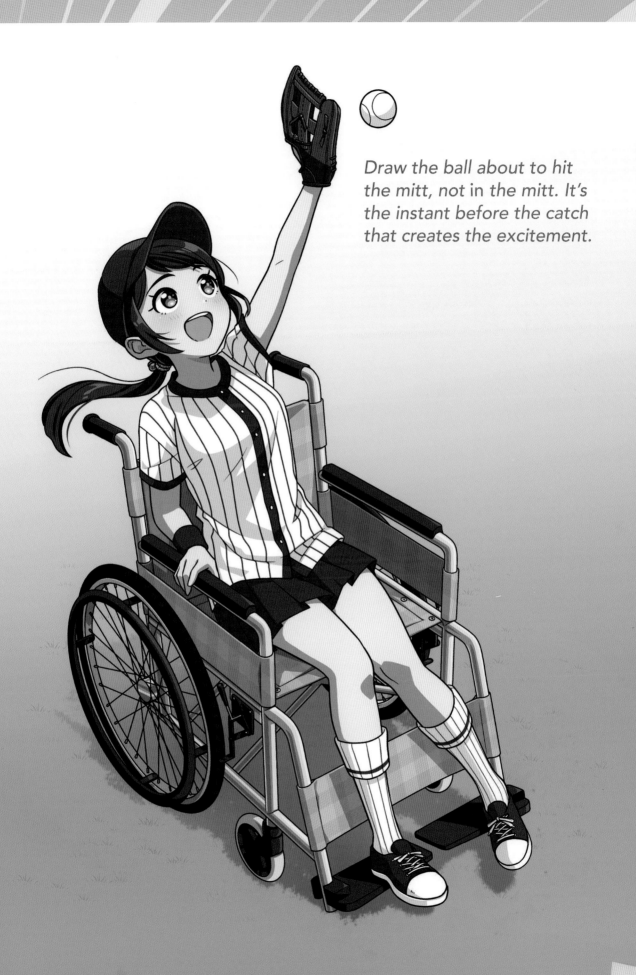

Draw the ball about to hit the mitt, not in the mitt. It's the instant before the catch that creates the excitement.

#66-67 You Almost Got Me!

This teen's misfortune is the puppy's good fortune! There's nothing he can do but pet his dog and tell him to enjoy it. The lesson we can take from this is to finish your ice cream before you get home. Or hide it from your dog.

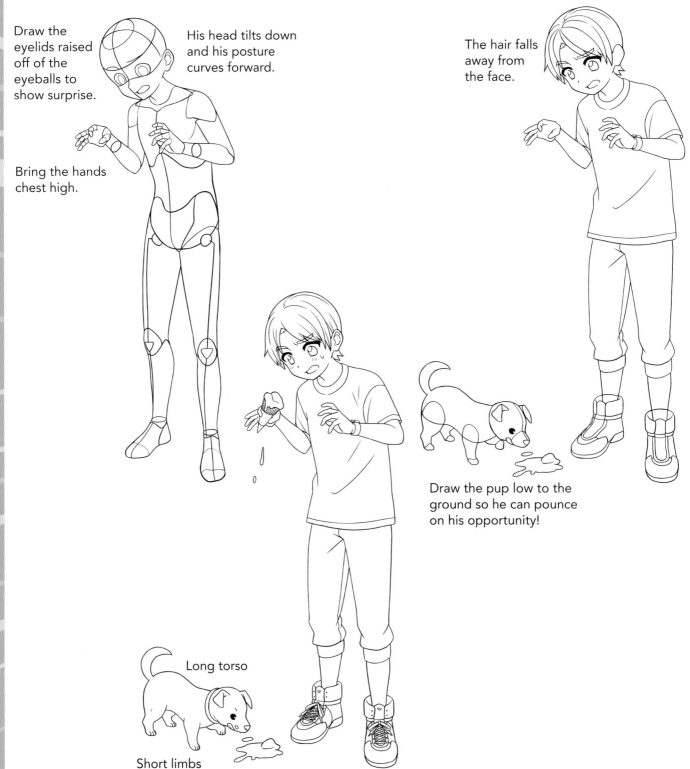

Draw the eyelids raised off of the eyeballs to show surprise.

His head tilts down and his posture curves forward.

The hair falls away from the face.

Bring the hands chest high.

Draw the pup low to the ground so he can pounce on his opportunity!

Long torso

Short limbs

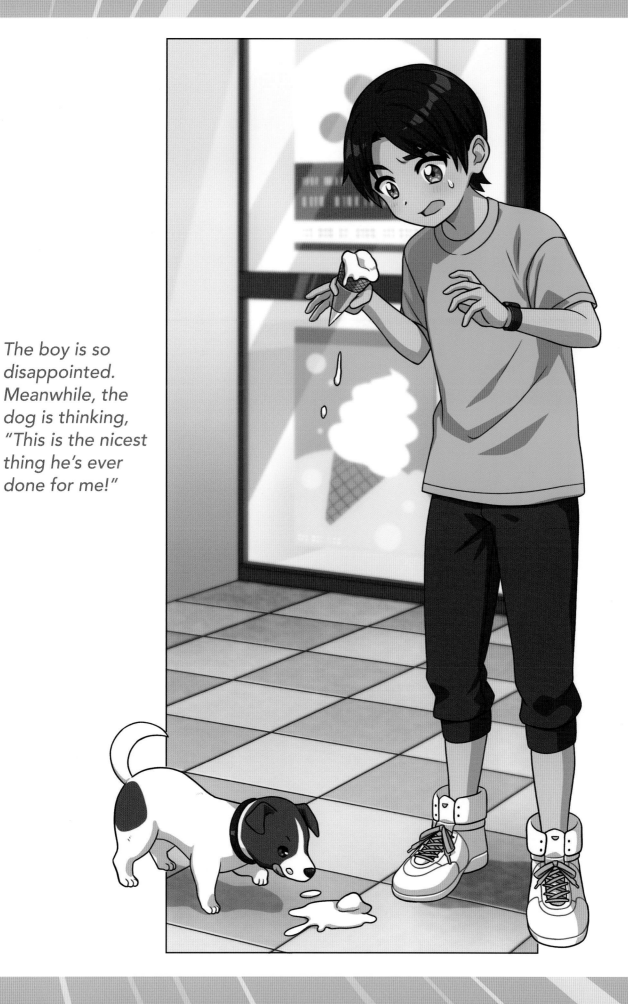

The boy is so disappointed. Meanwhile, the dog is thinking, "This is the nicest thing he's ever done for me!"

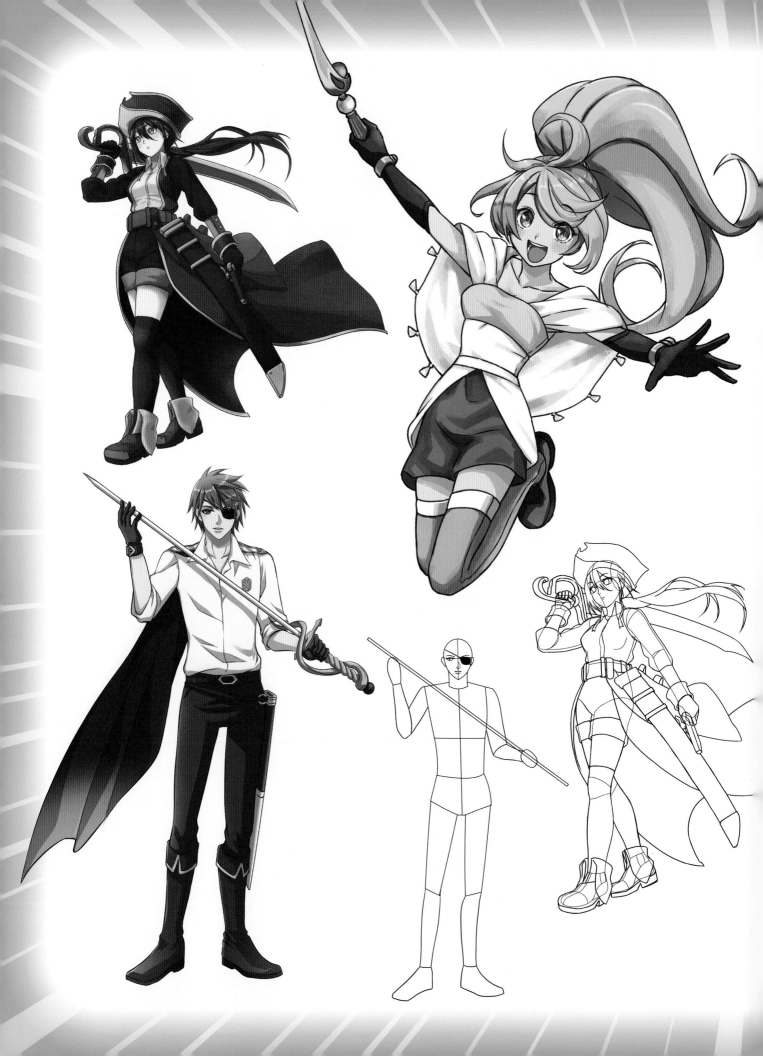

Fun Fashions and Costumes

Outfits define the look of a character, who they are and what they do. Fashion and costumes add snap. The look can be adorable, dynamic, contemporary or of a different time (fantasy). A good pose starts off every good fashionable outfit. If the clothes have a joyful look, and the character is joyful, it doubles the cheerfulness of the character. You'll get a wide variety of outfits and characters in this chapter, which can improve your skills and which are just plain fun to draw.

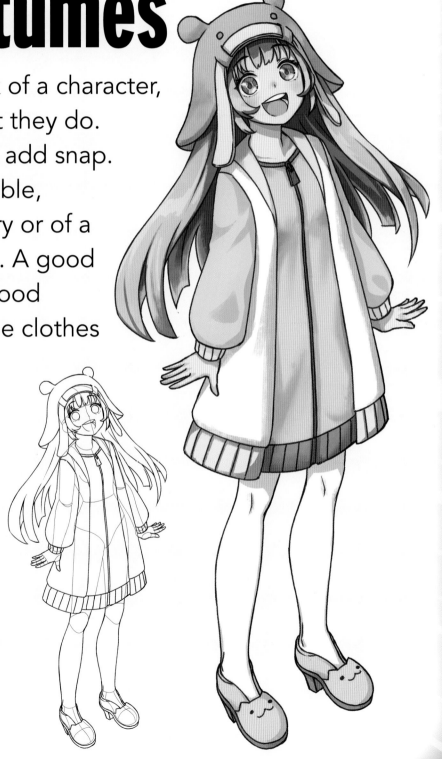

#68 Jazzy Leggings

Just one or two well placed highlights can make an outfit work. This character features a sleeveless top and patterned leggings. The leggings provide a lot of area for trying out new designs. You could create your own design for the legging patterns. For example, cute faces, animal heads, or symbols like hearts and stars.

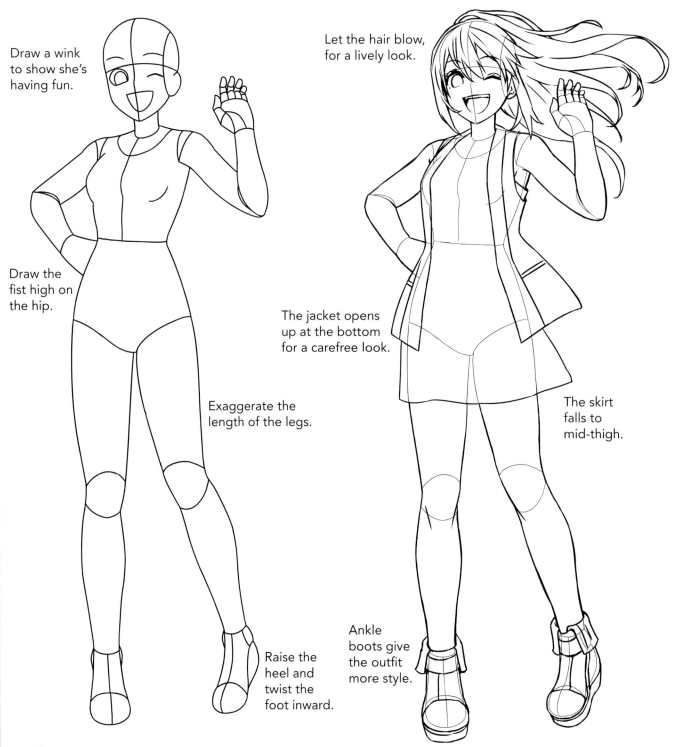

Draw a wink to show she's having fun.

Draw the fist high on the hip.

Exaggerate the length of the legs.

Raise the heel and twist the foot inward.

Let the hair blow, for a lively look.

The jacket opens up at the bottom for a carefree look.

The skirt falls to mid-thigh.

Ankle boots give the outfit more style.

It's helpful to choose a season for your character and her outfit. Summertime outfits are fun, breezy, and open.

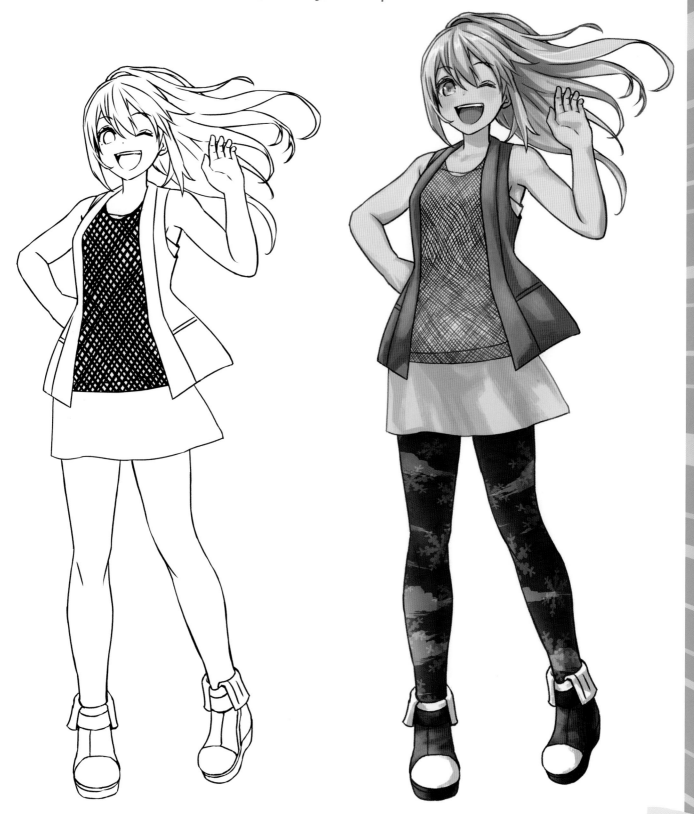

#69 Harajuku Fashion

One of the world's centers for contemporary fashion is in Tokyo. Its focus is Harajuku—the exaggerated, adorable look of manga. The styles, which range from charming to infinite cuteness, sometimes push the envelope. It's like a town that does ultra-sweet 24/7. How can you not love that? Check out this character's Harajuku look, which is as much fun to draw as it is to see.

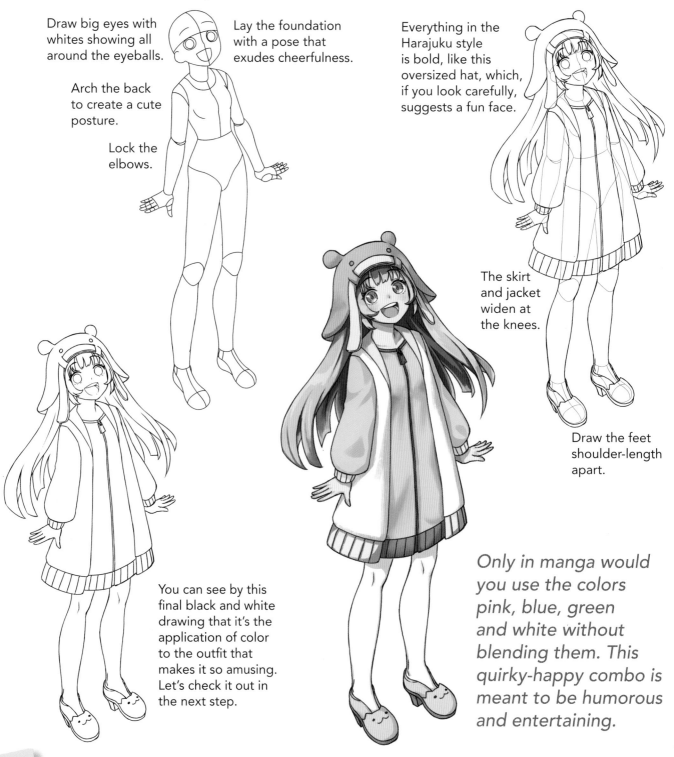

Draw big eyes with whites showing all around the eyeballs.

Arch the back to create a cute posture.

Lock the elbows.

Lay the foundation with a pose that exudes cheerfulness.

Everything in the Harajuku style is bold, like this oversized hat, which, if you look carefully, suggests a fun face.

The skirt and jacket widen at the knees.

Draw the feet shoulder-length apart.

You can see by this final black and white drawing that it's the application of color to the outfit that makes it so amusing. Let's check it out in the next step.

Only in manga would you use the colors pink, blue, green and white without blending them. This quirky-happy combo is meant to be humorous and entertaining.

Simple Sweater Top

This is a classic teen and young adult look. Loose sweater tops and jeans are an easy way to create a friendly character on the go. The oversized top contrasts with narrow jeans. The hairstyle takes a cue from the outfit, which is also casual. And the oversize bag finishes the look. Draw it with books inside of it, a laptop, or a small puppy.

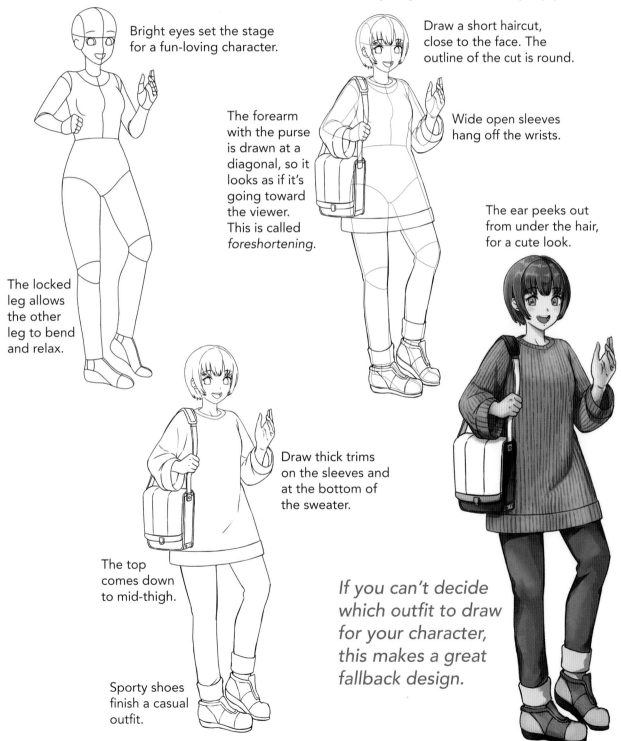

Bright eyes set the stage for a fun-loving character.

Draw a short haircut, close to the face. The outline of the cut is round.

The forearm with the purse is drawn at a diagonal, so it looks as if it's going toward the viewer. This is called *foreshortening*.

Wide open sleeves hang off the wrists.

The ear peeks out from under the hair, for a cute look.

The locked leg allows the other leg to bend and relax.

Draw thick trims on the sleeves and at the bottom of the sweater.

The top comes down to mid-thigh.

Sporty shoes finish a casual outfit.

If you can't decide which outfit to draw for your character, this makes a great fallback design.

#71 Enforcer (Uniform)

What is the difference between an outfit and a uniform? A uniform is meant to convey a character's role in a story. But an outfit is meant to bring out the personality. This one does both. She's an appealing looking character, but she's also a bodyguard—and she means business. She uses social media to post her moves with captions like, "Look at this cool kick I used to take down a bad guy!"

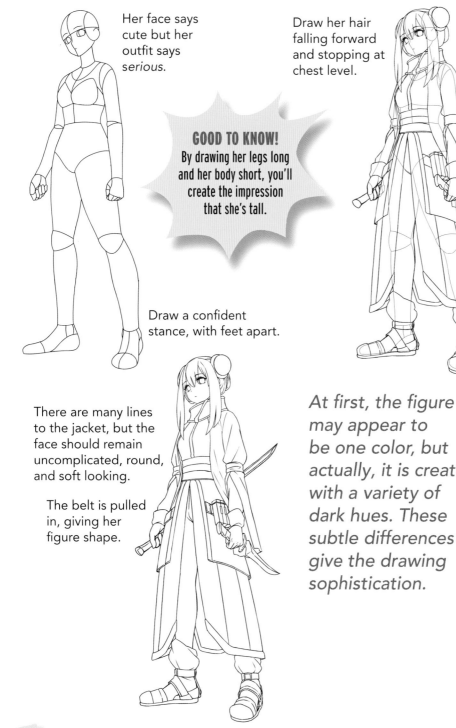

Her face says cute but her outfit says *serious*.

Draw her hair falling forward and stopping at chest level.

Draw a tall collar, which emphasizes her height.

GOOD TO KNOW!
By drawing her legs long and her body short, you'll create the impression that she's tall.

Draw a confident stance, with feet apart.

There are many lines to the jacket, but the face should remain uncomplicated, round, and soft looking.

The belt is pulled in, giving her figure shape.

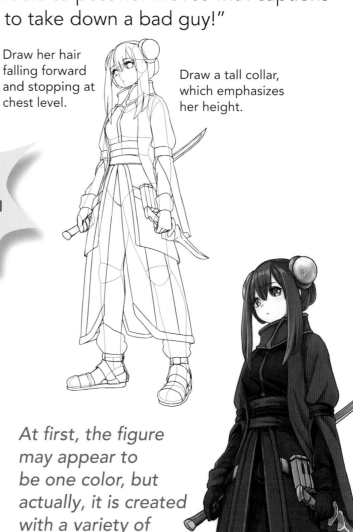

At first, the figure may appear to be one color, but actually, it is created with a variety of dark hues. These subtle differences give the drawing sophistication.

Warrior (Costume)

You can never have too many warriors in manga. Here's one to get you started. She's an idol-type, meaning that she's got glamour and fans. She plays the role with confidence and humor.

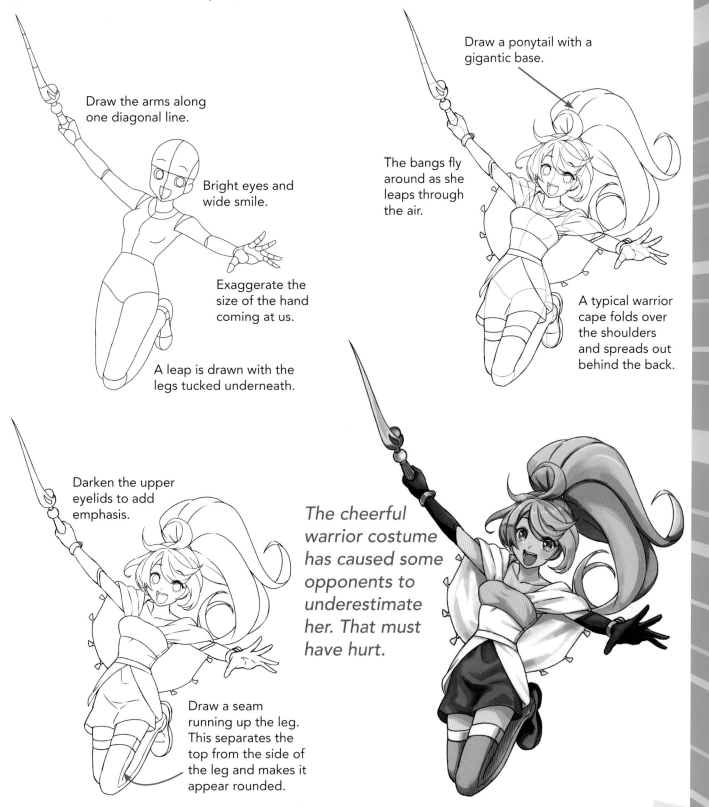

Draw the arms along one diagonal line.

Bright eyes and wide smile.

Exaggerate the size of the hand coming at us.

A leap is drawn with the legs tucked underneath.

Draw a ponytail with a gigantic base.

The bangs fly around as she leaps through the air.

A typical warrior cape folds over the shoulders and spreads out behind the back.

Darken the upper eyelids to add emphasis.

The cheerful warrior costume has caused some opponents to underestimate her. That must have hurt.

Draw a seam running up the leg. This separates the top from the side of the leg and makes it appear rounded.

#73 Knight (Fantasy Costume)

A costume can transport your character to a time in the past. It also conveys information. For example, a character wearing a billowy shirt and holding a sword tells the viewer that he's a knight.

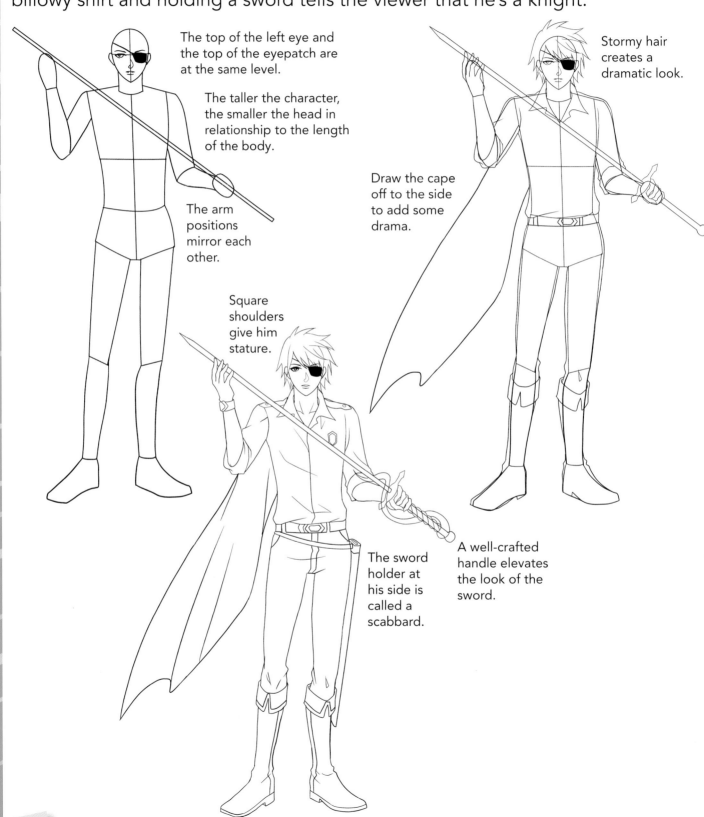

The top of the left eye and the top of the eyepatch are at the same level.

The taller the character, the smaller the head in relationship to the length of the body.

The arm positions mirror each other.

Stormy hair creates a dramatic look.

Draw the cape off to the side to add some drama.

Square shoulders give him stature.

The sword holder at his side is called a scabbard.

A well-crafted handle elevates the look of the sword.

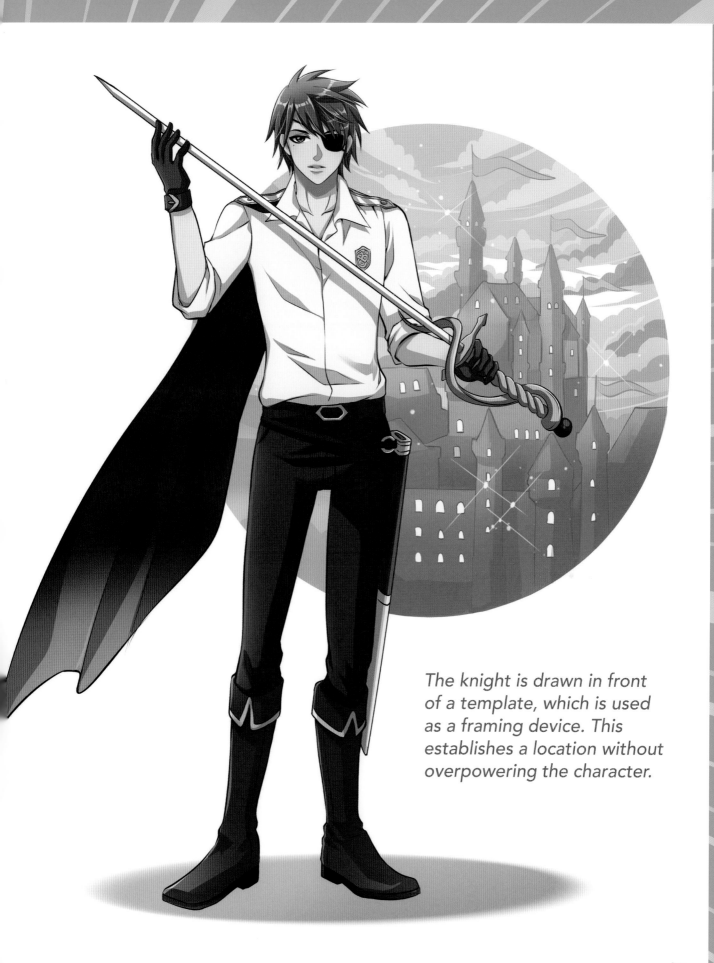

The knight is drawn in front of a template, which is used as a framing device. This establishes a location without overpowering the character.

#74 Pirate (Costume)

Some costumed characters, like pirates, are based on historical figures. But they've become so popular that they've taken on a new life in anime, comics, and media. And this extends to manga graphic novels. Their costumes have evolved to become more colorful and adventurous.

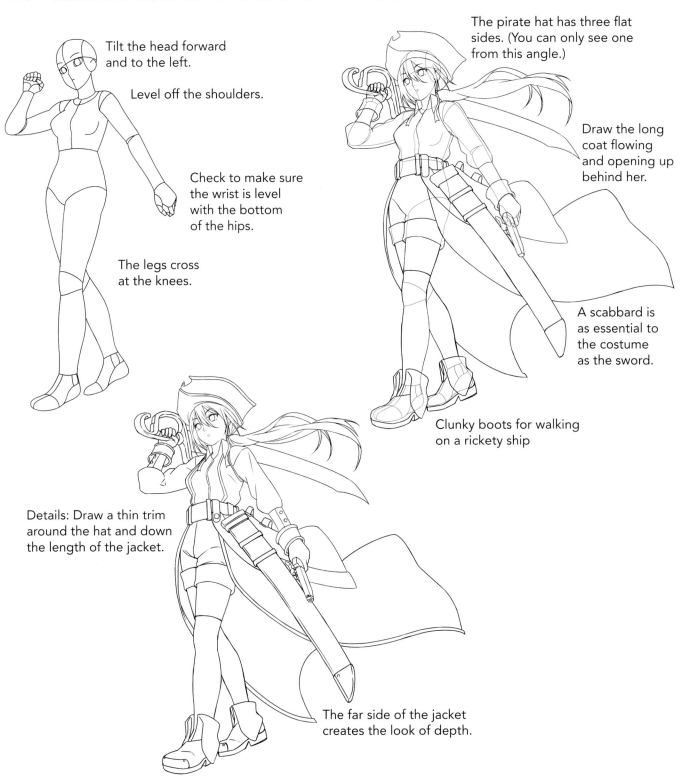

Tilt the head forward and to the left.

Level off the shoulders.

Check to make sure the wrist is level with the bottom of the hips.

The legs cross at the knees.

The pirate hat has three flat sides. (You can only see one from this angle.)

Draw the long coat flowing and opening up behind her.

A scabbard is as essential to the costume as the sword.

Clunky boots for walking on a rickety ship

Details: Draw a thin trim around the hat and down the length of the jacket.

The far side of the jacket creates the look of depth.

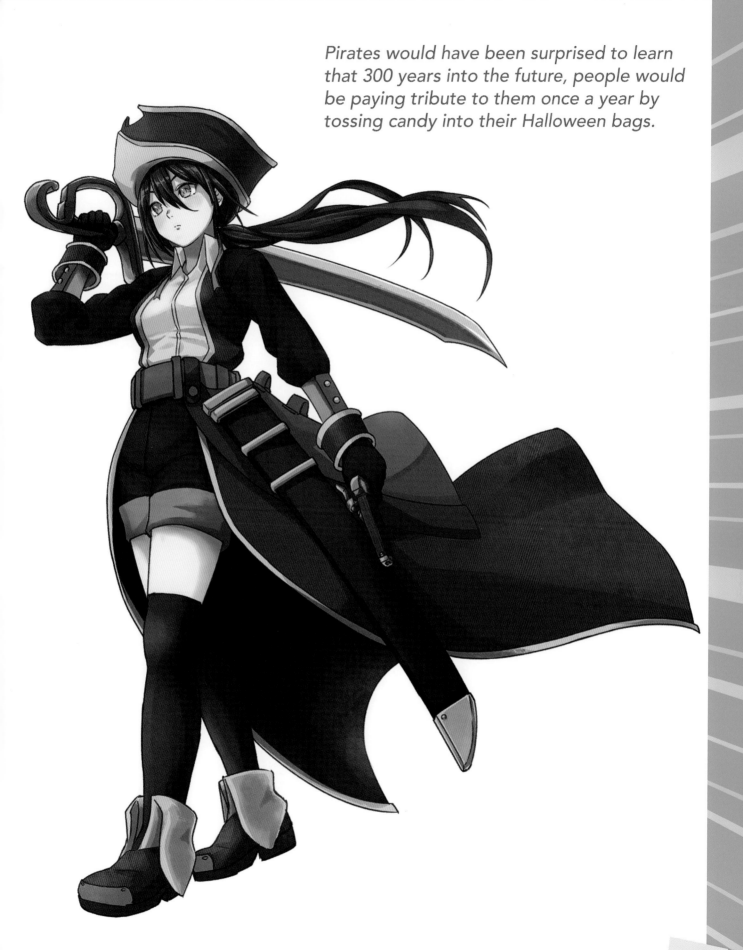

Pirates would have been surprised to learn that 300 years into the future, people would be paying tribute to them once a year by tossing candy into their Halloween bags.

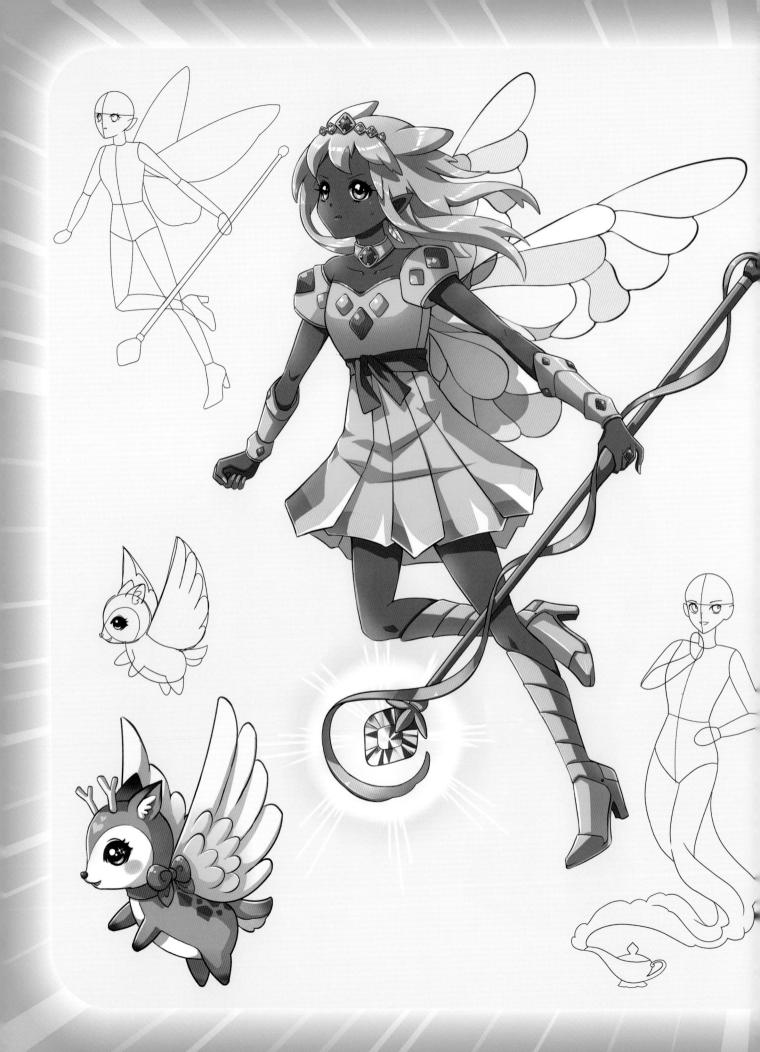

Magical Characters

The exciting thing about magical characters is that somewhere in the story, something unusual will happen. You just don't know when. Humans often interact with magical characters to create stories. And that makes sense. If every character were magical, no one would be impressed by the enchantment. Therefore, the human characters we've created earlier in the book can be used along with these magical types.

#75-76 Friendly Fighters

As a manga fan, you probably know that fighter characters are very popular, and appear in many genres. They don't always fight, but they're ready if they have to defend their friends. This robot girl has a robot companion who can fly way up and be a lookout for her. She's based on the proportions of a real figure. The only difference between her and a real girl is what she wants for her birthday: more batteries.

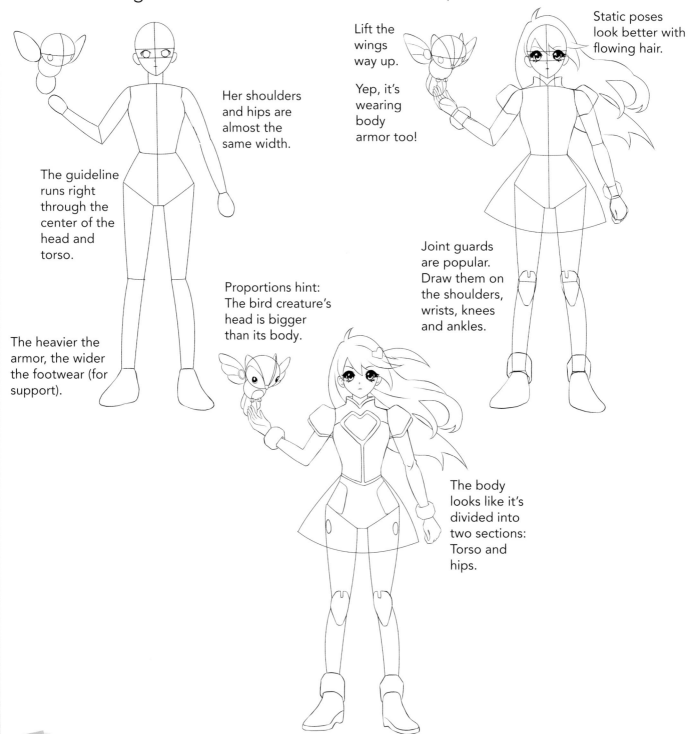

Her shoulders and hips are almost the same width.

Lift the wings way up.

Yep, it's wearing body armor too!

Static poses look better with flowing hair.

The guideline runs right through the center of the head and torso.

Proportions hint: The bird creature's head is bigger than its body.

Joint guards are popular. Draw them on the shoulders, wrists, knees and ankles.

The heavier the armor, the wider the footwear (for support).

The body looks like it's divided into two sections: Torso and hips.

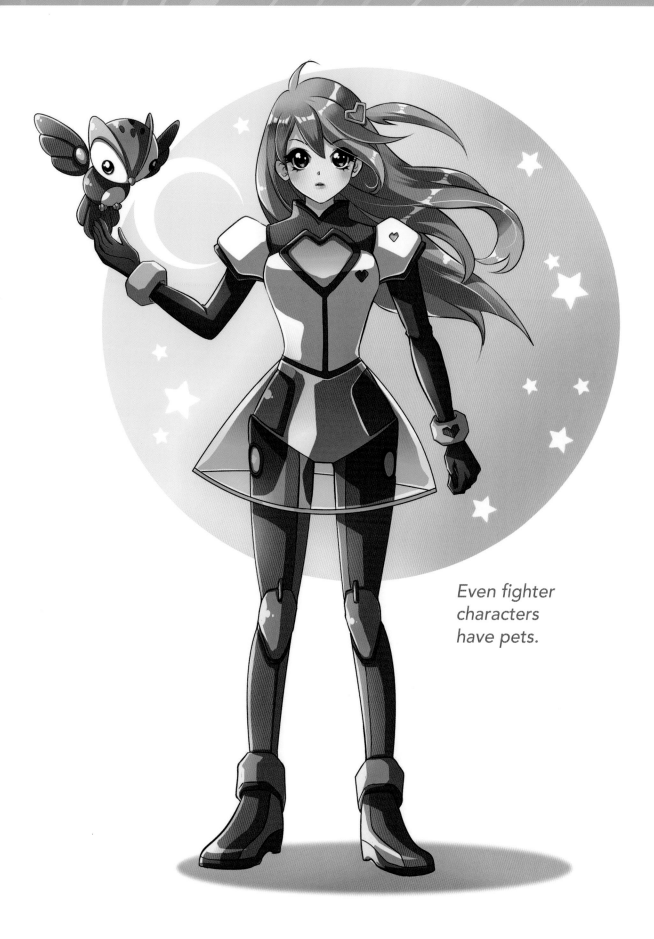

Even fighter
characters
have pets.

#77 Fairy Flight Instructor

When drawing a fairy in flight, draw the wings in an extended position. This creates a dynamic appearance. Although a fairy costume may appear to be elaborate, it is actually straightforward. It's a simple, one-piece dress with puffy shoulders and jewels!

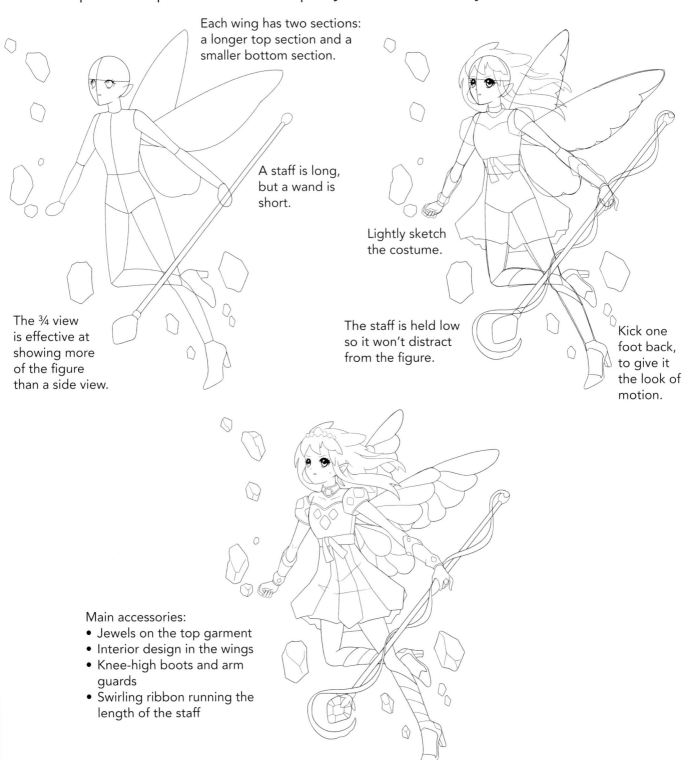

Each wing has two sections: a longer top section and a smaller bottom section.

A staff is long, but a wand is short.

The ¾ view is effective at showing more of the figure than a side view.

Lightly sketch the costume.

The staff is held low so it won't distract from the figure.

Kick one foot back, to give it the look of motion.

Main accessories:
- Jewels on the top garment
- Interior design in the wings
- Knee-high boots and arm guards
- Swirling ribbon running the length of the staff

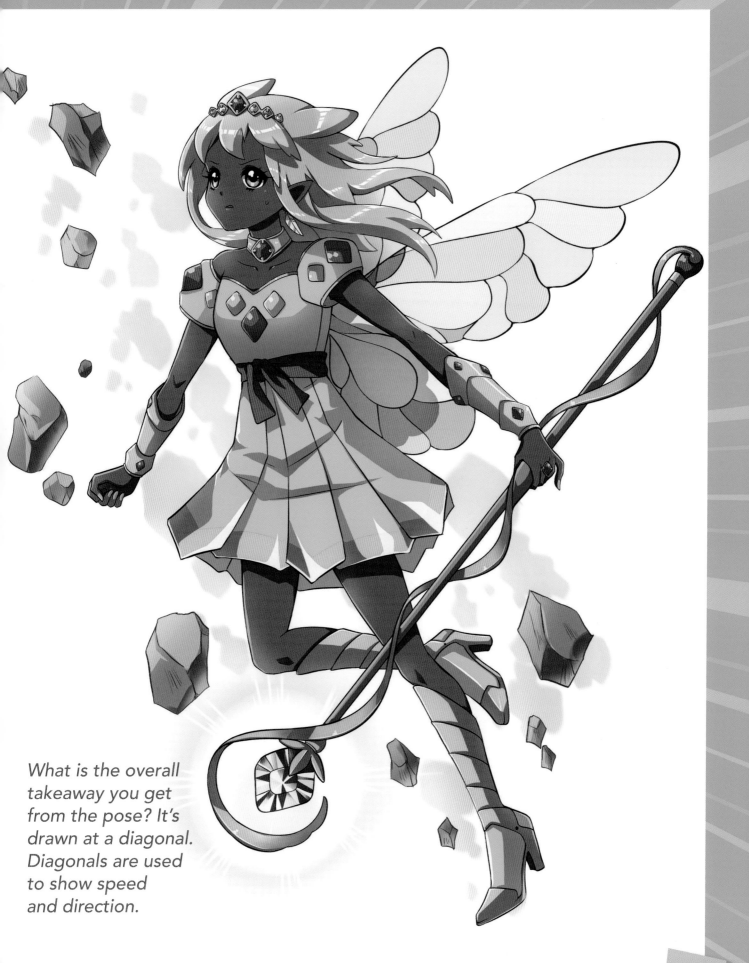

What is the overall takeaway you get from the pose? It's drawn at a diagonal. Diagonals are used to show speed and direction.

#78 Dragon Hunter

Dragon hunters are outfitted with adventure-style costumes, which have earth textures such as wood, metal, leather, and sometimes stone. But the dragon hunter's pose is as important as the costume. Your dragon hunter needs to appear nimble and dynamic.

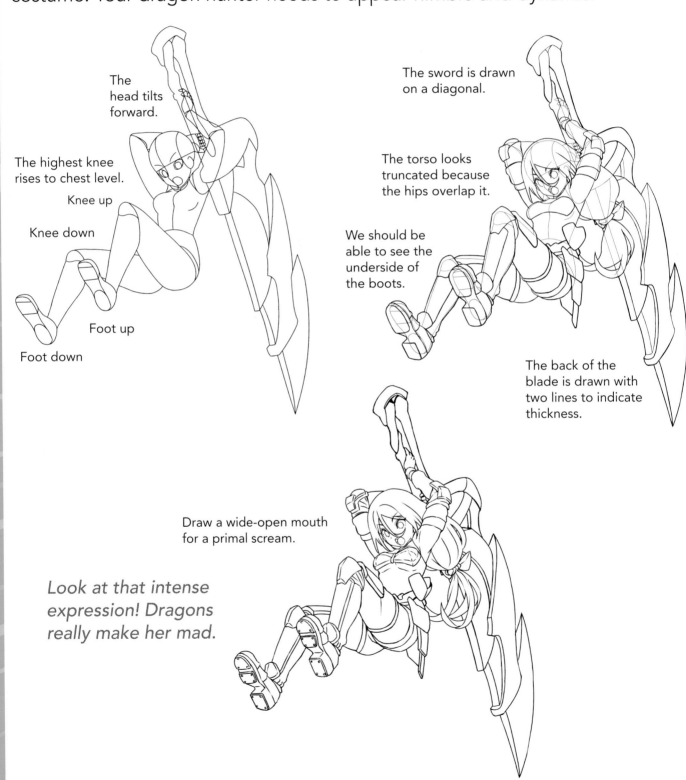

The head tilts forward.

The highest knee rises to chest level.

Knee up

Knee down

Foot up

Foot down

The sword is drawn on a diagonal.

The torso looks truncated because the hips overlap it.

We should be able to see the underside of the boots.

The back of the blade is drawn with two lines to indicate thickness.

Draw a wide-open mouth for a primal scream.

Look at that intense expression! Dragons really make her mad.

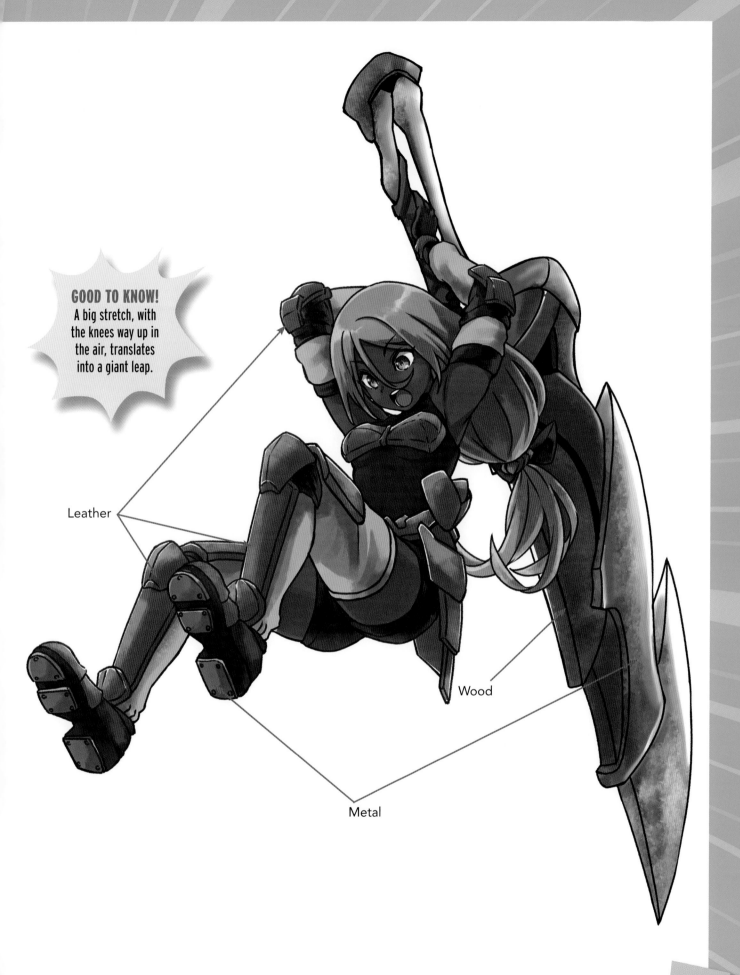

GOOD TO KNOW!
A big stretch, with the knees way up in the air, translates into a giant leap.

Leather

Wood

Metal

#79-80 Defender and Dolls

Big scenes with wall-to-wall images are called *splash pages*. Even when they're appealing and charming, they're dramatic. In this scene, a young girl is under siege from enemies, and she is in danger. All her human friends left, but her playthings from childhood, that she loved so much, have come to life in order to pay her back for all of her kindness to them.

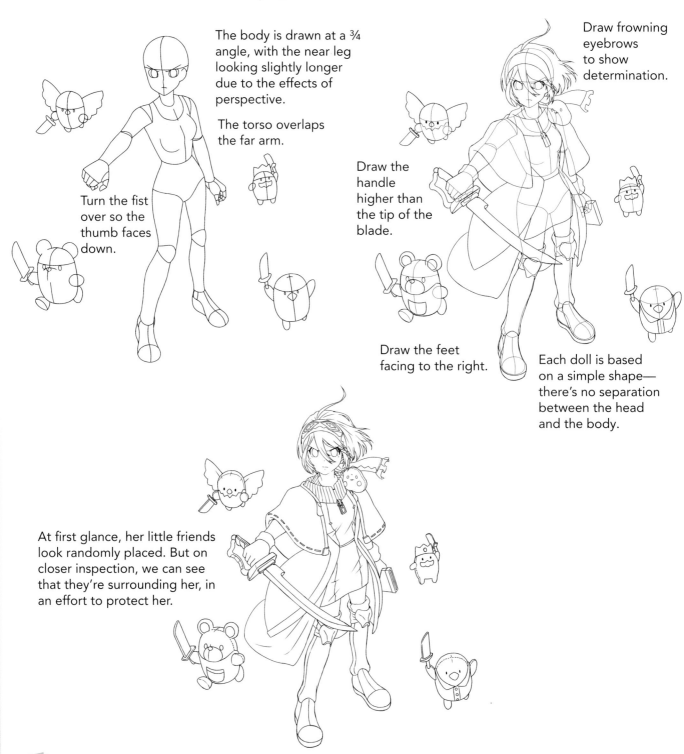

The body is drawn at a ¾ angle, with the near leg looking slightly longer due to the effects of perspective.

The torso overlaps the far arm.

Turn the fist over so the thumb faces down.

Draw frowning eyebrows to show determination.

Draw the handle higher than the tip of the blade.

Draw the feet facing to the right.

Each doll is based on a simple shape—there's no separation between the head and the body.

At first glance, her little friends look randomly placed. But on closer inspection, we can see that they're surrounding her, in an effort to protect her.

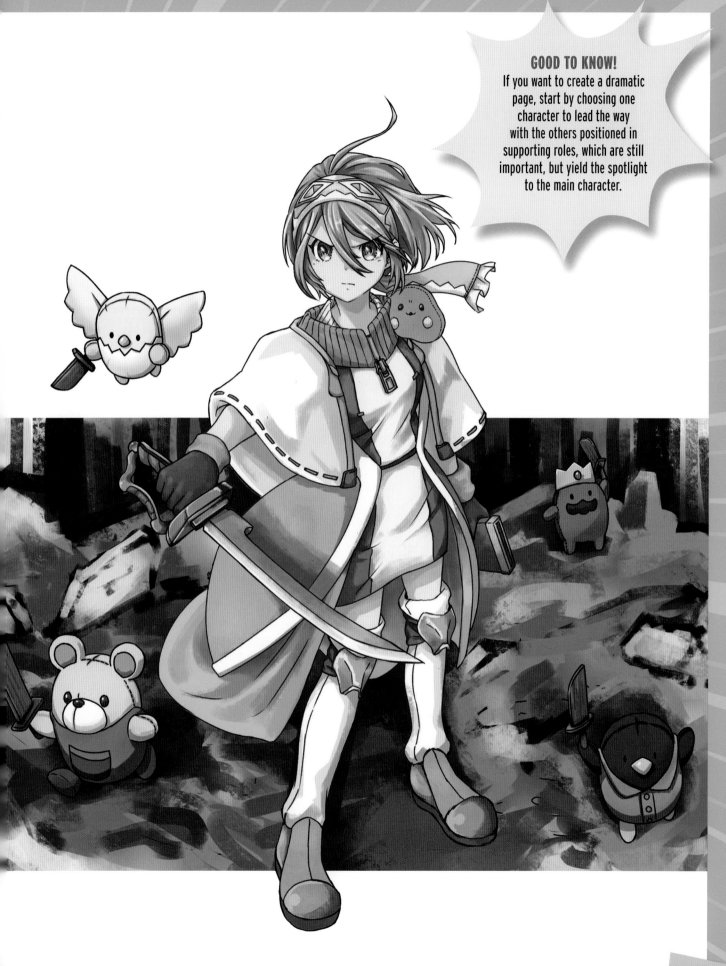

#81 Prince of the Forest

In magical stories, if you travel far enough, you'll eventually go too far and come upon a clearing in the forest where all things are possible. Here's one of the characters you might run into—the Prince of the Forest. It's hard to find this place. And even harder to find your way out!

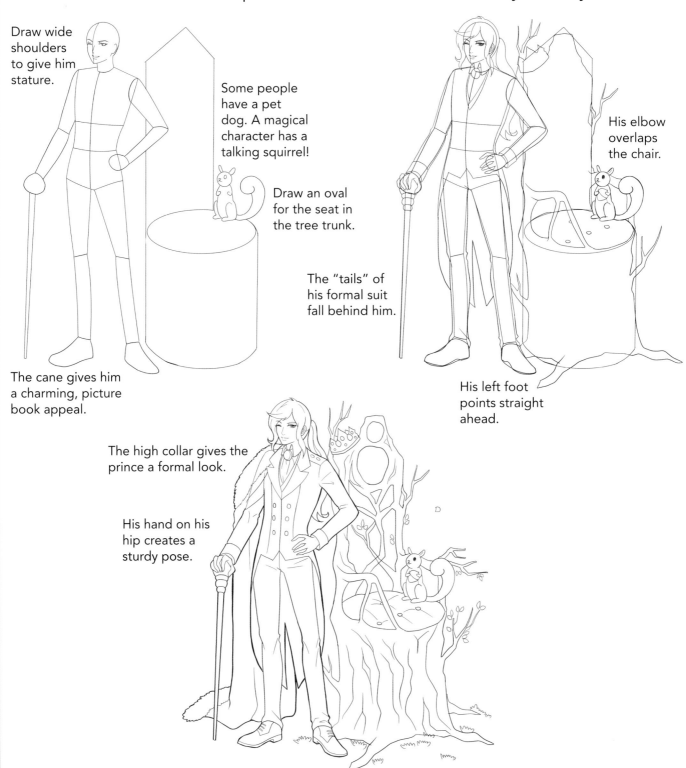

Draw wide shoulders to give him stature.

Some people have a pet dog. A magical character has a talking squirrel!

Draw an oval for the seat in the tree trunk.

His elbow overlaps the chair.

The "tails" of his formal suit fall behind him.

The cane gives him a charming, picture book appeal.

His left foot points straight ahead.

The high collar gives the prince a formal look.

His hand on his hip creates a sturdy pose.

He may look like a boy, but he could be an animal spirit, like a wolf.

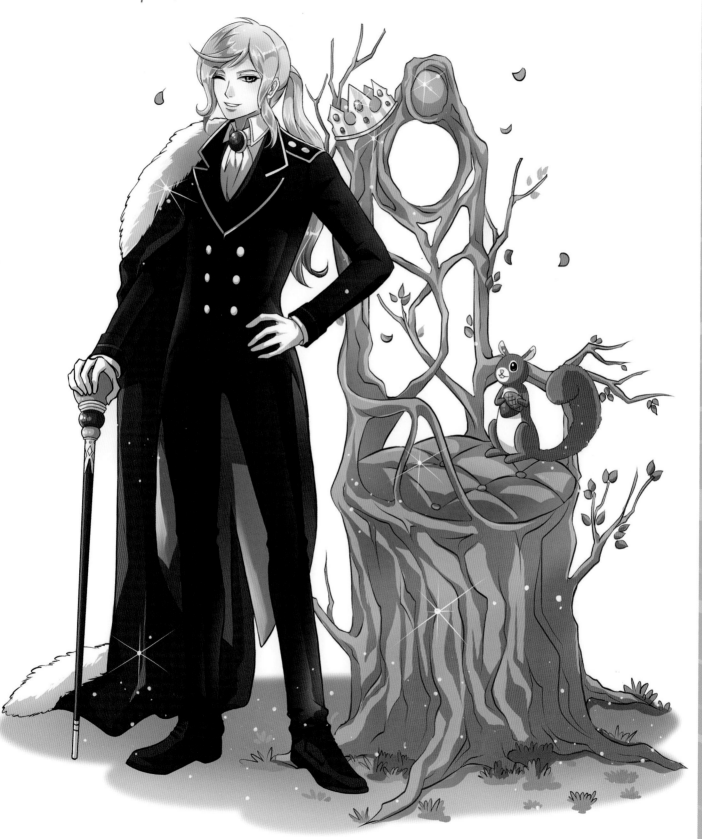

#82-83 You Can't Catch Me!

Magical friends are fun to chase. But you won't catch one. They're too fast. They hide behind trees and giggle as you run past. It's hard to maintain a resentment when they're so huggable. Let's learn how to draw this cute scene and make the magic come alive.

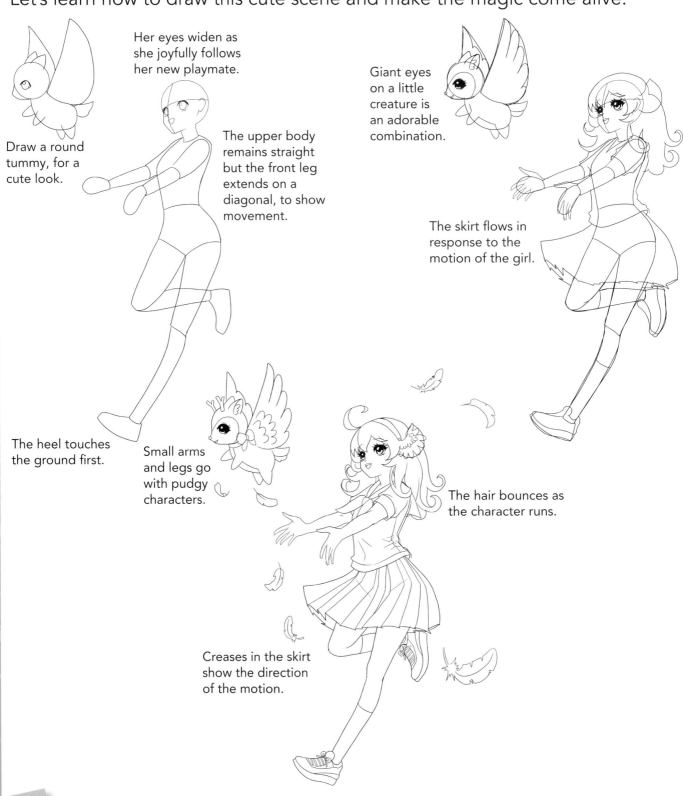

Her eyes widen as she joyfully follows her new playmate.

Draw a round tummy, for a cute look.

The upper body remains straight but the front leg extends on a diagonal, to show movement.

Giant eyes on a little creature is an adorable combination.

The skirt flows in response to the motion of the girl.

The heel touches the ground first.

Small arms and legs go with pudgy characters.

The hair bounces as the character runs.

Creases in the skirt show the direction of the motion.

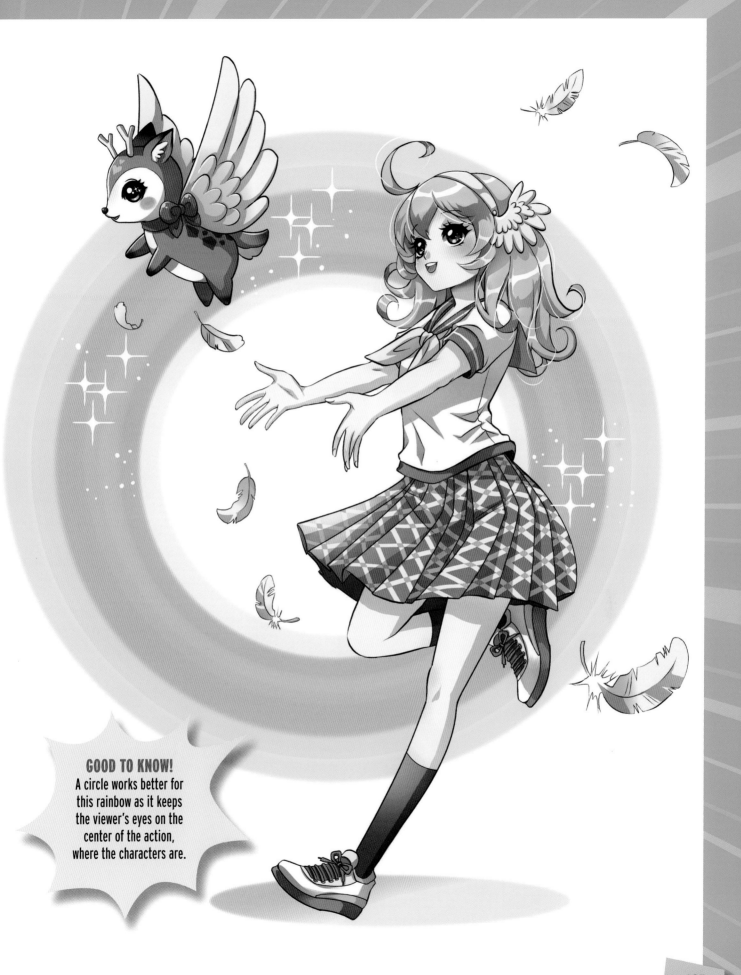

GOOD TO KNOW!
A circle works better for this rainbow as it keeps the viewer's eyes on the center of the action, where the characters are.

#84-85 Birthday Party with Friends

There's a temptation to rely on magical powers to create a magical scene. But more often, the charm lies in the characters' cool outfits, curious friends, and enchanted settings, like this clearing in the forest.

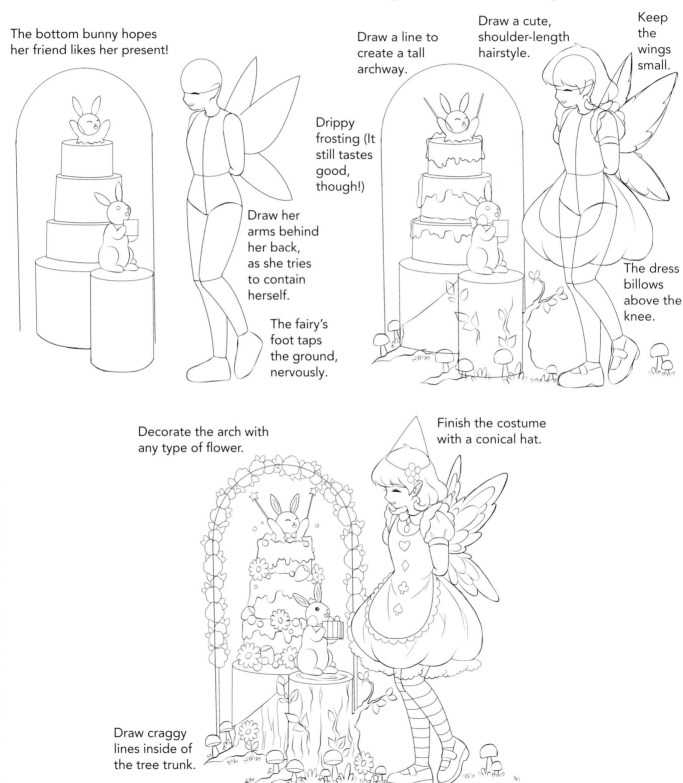

The bottom bunny hopes her friend likes her present!

Draw her arms behind her back, as she tries to contain herself.

The fairy's foot taps the ground, nervously.

Draw a line to create a tall archway.

Drippy frosting (It still tastes good, though!)

Draw a cute, shoulder-length hairstyle.

Keep the wings small.

The dress billows above the knee.

Decorate the arch with any type of flower.

Finish the costume with a conical hat.

Draw craggy lines inside of the tree trunk.

Don't you wish you were invited?
You are! That's the great thing about
being a manga artist—you can always
create your own enchanted party!

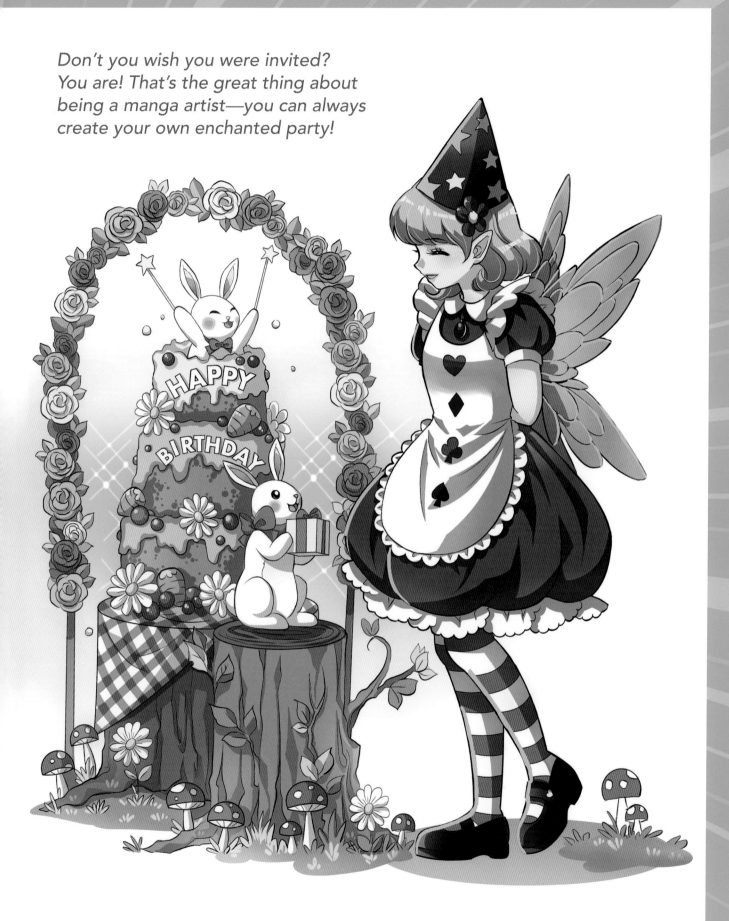

#86-87 Amazing Powers

When magical things come to life, they usually do so at night when no one else is around. Nighttime brings with it a mysterious quality, suspenseful and enchanted. Only children can see the magic. And here's a tip: The most popular magical expression is astonishment, which conveys the wonder of discovery.

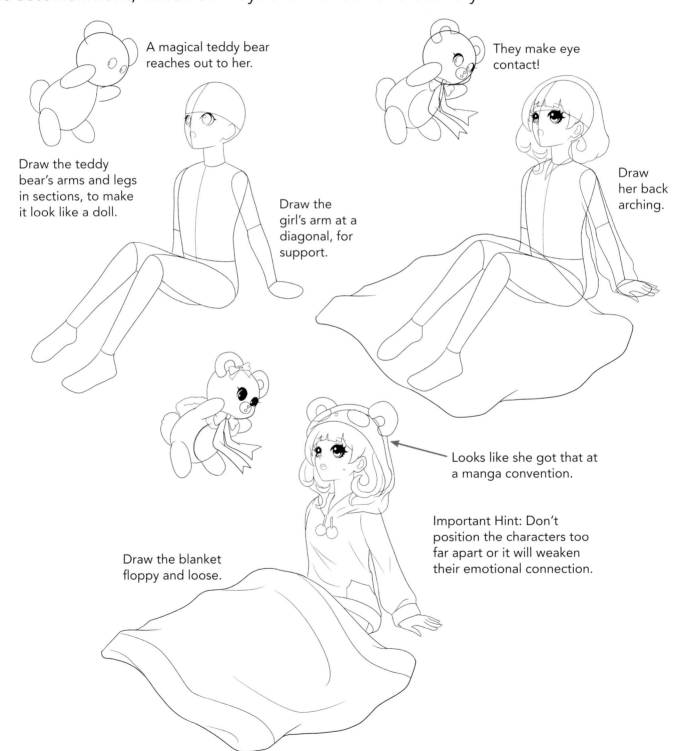

A magical teddy bear reaches out to her.

Draw the teddy bear's arms and legs in sections, to make it look like a doll.

Draw the girl's arm at a diagonal, for support.

They make eye contact!

Draw her back arching.

Looks like she got that at a manga convention.

Important Hint: Don't position the characters too far apart or it will weaken their emotional connection.

Draw the blanket floppy and loose.

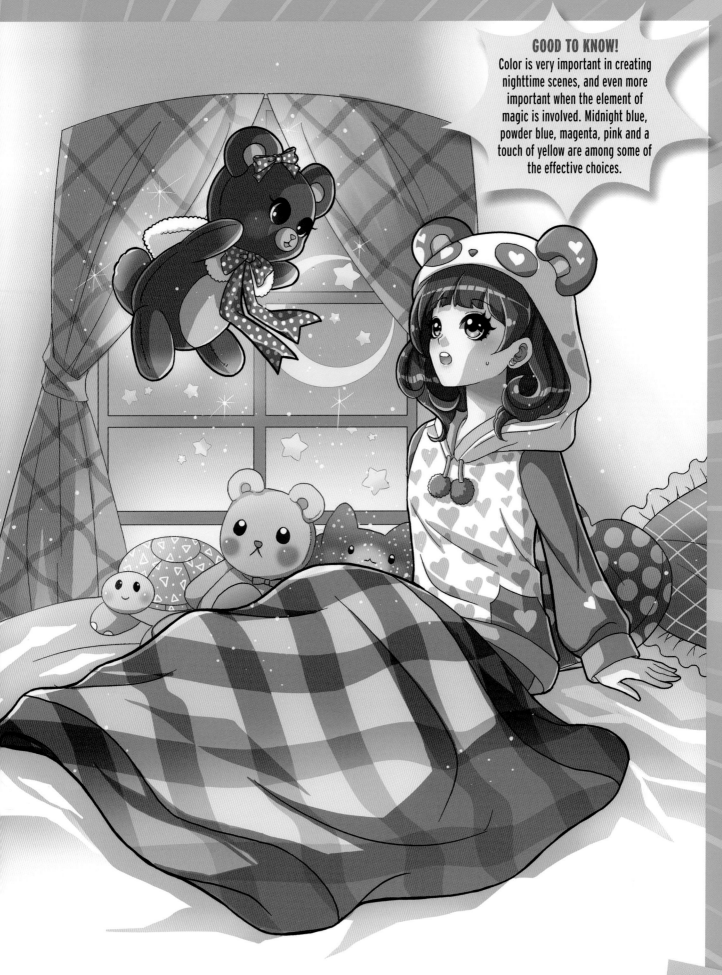

GOOD TO KNOW!
Color is very important in creating nighttime scenes, and even more important when the element of magic is involved. Midnight blue, powder blue, magenta, pink and a touch of yellow are among some of the effective choices.

#88 Doorway to the Imagination

The doorman opens the door. As we step through, an enchanted story begins. The tall doors make it look as though whatever is on the other side is mysterious.

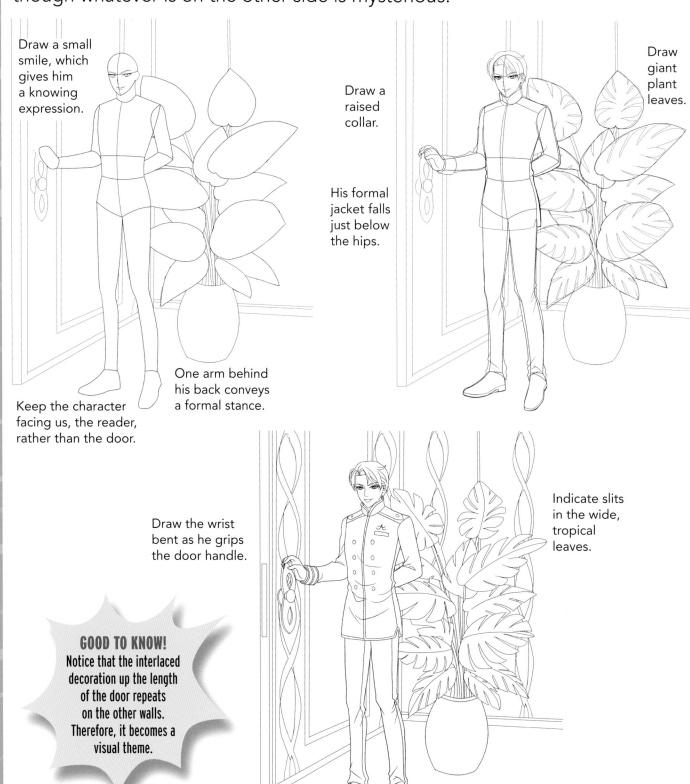

Draw a small smile, which gives him a knowing expression.

Keep the character facing us, the reader, rather than the door.

One arm behind his back conveys a formal stance.

Draw a raised collar.

His formal jacket falls just below the hips.

Draw giant plant leaves.

Draw the wrist bent as he grips the door handle.

Indicate slits in the wide, tropical leaves.

GOOD TO KNOW!
Notice that the interlaced decoration up the length of the door repeats on the other walls. Therefore, it becomes a visual theme.

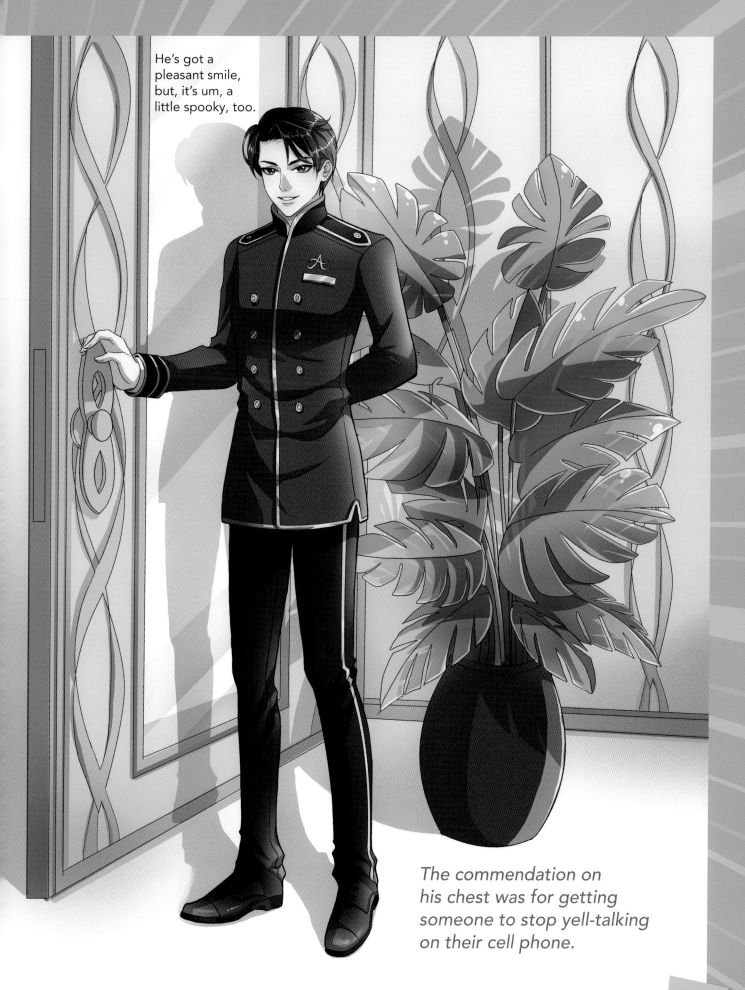

He's got a pleasant smile, but, it's um, a little spooky, too.

The commendation on his chest was for getting someone to stop yell-talking on their cell phone.

#89 Magical Bride

Being a bride is special, but being a *magical bride* is amazing. It took fourteen pixies to sew the dress and one to hammer out the tiara. Her bridesmaids are fairies, unicorns, and a mermaid who had to bring her own fish tank.

An oversized moon creates a magical look.

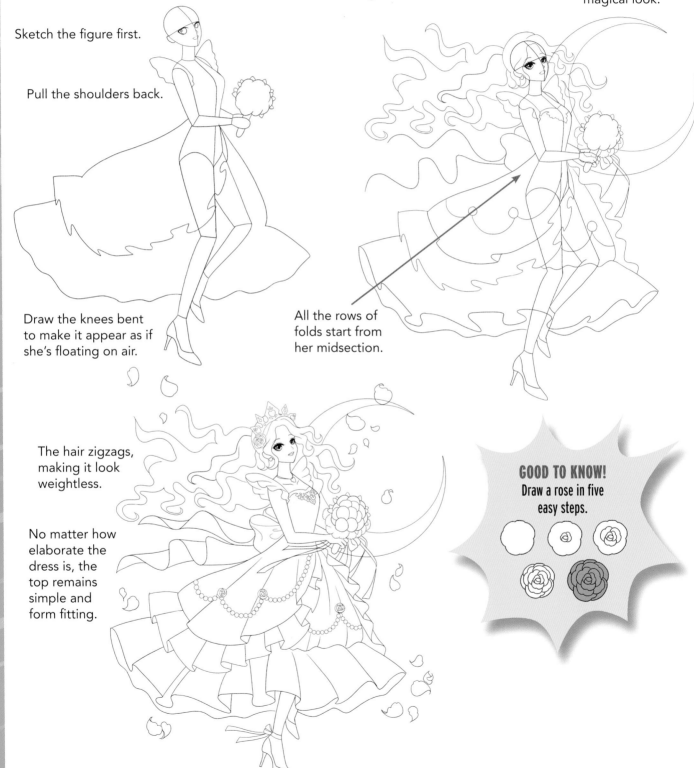

Sketch the figure first.

Pull the shoulders back.

Draw the knees bent to make it appear as if she's floating on air.

All the rows of folds start from her midsection.

The hair zigzags, making it look weightless.

No matter how elaborate the dress is, the top remains simple and form fitting.

GOOD TO KNOW!
Draw a rose in five easy steps.

Let's check the rest of the punch list: a super-fancy tiara, a jewel necklace, a string of pearls, and a bouquet of roses. No wonder magical brides marry for life. They can't afford to do it twice!

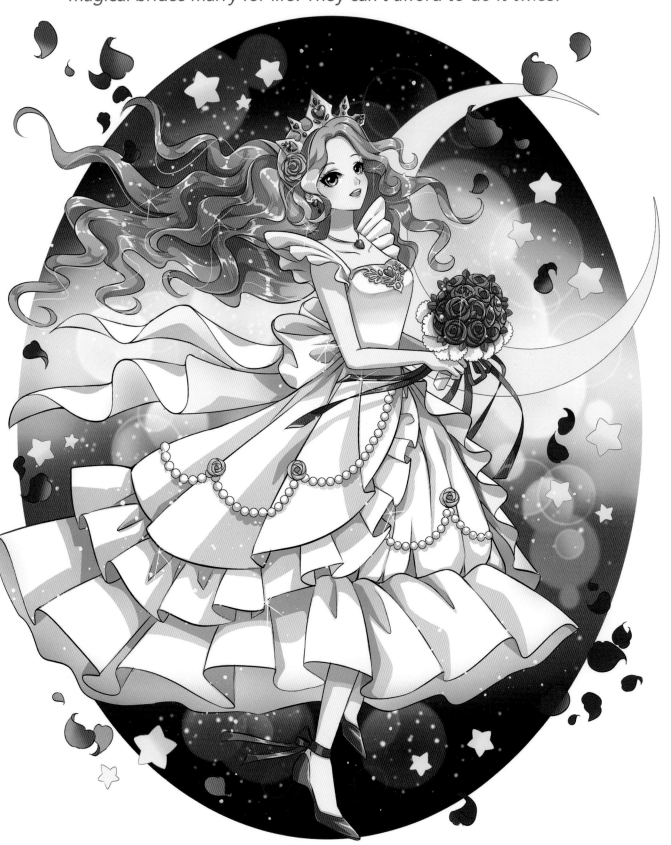

#90 Genie

Genies can be good, bad, or mischievous. And you won't know which until you make a wish. For example, the lamp's owner might wish for a limousine to take him and his date to the prom. But what he gets is a limousine that was spit out of a car crusher. Oooh, not such a nice genie. Now you're down to two wishes.

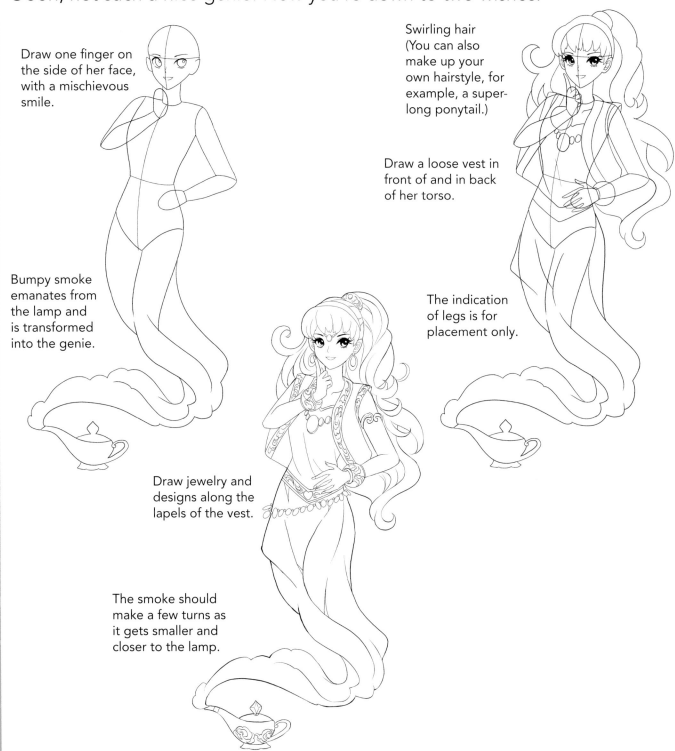

Draw one finger on the side of her face, with a mischievous smile.

Swirling hair (You can also make up your own hairstyle, for example, a super-long ponytail.)

Draw a loose vest in front of and in back of her torso.

Bumpy smoke emanates from the lamp and is transformed into the genie.

The indication of legs is for placement only.

Draw jewelry and designs along the lapels of the vest.

The smoke should make a few turns as it gets smaller and closer to the lamp.

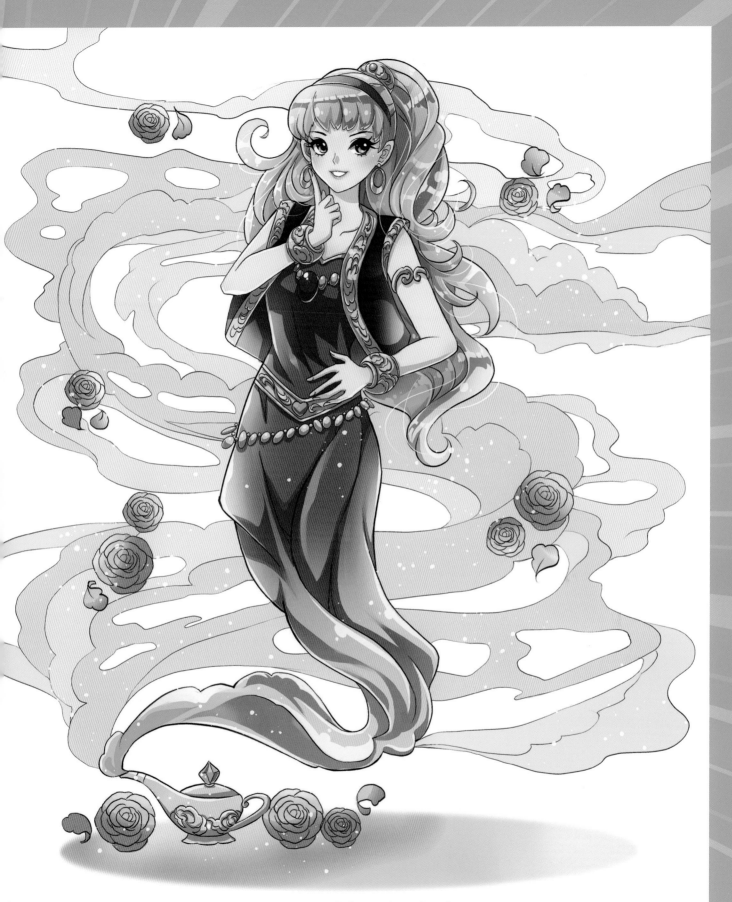

Genies are like magical friends who love to pull pranks on their owners. If you come across a lamp on the beach, better keep walking!

#91 Mysterious Visitor

This mysterious traveler has come from the mountains to deliver an important message. Someone should have told her they now have email. The flowing robe and drifting hair give her a magical look, while the archway (on the next page) creates a feeling of suspense.

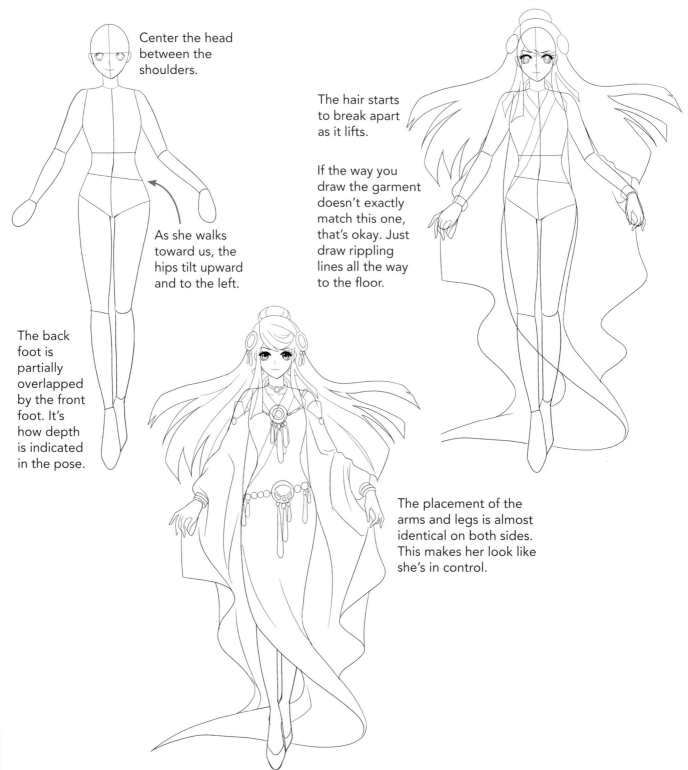

Center the head between the shoulders.

As she walks toward us, the hips tilt upward and to the left.

The back foot is partially overlapped by the front foot. It's how depth is indicated in the pose.

The hair starts to break apart as it lifts.

If the way you draw the garment doesn't exactly match this one, that's okay. Just draw rippling lines all the way to the floor.

The placement of the arms and legs is almost identical on both sides. This makes her look like she's in control.

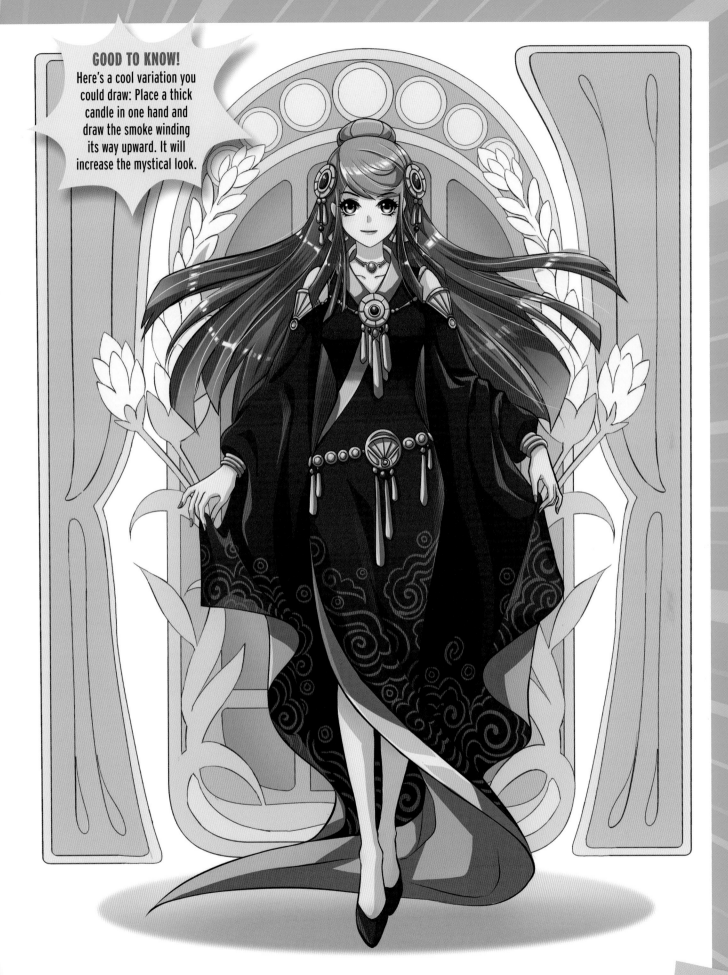

GOOD TO KNOW!
Here's a cool variation you could draw: Place a thick candle in one hand and draw the smoke winding its way upward. It will increase the mystical look.

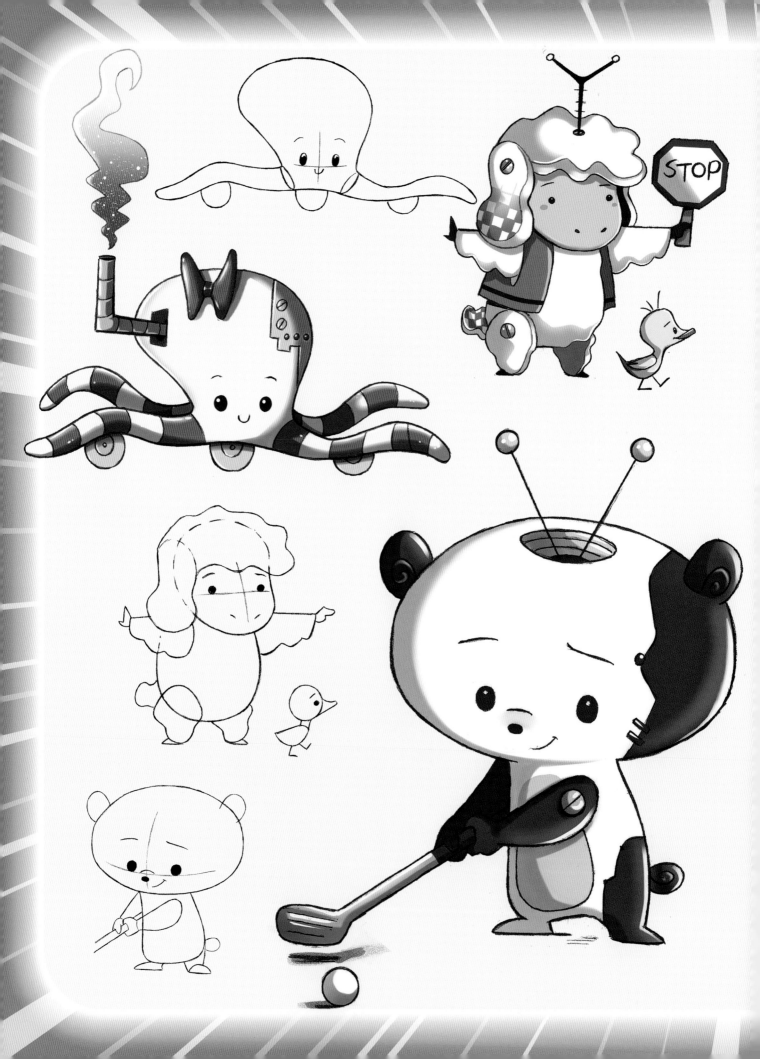

Pet Robots

Manga-style pet robots are a trend in Japan, and the newest thing in character design. It's where gigabytes meet adorable. When you have a robot for a pet, you have a buddy for life. And with lithium-ion batteries to power them, that could be 10,000 years!

These little guys can get into as much trouble as real pets, but they have their excuses already programmed in. The key to their character design is drawing them so they look a little like a pet and a little like a robot—an even balance.

Part of the fun of drawing these adorable techno-pets is giving them a job to do. So, I've designed each character with a different, equally humorous purpose. Have fun!

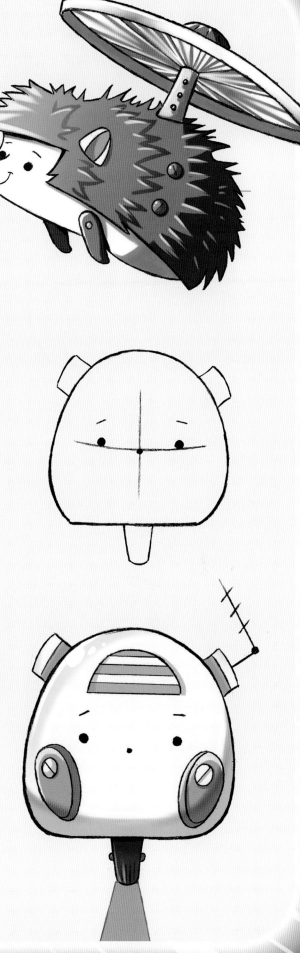

#92 Basic Robot Orb (Super-Simple Warm-Up)

Let's start with something simple, like this basic Model Z-9 Orb. The orb is at maximal cuteness due to its round shape. It can open the mail and pay the bills. (The advanced models also make smoothies.)

Draw two cylinders.

Draw dots for the eyes and nose. You guessed correctly—this is no ordinary egg.

Draw an egg shape, but cut it off across the bottom.

Install a meter into his forehead.

Sketch horizontal lines across the meter.

Draw an adjustable antenna.

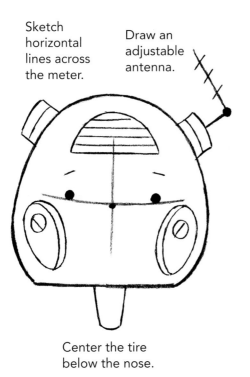

Center the tire below the nose.

When you're done playing with him, he can double as a vacuum cleaner.

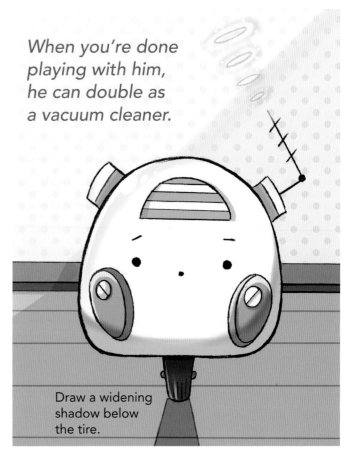

Draw a widening shadow below the tire.

Petting Zoo

Everyone loves a petting zoo. Now you can bring the petting zoo into your own home. You'll enjoy the companionship, although your next door neighbors may not love the constant bleating. No problem! You can change the software to play something else!

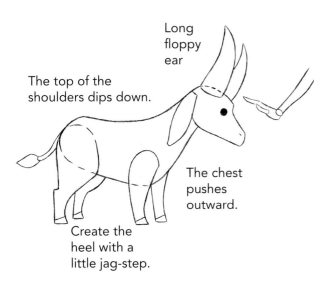

Long floppy ear

The top of the shoulders dips down.

The chest pushes outward.

Create the heel with a little jag-step.

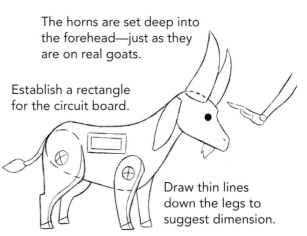

The horns are set deep into the forehead—just as they are on real goats.

Establish a rectangle for the circuit board.

Draw thin lines down the legs to suggest dimension.

Add the hardware! Draw screw-in bolts for the upper thigh and shoulder.

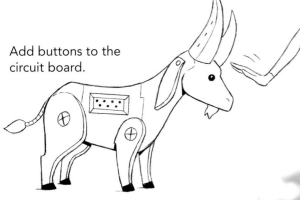

Add buttons to the circuit board.

Fill in the hooves with black.

His feedbag has nuts and bolts in it. Num, num, num!

#94 Crossing Guard Sheep

Crossing guard sheep is ready when anyone needs assistance. Cars stop as he walks pedestrians safely to the other side of the road. If a driver gets impatient, crossing guard sheep will walk slower.

With a fluffy top, its head is as tall as the body!

Fluffy arms with tiny hooves

Small bumpy tail

The legs are shorter than the arms.

The duck has a circle for the head and a smaller shape for the body.

Guidance system

The vest overlaps the body.

The body overlaps the vest.

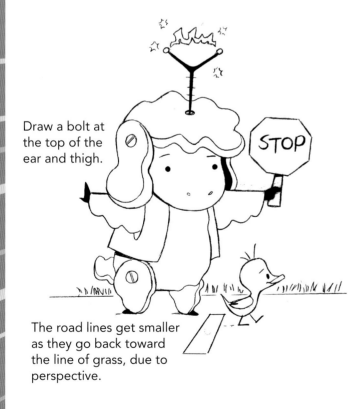

Draw a bolt at the top of the ear and thigh.

The road lines get smaller as they go back toward the line of grass, due to perspective.

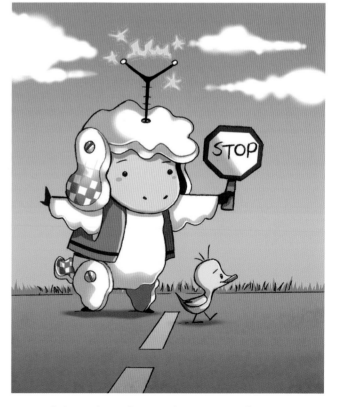

To add style, draw the top of the arms with straight lines and the bottom with bumpy lines.

Playmate

This is one of the coolest toys you can get your kid for the holidays. And it doesn't even require a litter box. Give the bubbles random placement, which offsets the mechanical appearance of the robot pet.

Rounded tummy

Rounded tummy

Draw a floor line to keep both characters on the same level.

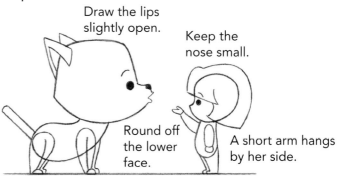

Draw the lips slightly open.

Keep the nose small.

Round off the lower face.

A short arm hangs by her side.

Pudgy arms and legs

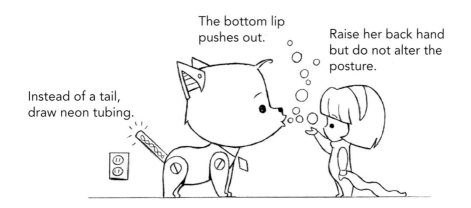

The bottom lip pushes out.

Raise her back hand but do not alter the posture.

Instead of a tail, draw neon tubing.

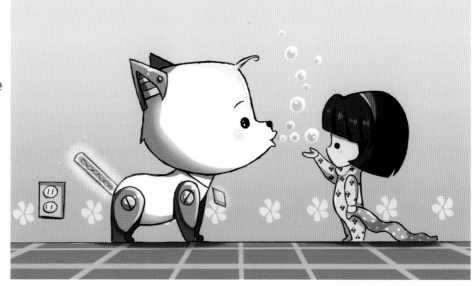

If you want to play up the techno angle even more, draw square bubbles.

#96 Aqua Friends

Some people like the idea of getting a rare dog breed as a pet. But an octopus in your living room beats that hands down. Oops, time to go! He's got a playdate with the neighbor's squid.

Draw the large forehead so that it blobs to the left.

Draw two front tentacles.

The features of the face are smooshed all the way to the bottom.

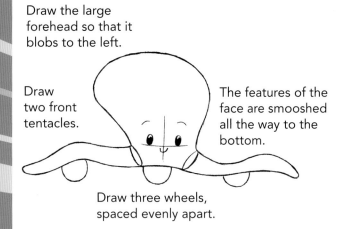

Draw three wheels, spaced evenly apart.

Begin to draw a buddy to its right.

Draw the two back tentacles higher than the front tentacles.

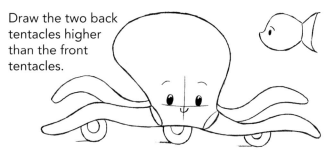

Indicate the "hubcaps" inside of the wheels. (It's a souped-up model.)

Draw an elaborate pressure valve any way you like. This is just one suggestion.

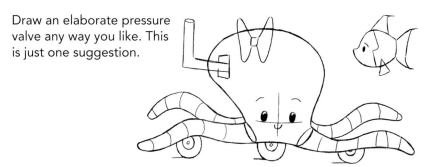

The nice thing about having a robot friend instead of a real octopus is that the living room doesn't smell of brine shrimp.

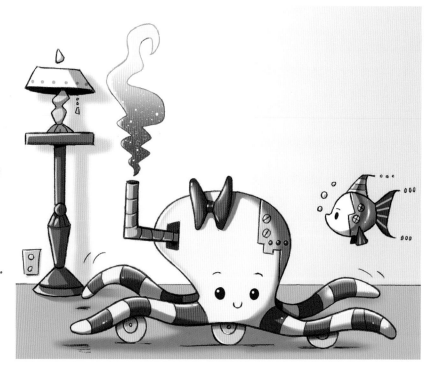

Delivery Mouse

When you want to send something quicker than overnight, Delivery Mouse is the answer. Unfortunately, due to his size, he can only carry stuff as far as the next room.

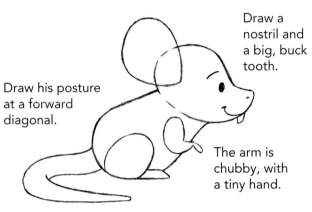

Draw a nostril and a big, buck tooth.

Draw his posture at a forward diagonal.

The arm is chubby, with a tiny hand.

The tail will look more natural if it is curved.

Draw the thigh big and round.

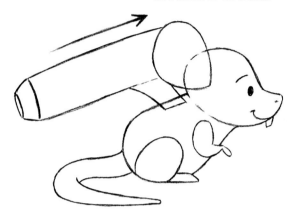

The jet tank mirrors the direction of its back.

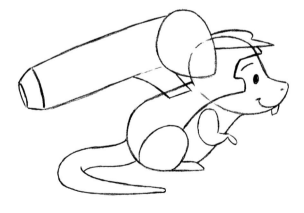

Draw protective armor over the top half of its body.

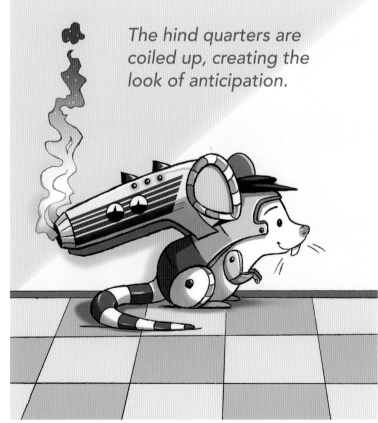

The hind quarters are coiled up, creating the look of anticipation.

#98 Hedge-Copter

If your robots come out looking too much like a real animal, then adding a propeller should to the trick. Not too many animals in the wild come with one. And anyway, most animals don't have a license to fly with one. Draw an oval for the basic shape of the propeller. Within the oval, define individual rotor blades.

The snout is pointed.

This basic shape is a pillow.

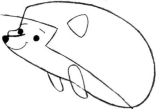

Draw a line separating the back (spikes) from the underside, which is soft.

Straighten each end of the propeller.

The ear is set back.

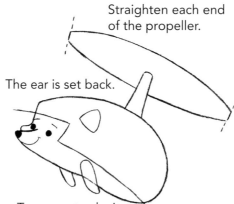

To suggest velocity through the air, draw the arms going back.

Give thickness to the propeller.

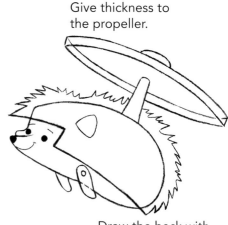

Draw the back with random fuzziness.

Although a hedgehog has spikes, they're short, which gives it a cuddly appearance.

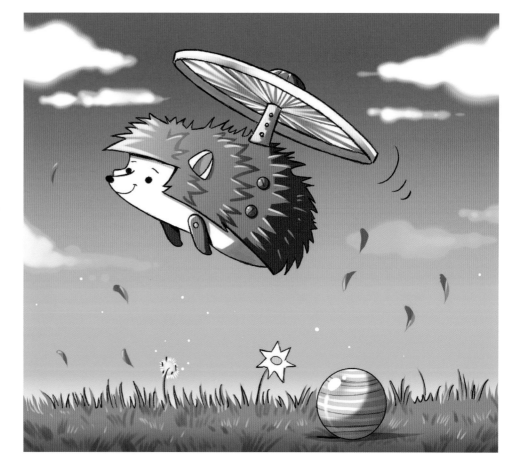

Sports Buddy

Be the first one on your block to have a coach and a bear, all in one. He's a fun partner for mini golfing, except for the fact that he never misses. Shall I put you down for eighteen holes-in-one today?

Draw the head as a big, fat oval for maximum cuteness.

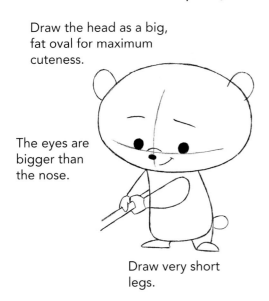

The eyes are bigger than the nose.

Draw very short legs.

Two cupped ears

Draw an opening for the power source.

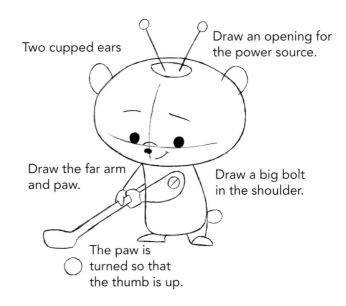

Draw the far arm and paw.

Draw a big bolt in the shoulder.

The paw is turned so that the thumb is up.

Draw swirls inside the ears.

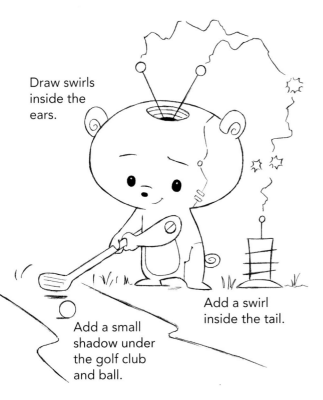

Add a small shadow under the golf club and ball.

Add a swirl inside the tail.

The fun is making the pet unaware he's a robot. In fact, he'd probably be insulted!

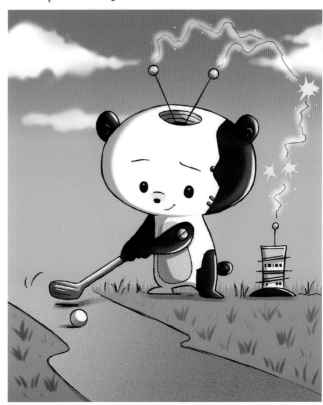

#100 Water Bunny

Don't you hate it when your mom or dad asks you to water the lawn? Like that's as important as whatever's happening on social media. But now, you don't have to choose between them. Be sure to give your bunny a robot carrot to thank him.

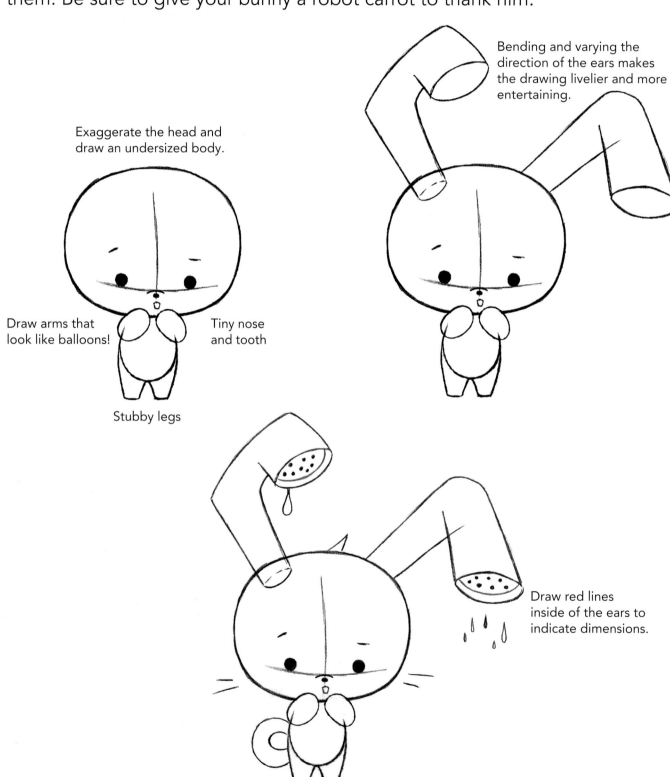

Exaggerate the head and draw an undersized body.

Draw arms that look like balloons!

Tiny nose and tooth

Stubby legs

Bending and varying the direction of the ears makes the drawing livelier and more entertaining.

Draw red lines inside of the ears to indicate dimensions.

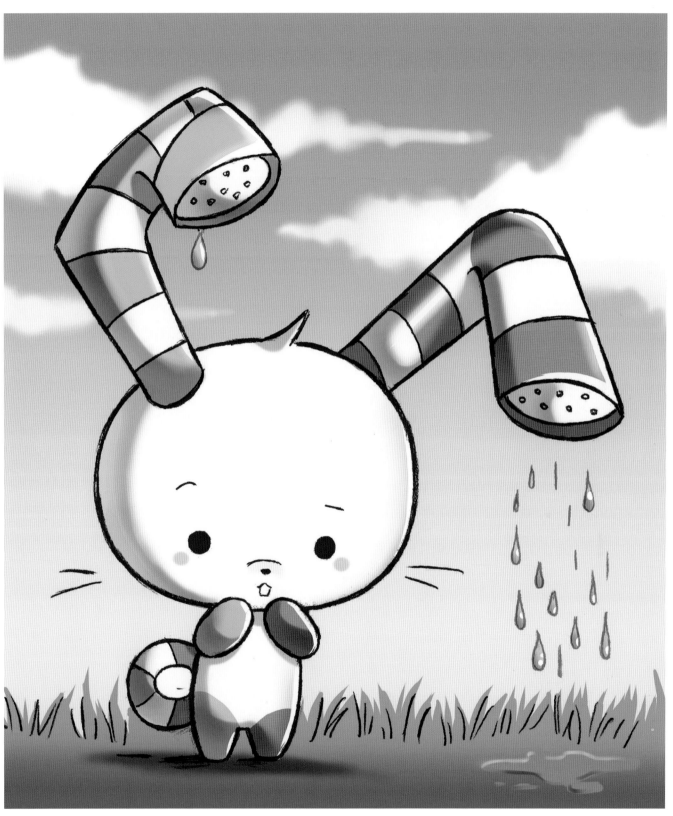

Kids love playing with him because once he's finished watering the garden, he becomes soda bunny!

Index